11/24/00

2498/
50.00+
est.

HPB/ Broadway

›EXITS‹

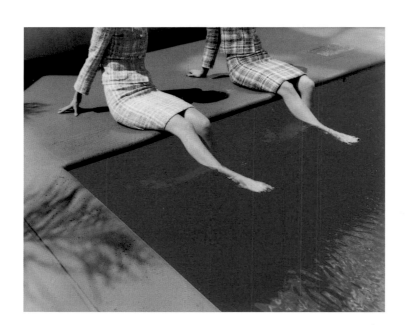

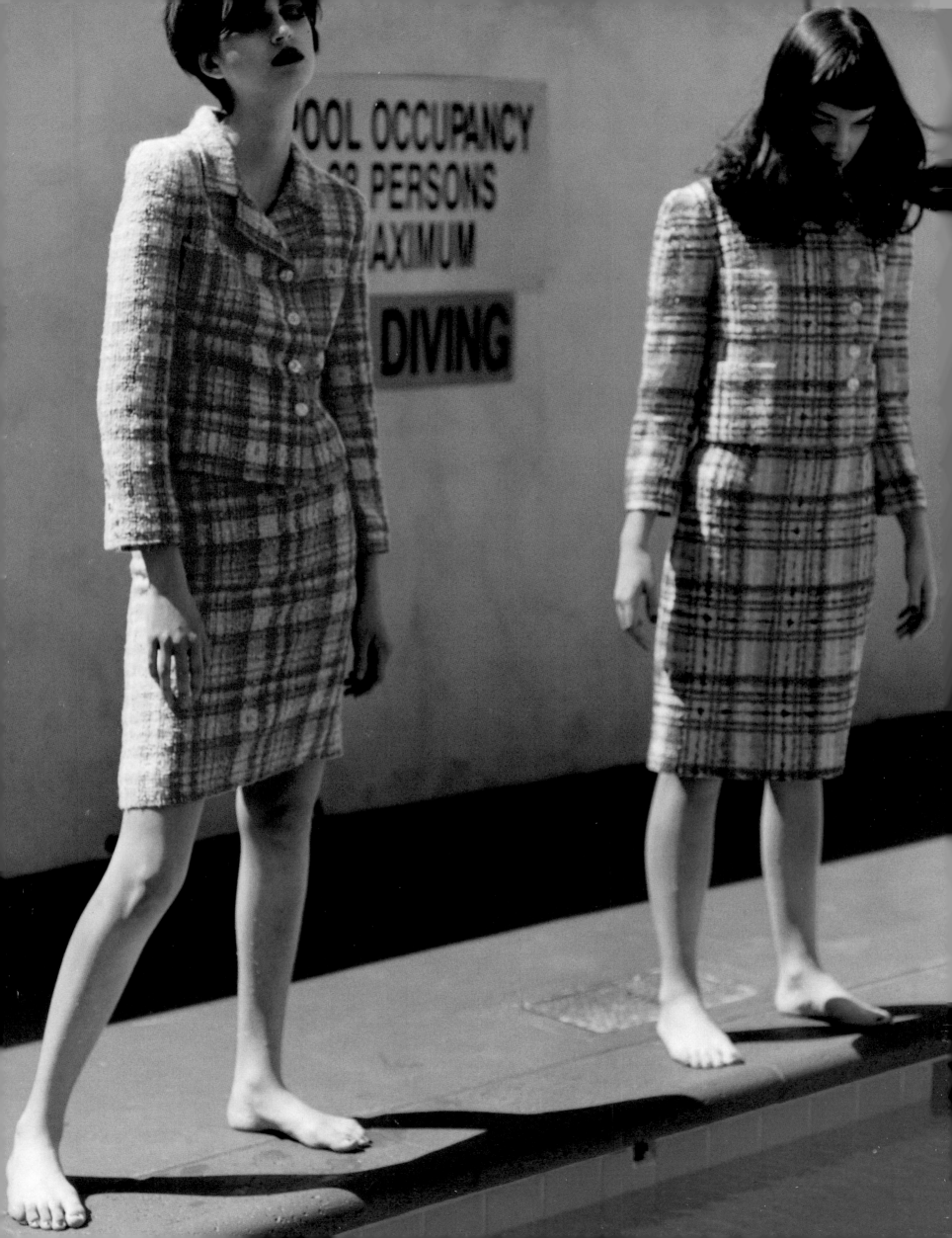

KATRIN THOMAS ›EXITS‹ LIVING FASHION

Texts by
Iké Udé and Michelle Nicol

*E*DITION *S*TEMMLE

Zurich New York

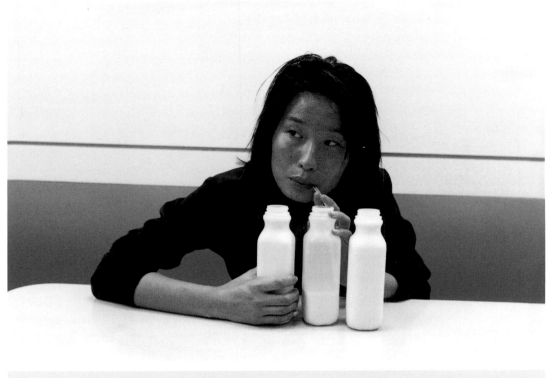

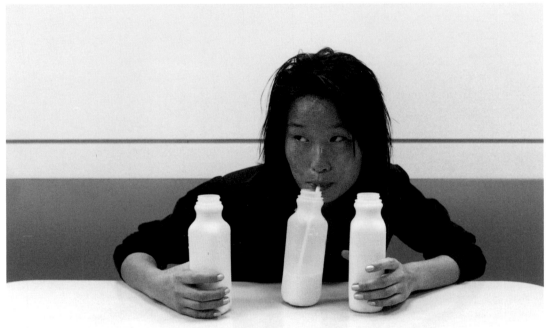

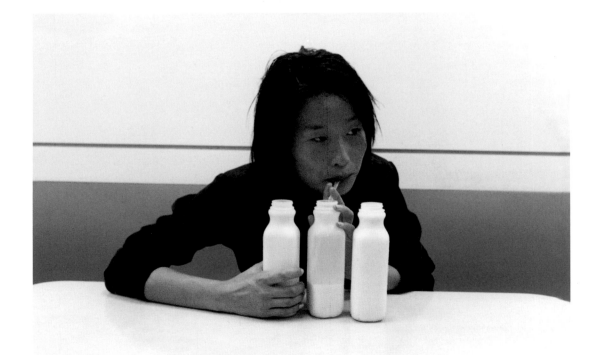

▶CONTENTS◀

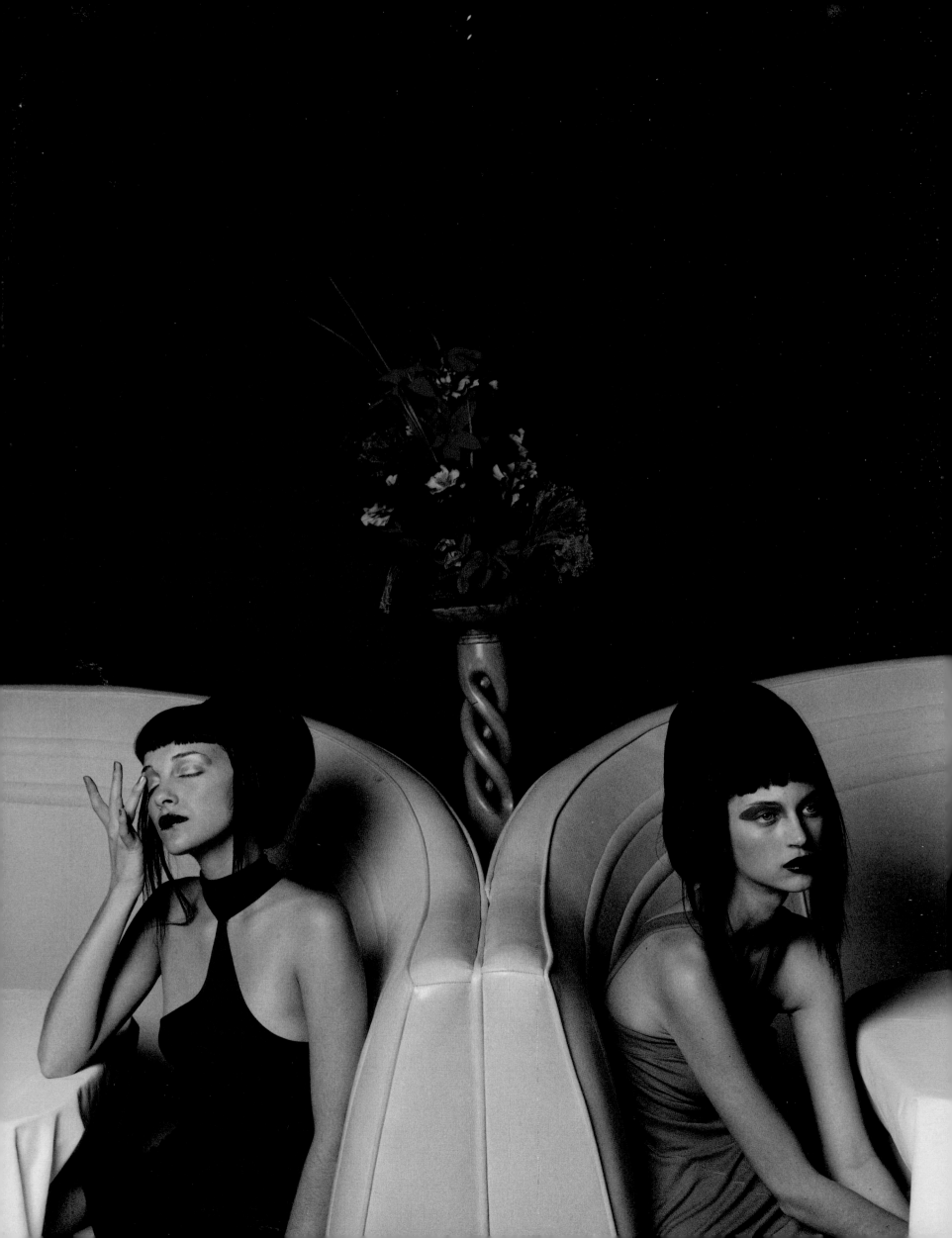

▸CIPHERS, IMPS AND VAGARIES OF FASHION◂

Iké Udé

Getting Katrin Thomas to explain her own photographs is a daunting task, nonetheless, everything that she needs to say about her work is deftly woven and crisply realized. Asked how she would describe her photography to the average person, she answers, "I would have to say that it is related to movies I'm creating at that particular moment. I've always been inspired by the films of Godard, Antonioni and Truffaut. They are very real, yet they are not. Like the way all these directors use simple but profound language in an abstract, humorous, romantic way. In my photography, I try to explore in a similar way." Thomas' photography re-enacts slices of everyday life and trends, to create a poetics of glamour, misery, ambivalence, attitude, ennui, etc.

A 1997 photograph that she shot in Los Angeles shows two young girls—each barely twenty years old—exquisitely decked out in fetching single-breasted, Chanel-inspired plaid suits (p. 66/67). Their bodies are criss-crossed with lemon-yellow and ochre chalk-bands beside a gleaming blue swimming pool, accentuated by the girls' pale nude legs partially immersed in the pool. The alluring saturation characteristic of the California sun is evident, with its attendant aura of leisure, but the ironic subtext of chic boredom underscored in this picture, and not least punctuated by one of the girls' yawning, exemplifies the care that Thomas took in elucidating and, in effect, demystifying the everyday life of privileged Beverly Hills girls. Fantasy and desire have a clear purpose in fashion: people want to look through, and not at, fashion photographs. They want to be entertained, amused, comforted and, hopefully, live vicariously through glossy photographs of beautifully posed, manicured models. But in celebrating these iconic, spoiled girls, Thomas also betrays the limitations of the luxury that under-privileged girls—unaware—long for.

The edginess of Thomas' photography is derived not from its casualness, but from its cinematic urgency, which stirs the viewer while retaining a photographic stillness that invites contemplation. The urgency of the cinematic style captures fleeting moments. Looking at (not through) Thomas' sepia-toned portraits of impressionable young boys and girls one by one, we find that, a touch cruel, she catalogues all the pretences of "cutting-edge" fin-de-siècle: from punk grimace, homeboy-wannabe, rastafarian anti-coif, to Soho pseudo-downtown art scene. Gone are the days when bohemia, underground, cutting-edge or rudeboys meant something. Nowadays, faking it succeeds more than being it. A pose, a look, an attitude or a style can all be bought or sold in a second. In a five-minute makeover, a suburbanite can be transformed from a pale young thing into the IT girl or boy of the moment. "Escape from reality" is no longer necessary; reality has become an escape, and perception the only reality. Our life has become as real as cloning, test-tube babies, breast implants, nose jobs, face-lifts, sex-changes, race-changes, spin doctors, clever lawyers or sexgate. What are we left with but our true picture, a silhouette whose true color is the greenback? Hardcore capitalism commodifies everything and anything. In Puff Daddy's words, "It's all about the Benjamins."

As the popularity of fashion as a worthy cultural phenomenal grows in learned circles, so the role of fashion photography will progress from a mere decorative medium to a demanding one with a critical framework that can enable us to see beyond our glamorized decorum. Fashion is not only contagious, it is also worth catching, regardless of cultural, religious or gender homogeneity. Perhaps playing, for instance, with the homogeneous trope and stereotype of what it means to be Asian, female and probably Buddhist, Thomas photographed a young Asian girl in two frames (p. 108/109). In one frame, dressed in a Maoesque revolutionary white suit against a background horizontally banded in green, white and black, this young girl sits leaning on a white table, her back slightly bent with anxiety, peering in enigmatic contemplation at her white plate of food. Clearly, Kate Moss, not the Buddha, is the icon of faith and salvation in this picture: faith in self-starvation, salvation in thinness. The charged symbolic analogies of sanitation and purity, anorexia and thinness, bulimia and ambivalence, fashion and body, culture and nature bear witness to the collective psychological damage we are suffering from. As if to drive her point home, Thomas' second frame freezes her subject's evident expression of *mea culpa*.

Those who glibly dismiss fashion as harmless and irrelevant should think again. The pervasive tyranny imposed by waif-chic, epitomized by Kate Moss' well-orchestrated fashion campaigns, is omni-present, day and night, throughout the world; whether Buddhist, Christian or Mohammedan, none can escape the contagion of fashion. Look again at the young Asian girl's ambivalence when confronted with her plate of food. The dilemma she faces between feeding herself and possibly getting fat on the one hand, or starving herself to desirable thinness on the

other, is etched in her bemused stare. Trapped as she is in the knot of indecision, her portrait is not mere fashion photography, but a tragic depiction of the ambivalence of fashion and beauty. This is one picture you will not be seeing soon in *Vogue* or *Harper's Bazaar:* it is too real.

"I love repetition," says Thomas "it strengthens an idea, it is persistent. It is excellent for memory retention." Again and again, the leitmotif of the EXIT sign appears in Katrin Thomas' photographs. Her work constantly requires her to travel from one place to another, and in so doing, she is continually exiting from one space and entering another. Her perpetual crossing of boundaries symbolizes what has increasingly become a post-modern condition for most of us. The ubiquity and universality of the EXIT sign in our modern environment has given it a physical presence and a psychological authority that renders it more pictorial than textual. Aware of this fact, Thomas employs EXITs more as a pictorial than as a textual device. On the cover photograph of this first monograph of hers, we see five fashionable young women—or are there perhaps more of them?—exiting from wherever to who-knows-where. Is this a still from a motion picture? Are they leaving a fashion show, or returning unwanted merchandise? We don't know, for despite our initial inclination to assume that these girls are on their way out, they might just as well be on their way in. The promise of certainty is called into question by the element of uncertainty in this picture, making Thomas' photograph an irresistible palimpsest of youth culture and fashion trends.

At times, the acute transparency encountered in Thomas' work is every bit as damning as it is intense. In a "bathroom" picture (p. 14/15) of three young women the photographer depicts, viewed clockwise from the left, an uninvolved blonde wearing tights, her left hand partially clasped over her mouth and nose, her right forearm resting on a glass shelf for support and balance. A second girl, a brunette, is standing in the middle facing away from the viewer, her left arm bent at the elbow with the palm of her hand cupped, and her head bowed. Her unseen right hand could be touching the middle of her face. Half-emerging from the toilet and half-standing, the third, also a brunette, is leaning against the door with her arms raised, her left arm at an angle that, once again, covers her mouth, her nose and an eye. All three girls are, to a greater or lesser degree, preoccupied with their noses. This picture entertains multiple readings, including the recreational use of cocaine by these three

girls, who look as if they may be dancers or something similar. It should be borne in mind that cocaine is reputed to undermine the appetite for food—a necessary evil for dancers.

By realizing this "bathroom" picture without any suggestion that her subjects are posing, Thomas succeeds in capturing an emblematic moment of decadence, guilt, shame, and the all-too-familiar insatiable consumption that characterizes the so-called Generation X. This is not a rehashed, trendy photograph of, say, heroin-chic, designed to affect a cutting-edge gesture in order to shock the bourgeoisie. Like Edouard Manet, who insisted that "We must accept our own times and paint what we see," Thomas fully embraces her own time and photographs what she sees.

The eldest of three children, Katrin Thomas was born in Bonn, Germany, on January 5th 1963, at the start of a decade that was marked by anti-bourgeois values, sexual promiscuity, "free love" and unashamed drug abuse; hence, in many ways, it created a template for the continuing moral decay of today's Generation X. At the age of seven, she left Bonn for Frankenthal, where she spent the rest of her childhood. Later, she studied Visual Communication and Graphic Design at Darmstadt. In 1991–1992, she attended the Art Center College of Design in Pasadena, California, on a Fulbright scholarship. For as long as she can remember, she has been a child of the arts: she was an actress for a while, and from the age of fifteen to twenty-five, she sang and studied opera. Throughout these formative years, she also studied modern dance, which explains her evident agility. Faced with her competing talents, she increasingly turned to still and motion pictures.

Occasionally, fate or providence dictates that an impresario will discover a great and lasting talent. Carmen dell' Orefice, the ageless American beauty who is still working as a fashion model at the age of sixty-seven, was discovered one day in a Manhattan cross-town bus. Iman, the enduring Somalian beauty, was discovered as a fashion model while attending college in the United States. Likewise, Katrin Thomas was "discovered"—a thorny term—as a photographer by Thomas N. Stemmle, President and Publisher of Edition Stemmle, in *Photo News*, a German photography magazine, when one of her photographs adorned the cover. His curiosity aroused, Stemmle determined to meet Thomas and see more of her work; impressed by what she showed him, he of-

fered to publish her photographs—a decision based on the strength of her work rather than on her apparent lack of celebrity. But of course, Thomas had been working for at least the past ten years; and like all "discovered" heroines and heroes, her discovery owed as much to the eye of the discoverer as to her untapped talent.

When Thomas delves squarely into fashion photography, the obviousness with which she does so suggests deliberate parody. In *Rouge* (p. 6), she portrays two girls in exaggerated black wigs, seated back to back against a burgundy wall; they are separated by two shoulder-high couch backs, with a fake-looking bouquet—a tawdry attempt at flower arrangement—wedged exactly in the center, where the curved arms of the two couches join in an embrace. At first glance, the atmosphere of this lounge suggests sheer abandonment and luxury, but the underlying hypocrisy of glamour that Thomas captures in this photograph betrays the "escape from reality" epitomized in the cult of supermodels and their wannabes. Trapped in contradictions, these girls also mirror the malaise of fashion-victimhood, suffered by millions of girls the world over. "I do not rely on or need beautiful models, or a photo studio, in order to create a strong picture. In fact, although I'm not against the use of beautiful models, I'm confident that my vision and artistry can always suffice. I'm more interested in taking an interesting picture from a seemingly uninteresting situation. It's always important for me to not only realize beauty but also its attendant consequences."

For most leading fashion photographers, Gallagher Paper—a New York City store specialising in second-hand and sought-after out-of-print fashion magazines—has become a sort of Harvard. Boasting an inexhaustible collection of magazines —*Vogue, Harper's Bazaar, Vu, Look,* and some periodicals dating as far back as the 1900s—Gallagher Paper inspires "fresh" ideas in many fashion photographers, who only have to look at and copy the past work of Cecil Beaton, Erwin Blumenfeld and others. Take Cecil Beaton and Horst, for instance: there can be no doubt as to their exceptional mastery of lighting effects, costumes, props and celebrity subjects, a synergy that yielded superbly lasting photographs. But there is an undeniable coldness in their work. Edge and surprise in photography today can only be realized with a certain spontaneity, or at least a smartly wrought casualness. The cold, august aura of erstwhile masters like Beaton or Horst is—today, when "anything goes"—generally irrelevant and too quaint. Yet, ironically, there is a great insight embodied in the ancient Chinese belief that the amateur is the true artist; unburdened by the weight of reputation, he is open to chance, willing to take risks with nothing to lose, and hence free to constantly explore and chart new territory. True to post-modernism, with its attendant parody, irony, metafiction, ambiguity, open-ended or not-yet future, Thomas confidently seeks to imbue her photographs with an ineffable freshness that is immediate, and deceptively unrehearsed.

Katrin Thomas' debt to motion pictures is manifest in a picture of six young women (p. 16/17), scantily-clad in swimsuits with their backs to the camera, walking away from the viewer in single file towards what appears to be a freight elevator or loading dock. The girl in the foreground has her arms wrapped around her in an apparent attempt to ward off an uncomfortable draft; the second girl, a considerable distance behind, is walking with a defiant poise, while the remaining four girls seem to be in varying stages of psychological preparation for their exit.

Poll after poll has shown that the average young girl's dream job is to be a fashion model. With religion in rapid decline, faith lost with one hand is regained by the other. Today, the fashion magazine is the young girl's bible, the fashion designer her god, and the fashion model her supreme goddess. Using the fleeting nature of fashion as a trope, Katrin Thomas has summarily articulated the vernacular and pernicious ideals of beauty of today's young girl.

Throughout Katrin Thomas' work, there abound the aura and fetching beauty epitomized by the breeziness of Françoise Hardy's voice, the disarming dissonance of Billy Holiday's phrasing, the dionysian wantonness of Prince or Madonna, or the savory melancholy of Tricky, say, infused with the pop irreverence of Björk. Thomas' grasp of her photographic composition always manages to delineate the complex and quotidian with such rare musical breadth, such artistic restraint and poetic immediacy that it is able to surprise the jaded retina of even the most hardened cognoscenti. Whilst any definition of what constitutes a masterpiece is relative, work like Thomas', which unfailingly engenders a sensation of passion, holds eternal sway. The fuel of passion that fires and lovingly stirs Katrin Thomas' photography will always reward us with its warmth.

10 ▸PLATES◂

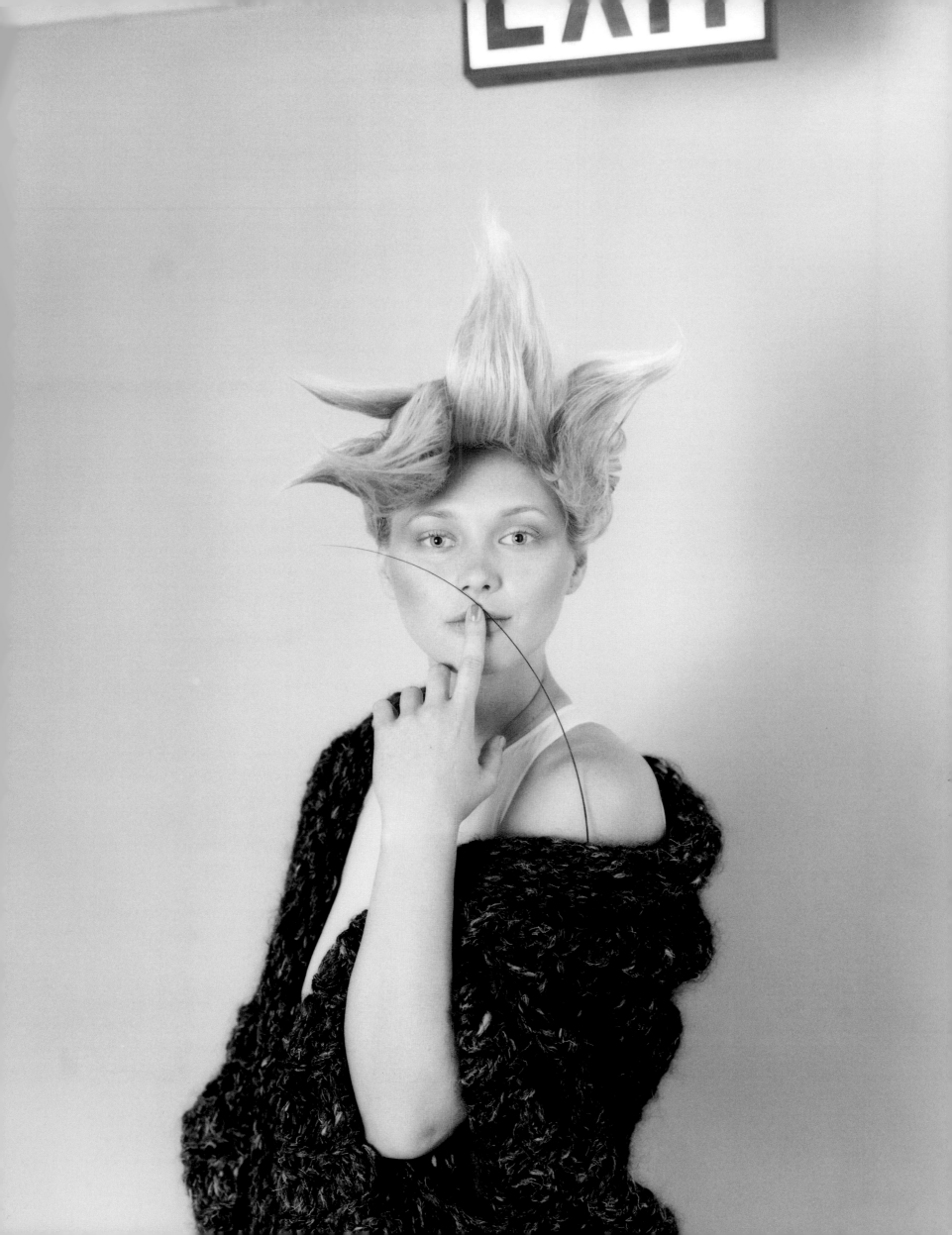

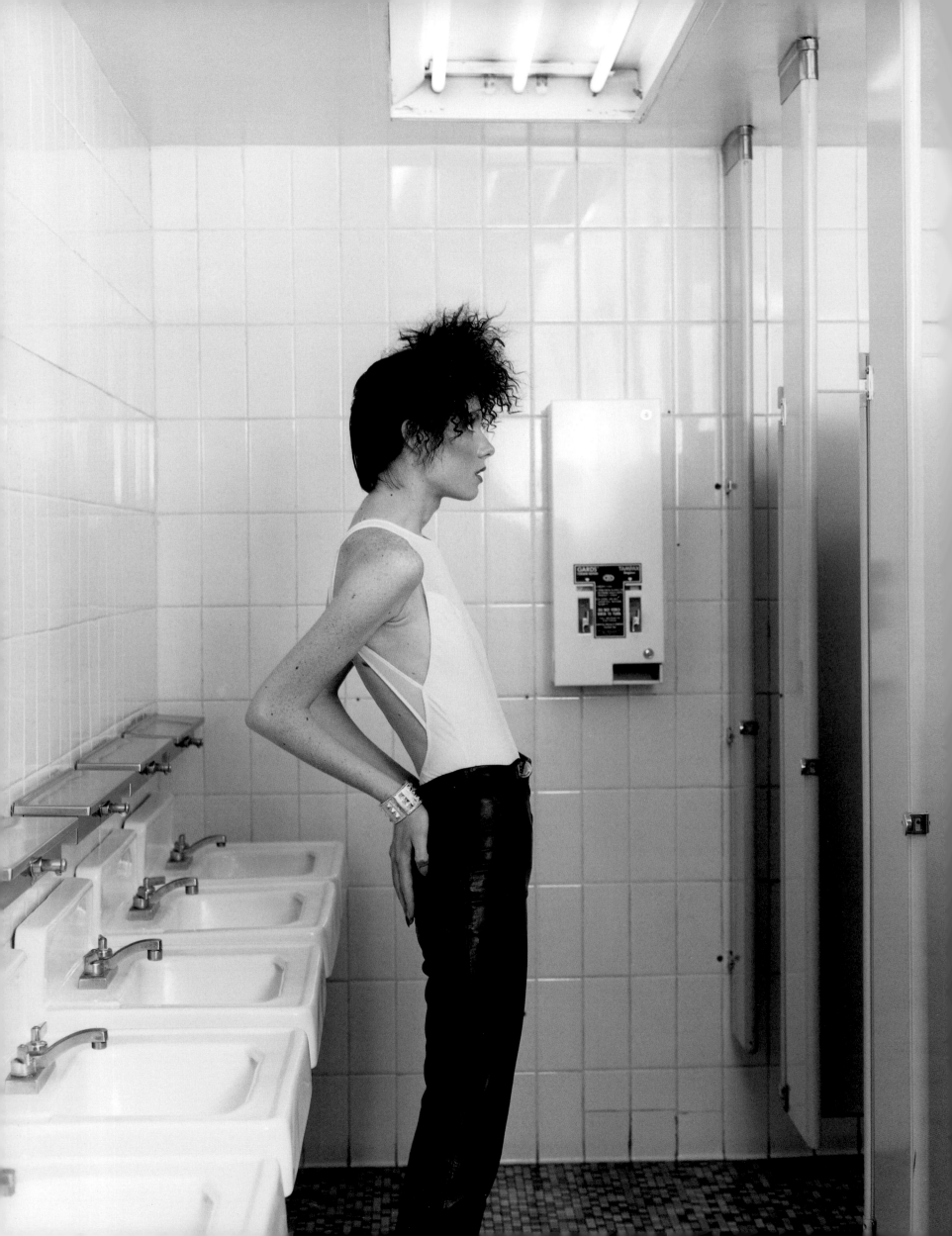

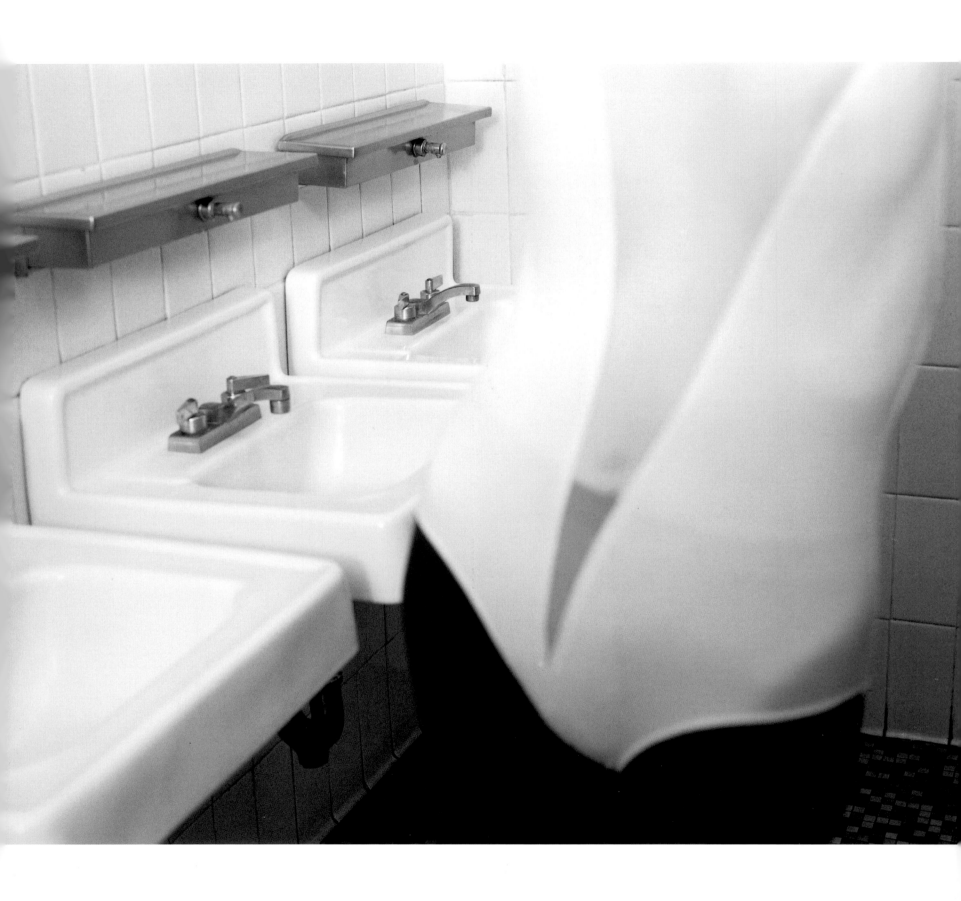

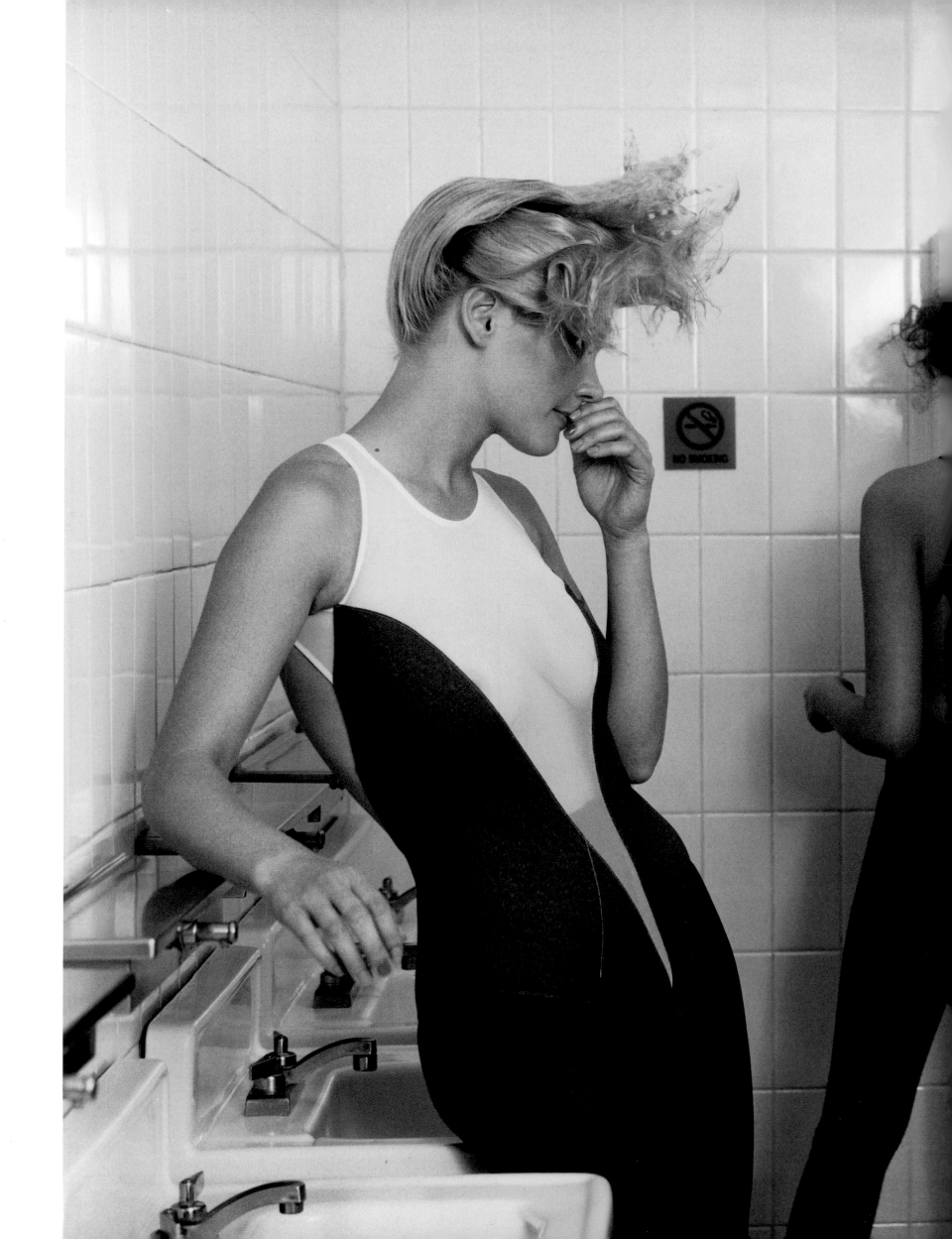

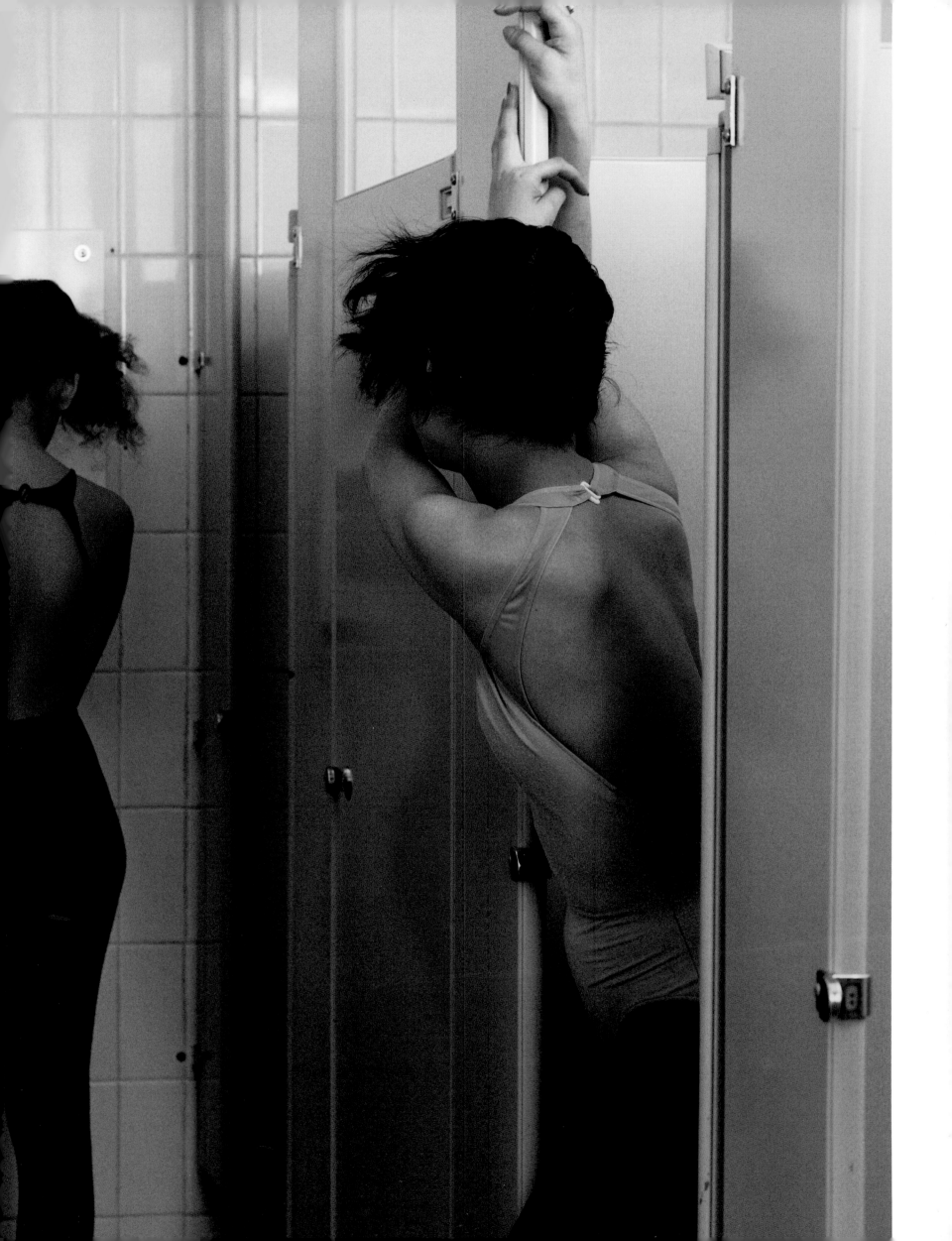

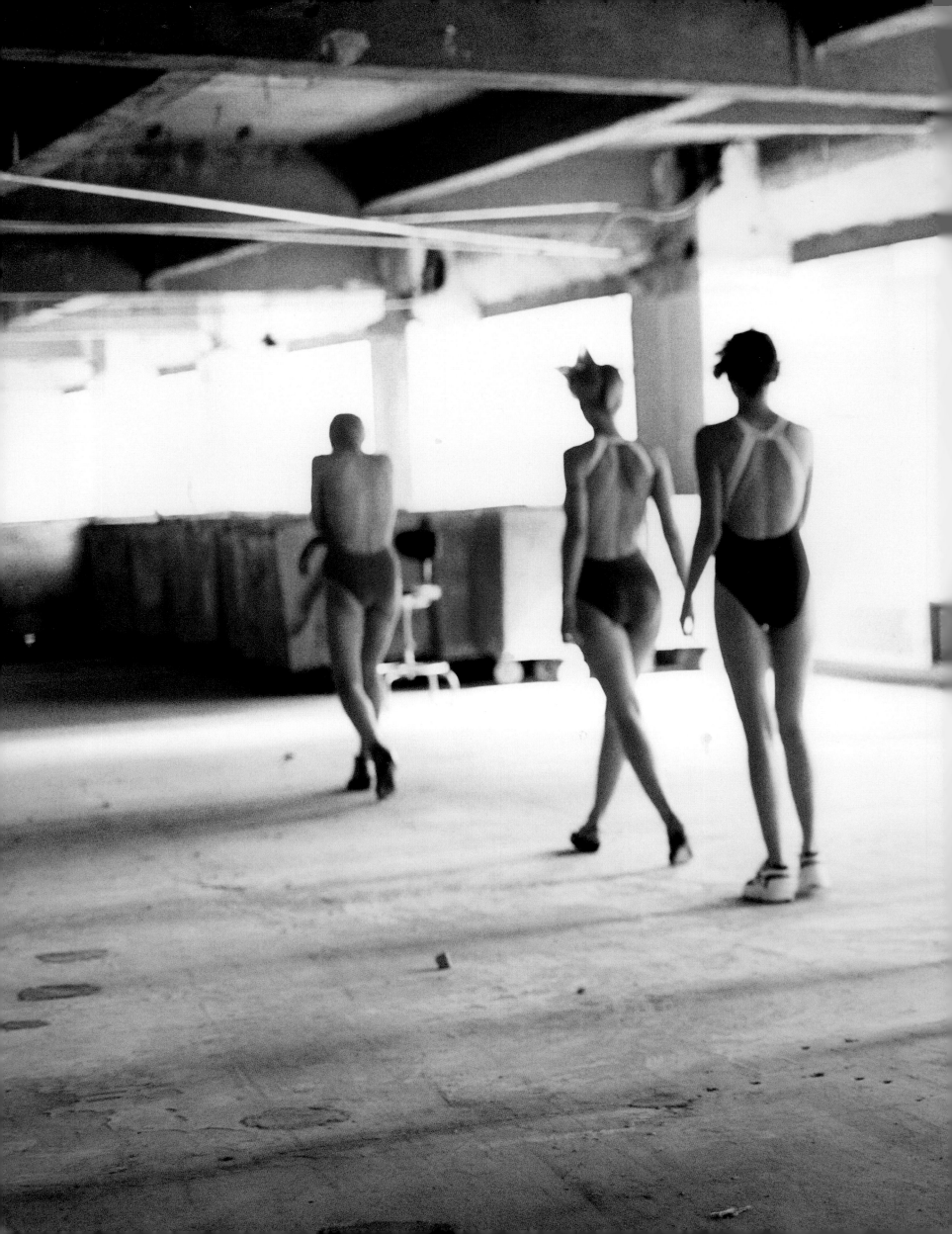

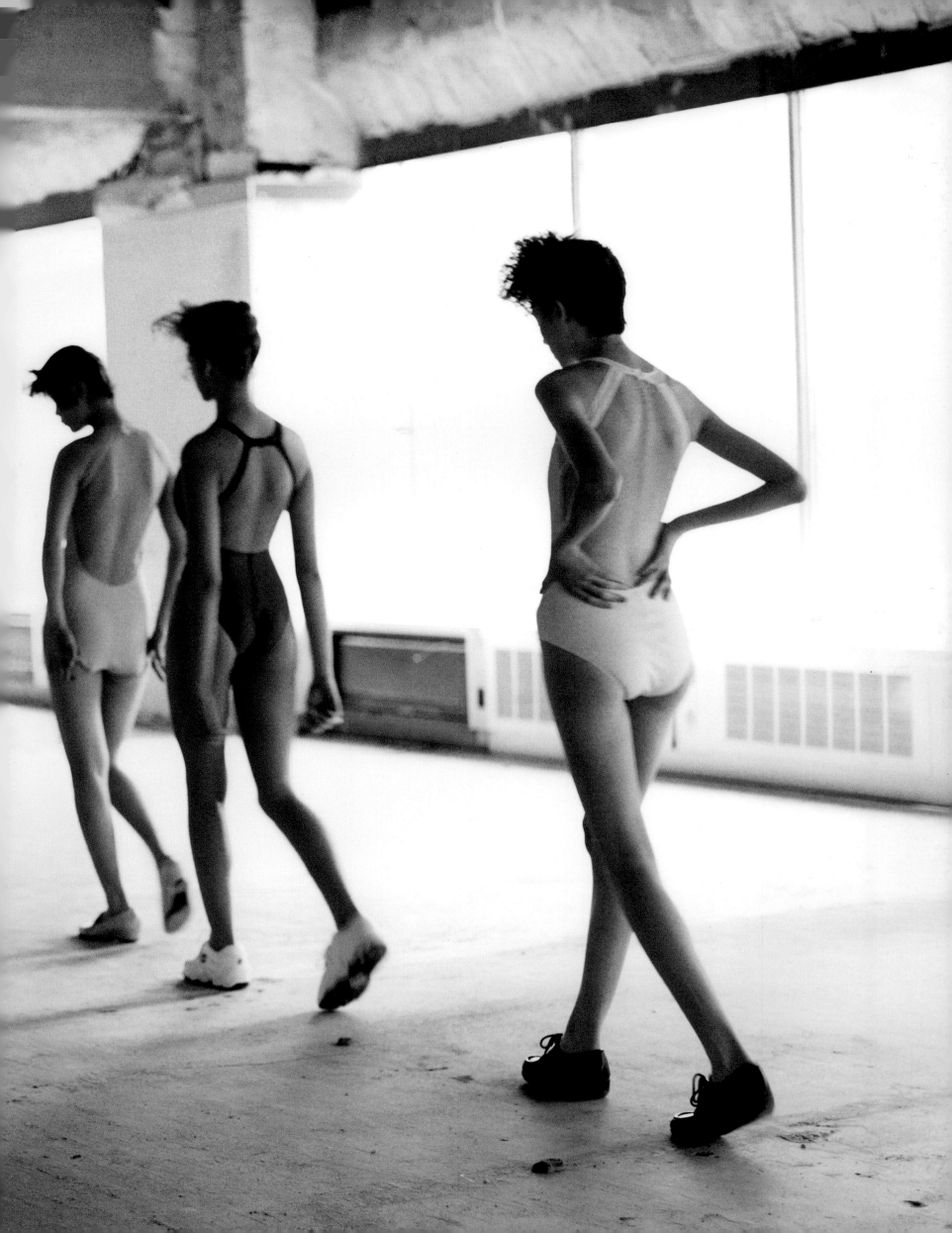

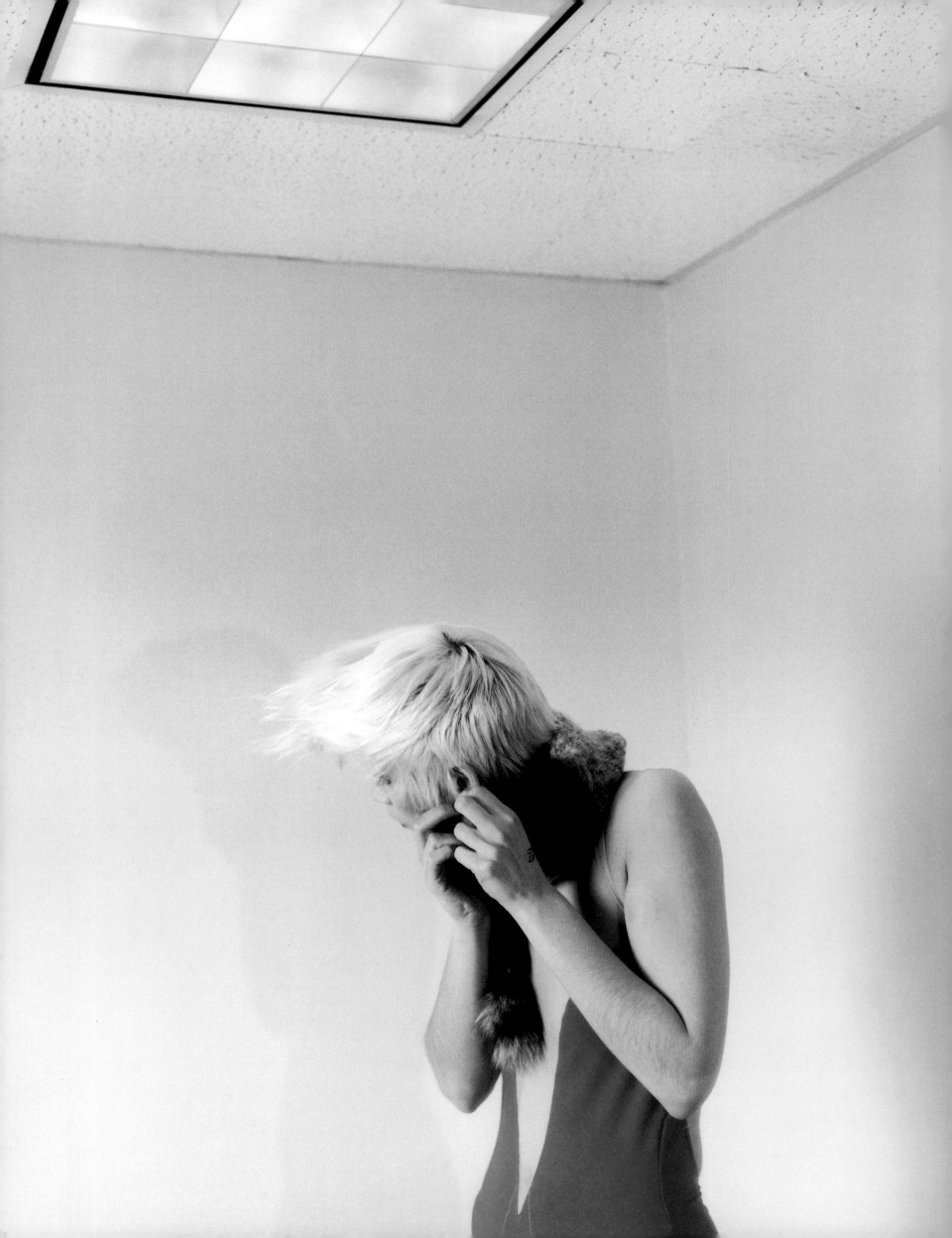

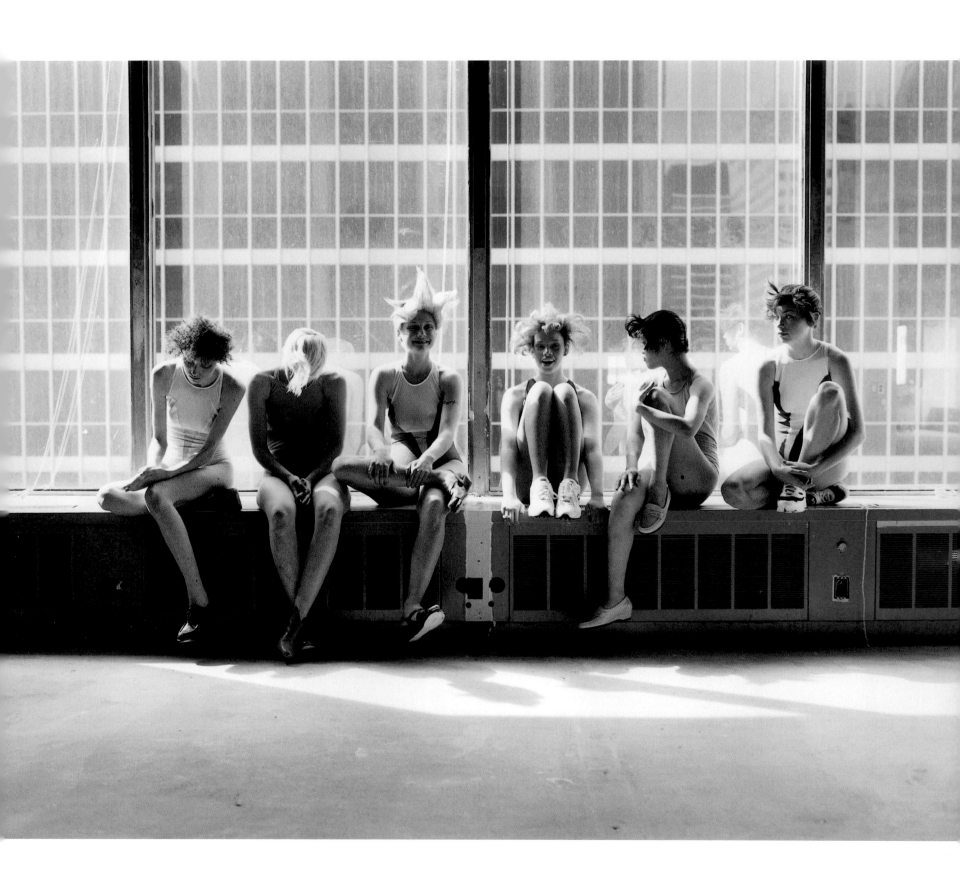

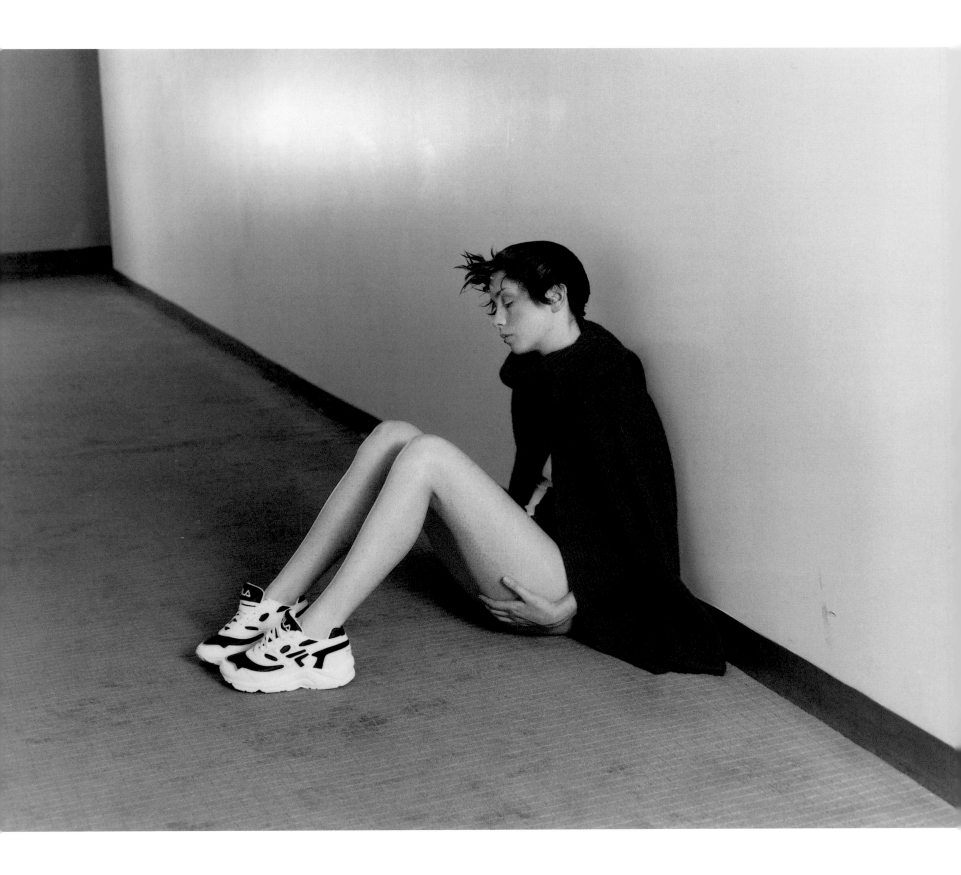

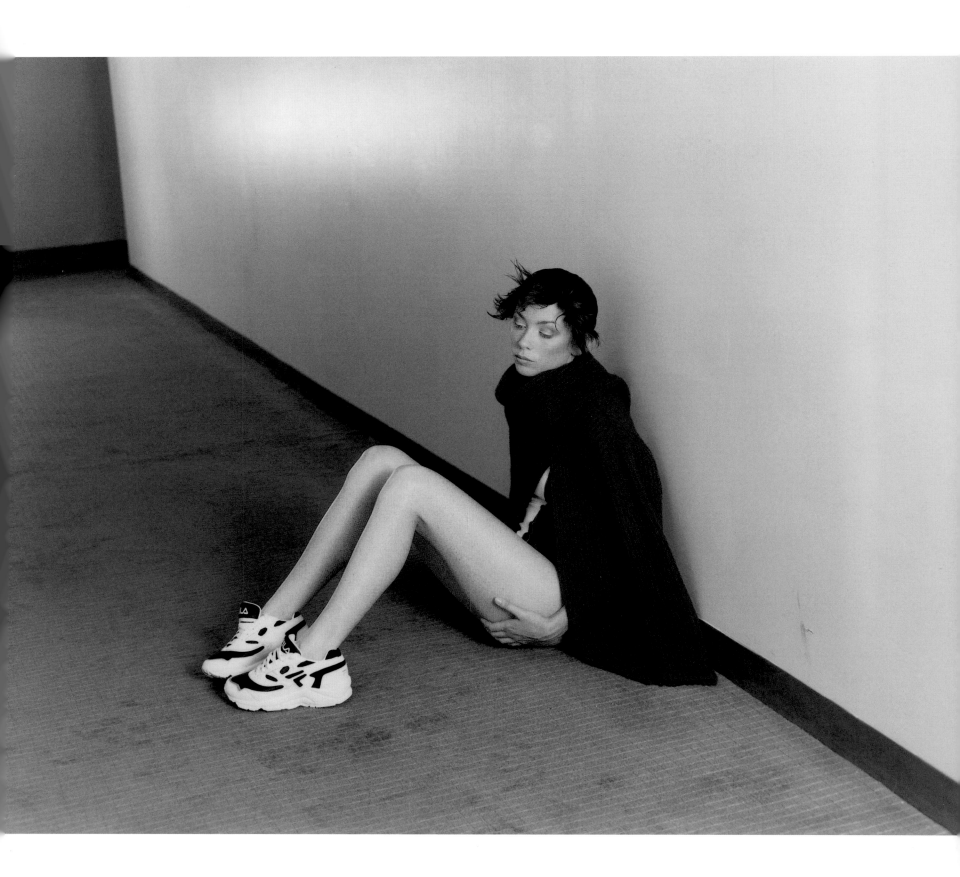

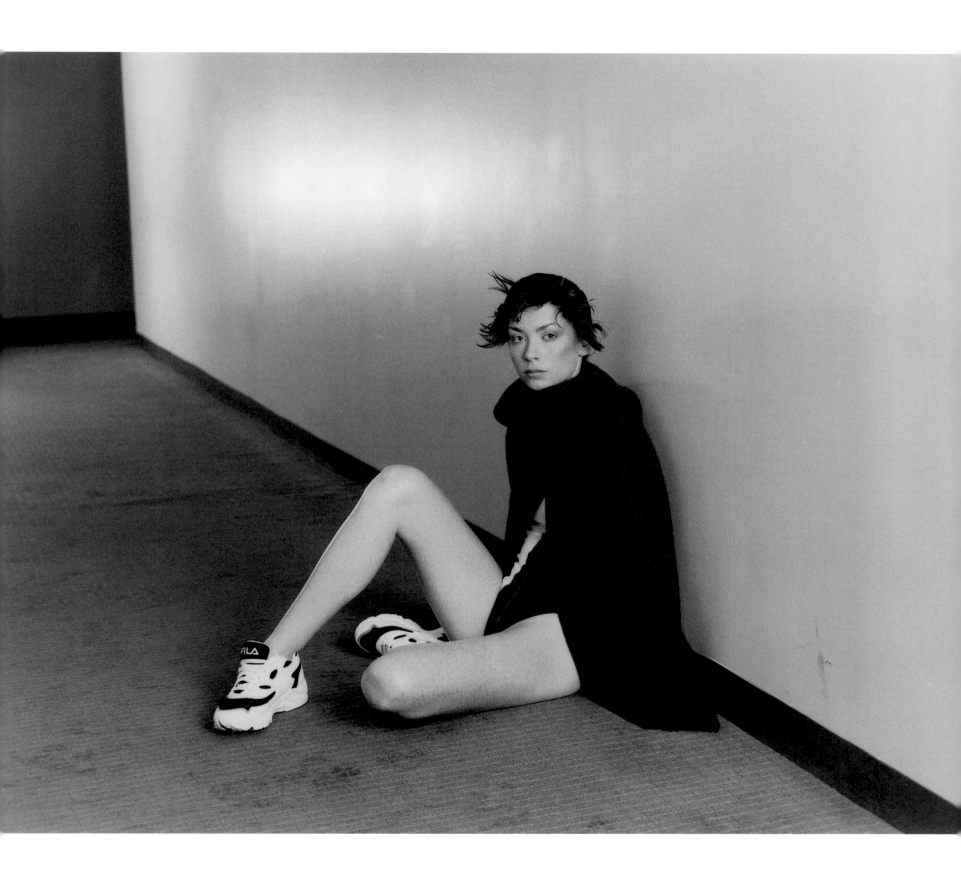

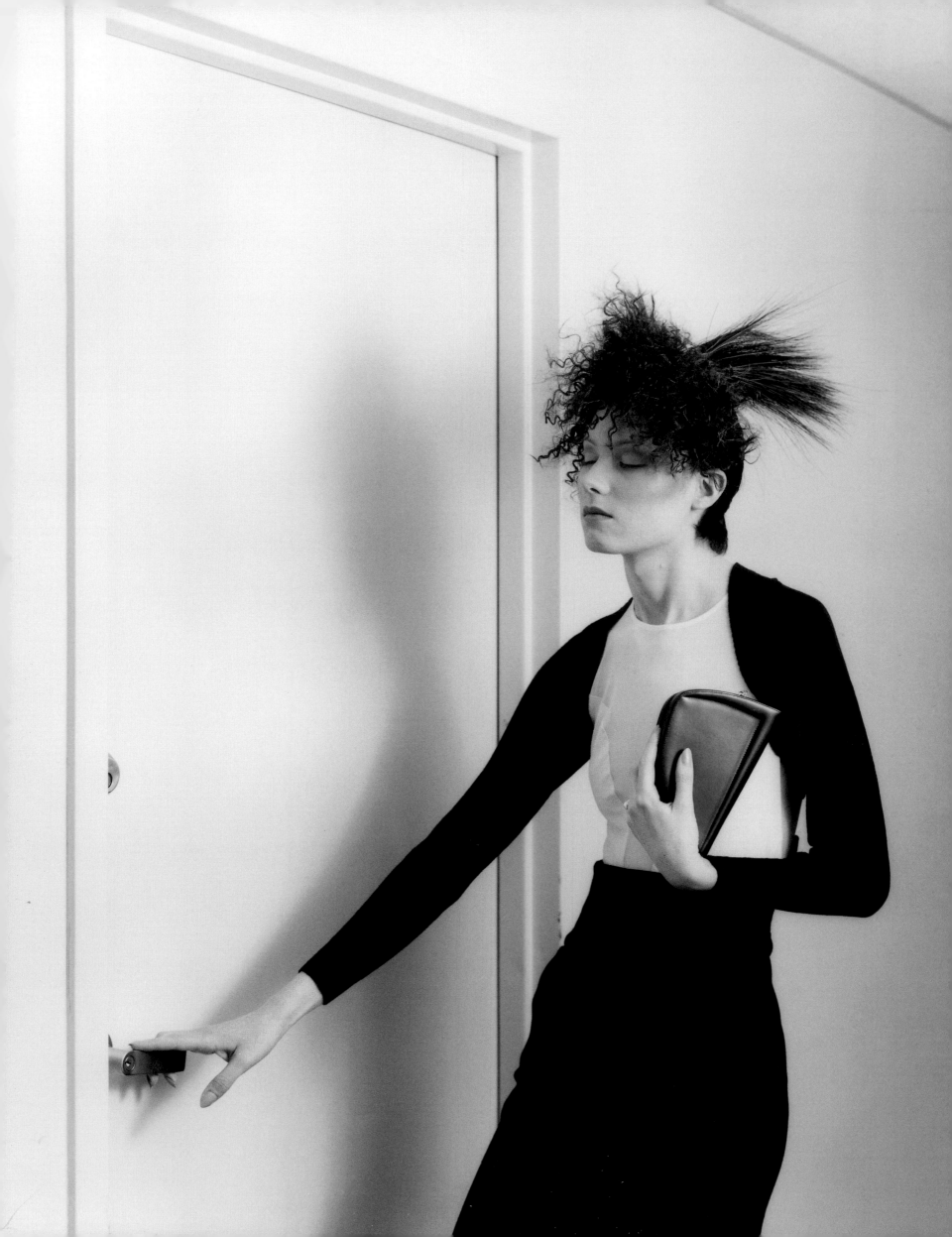

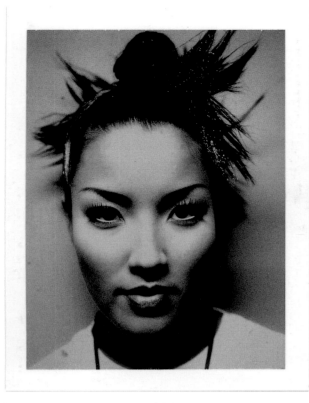
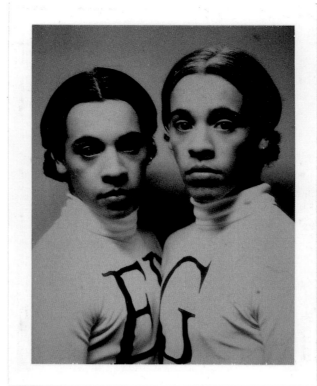
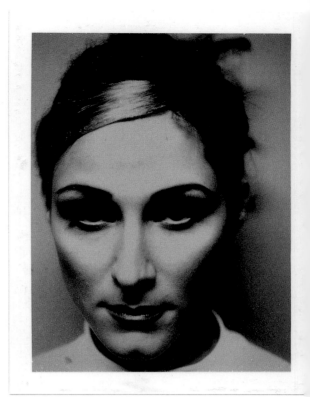
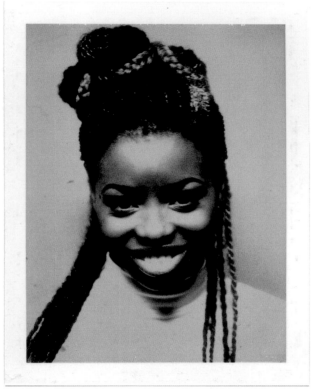
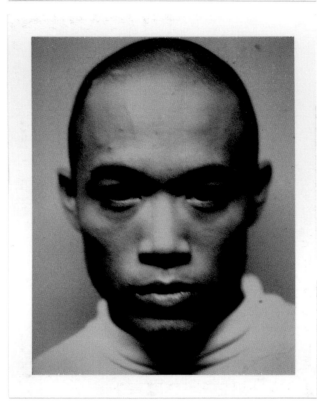
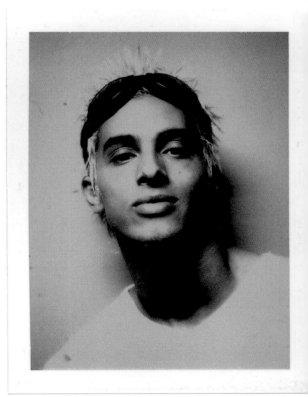
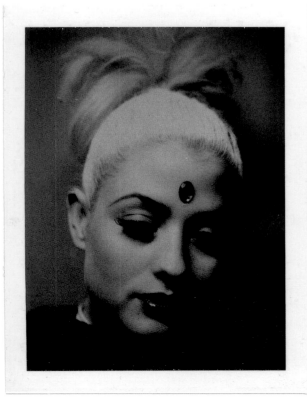
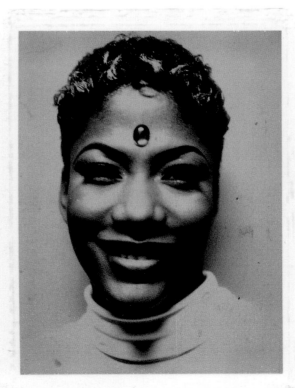
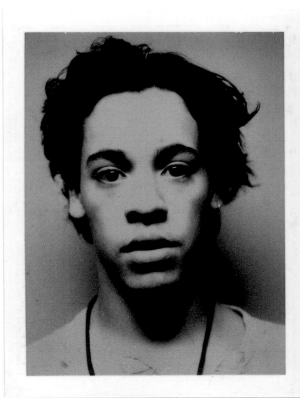

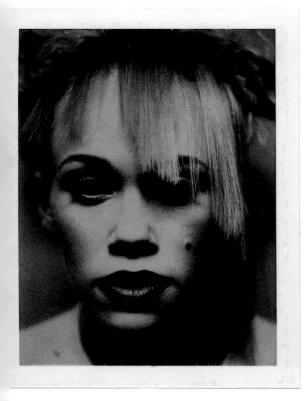
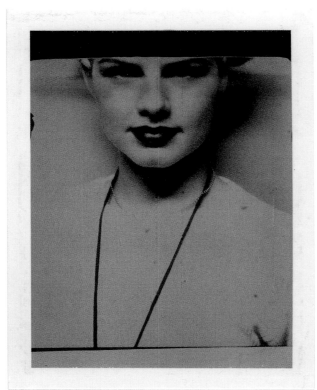
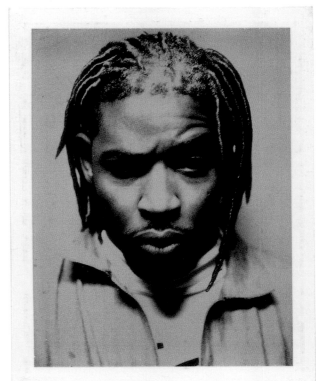
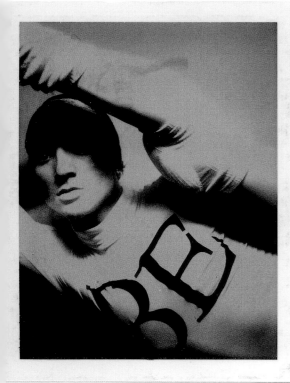
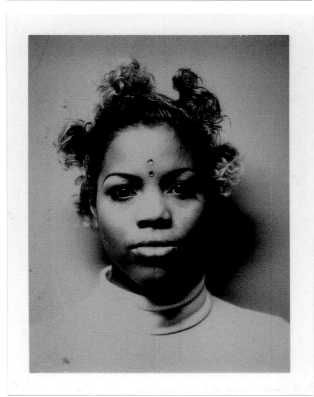
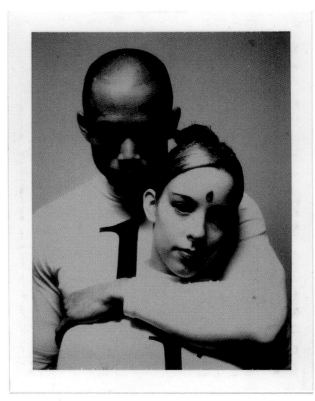
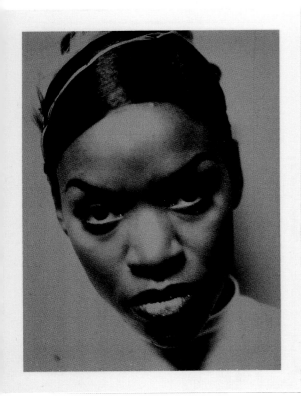
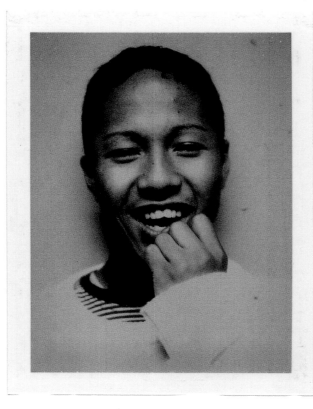
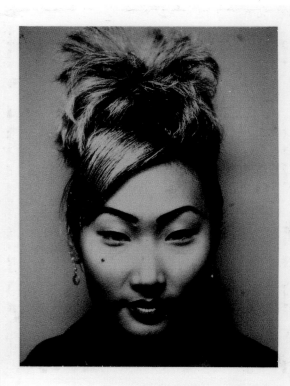

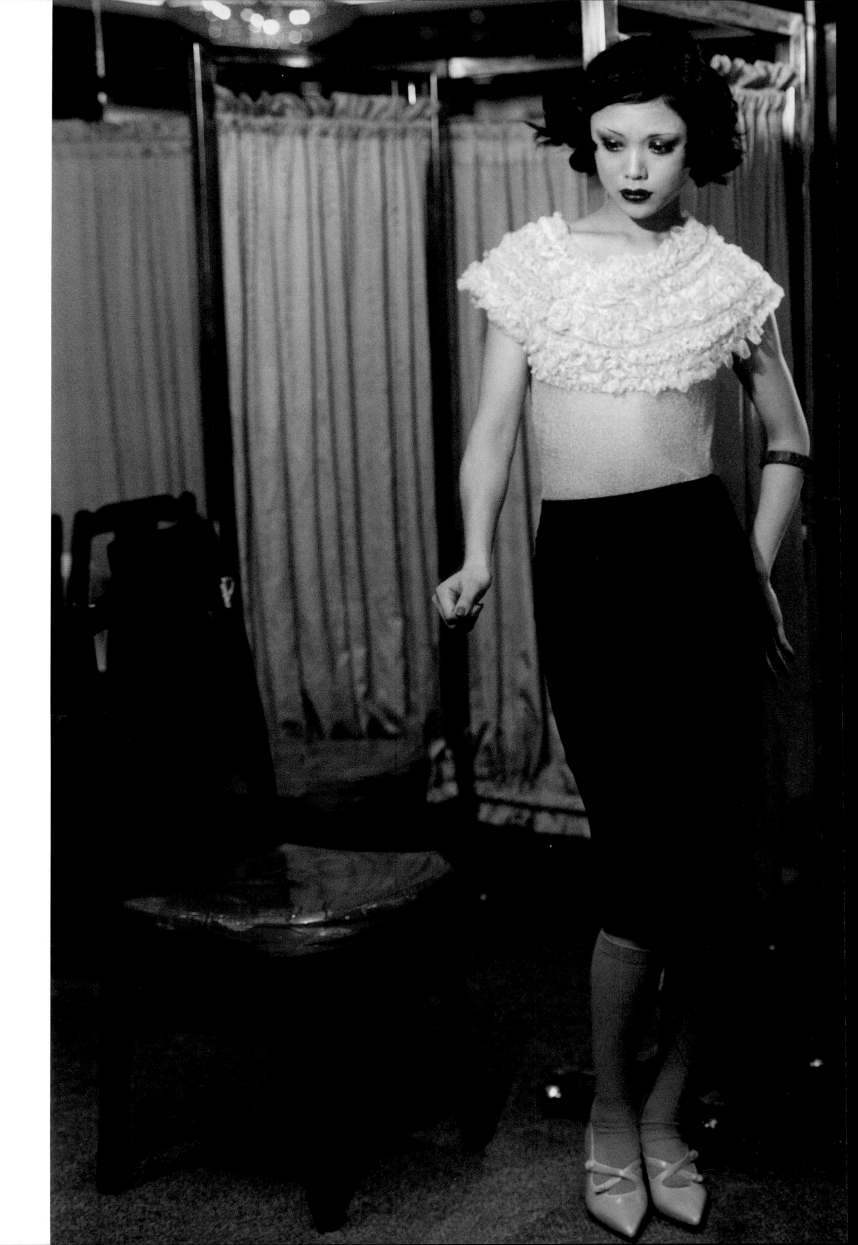

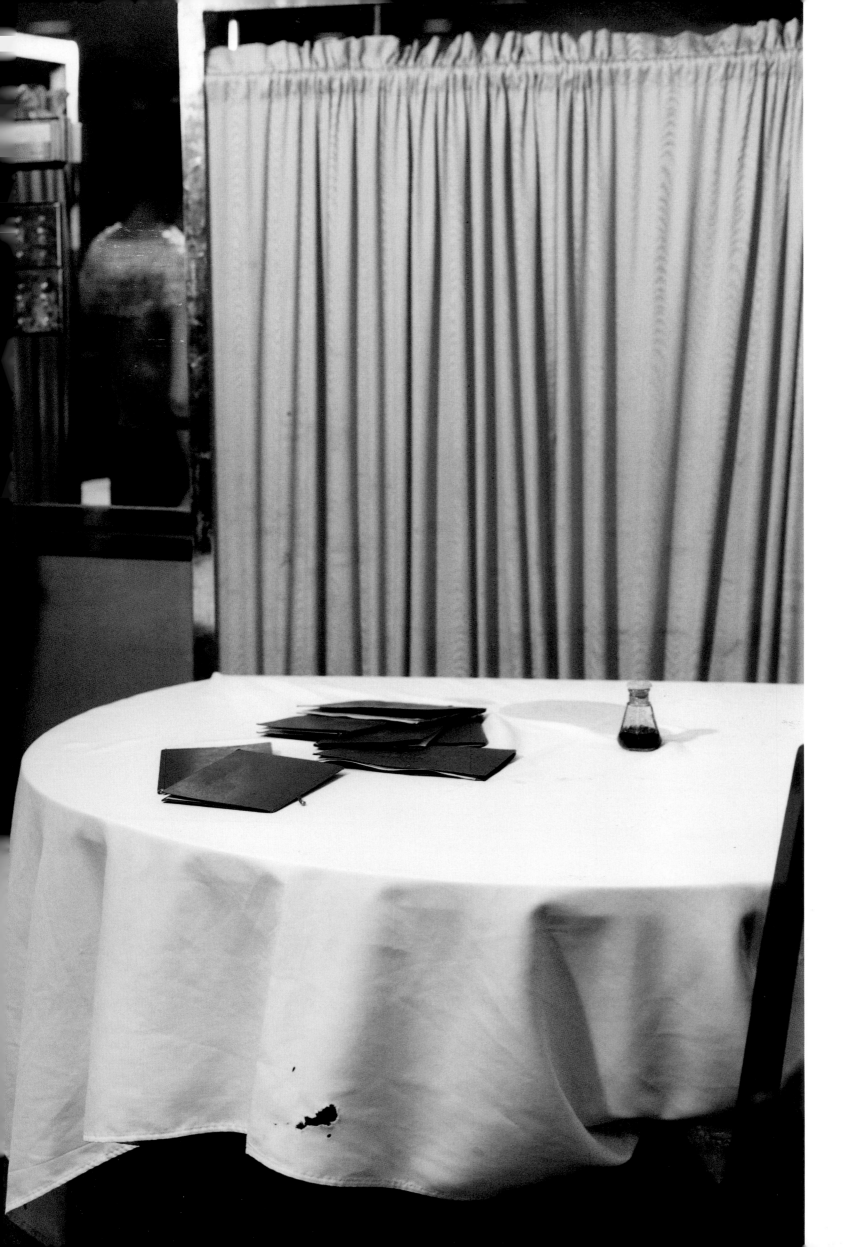

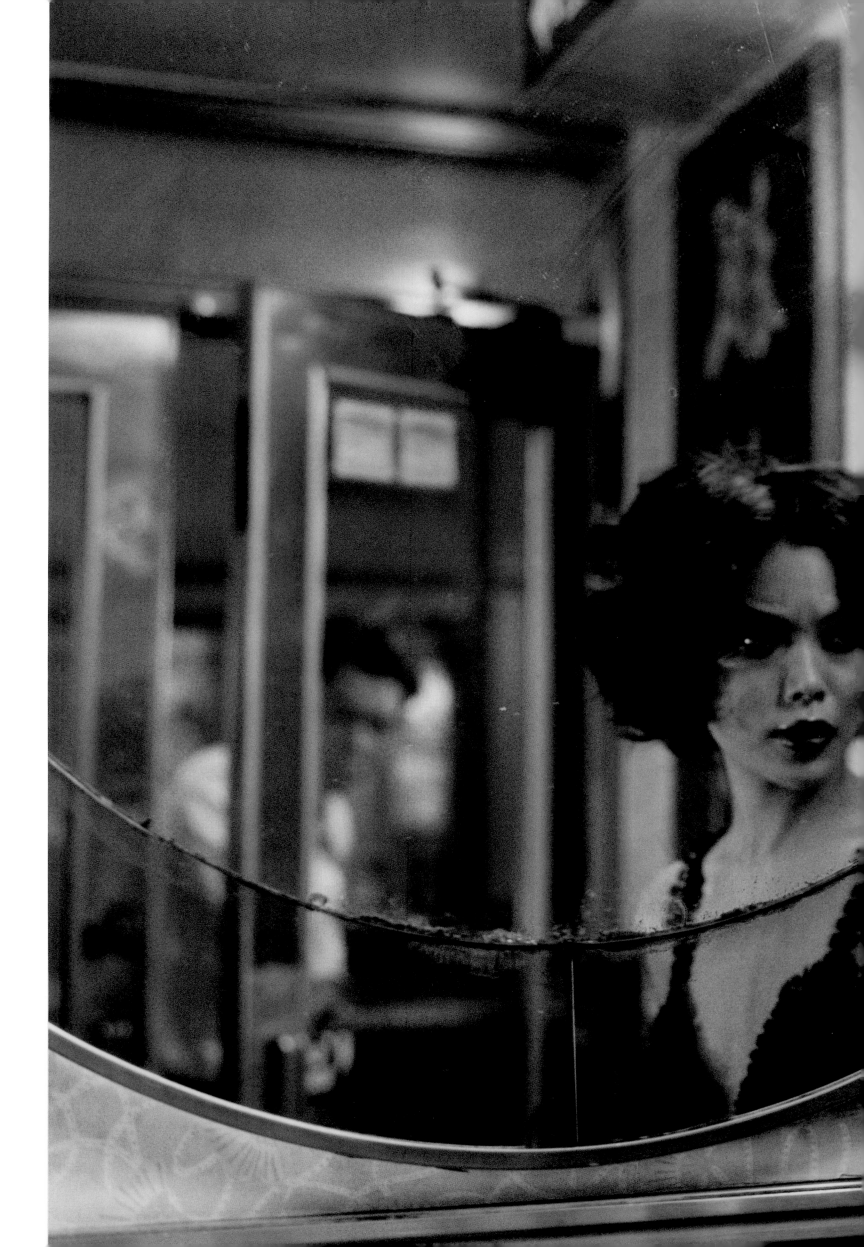

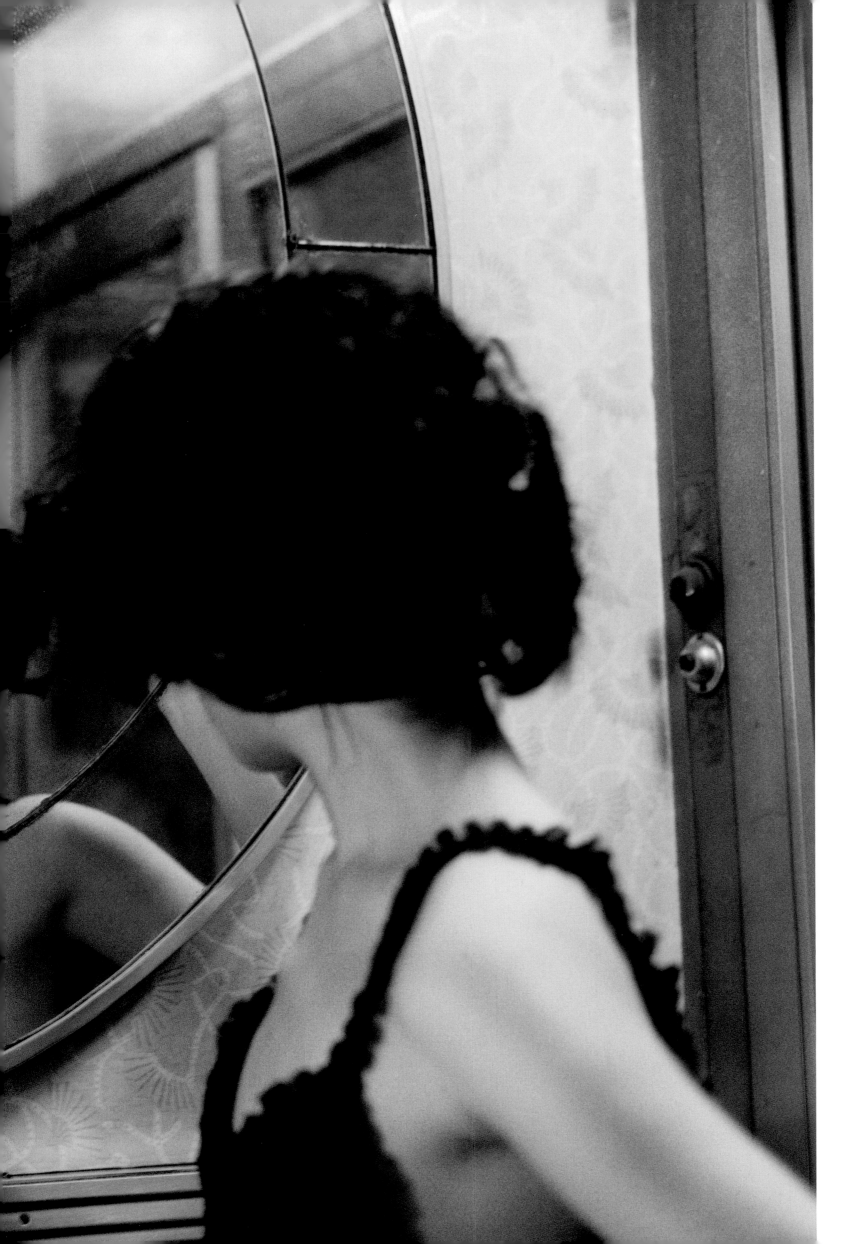

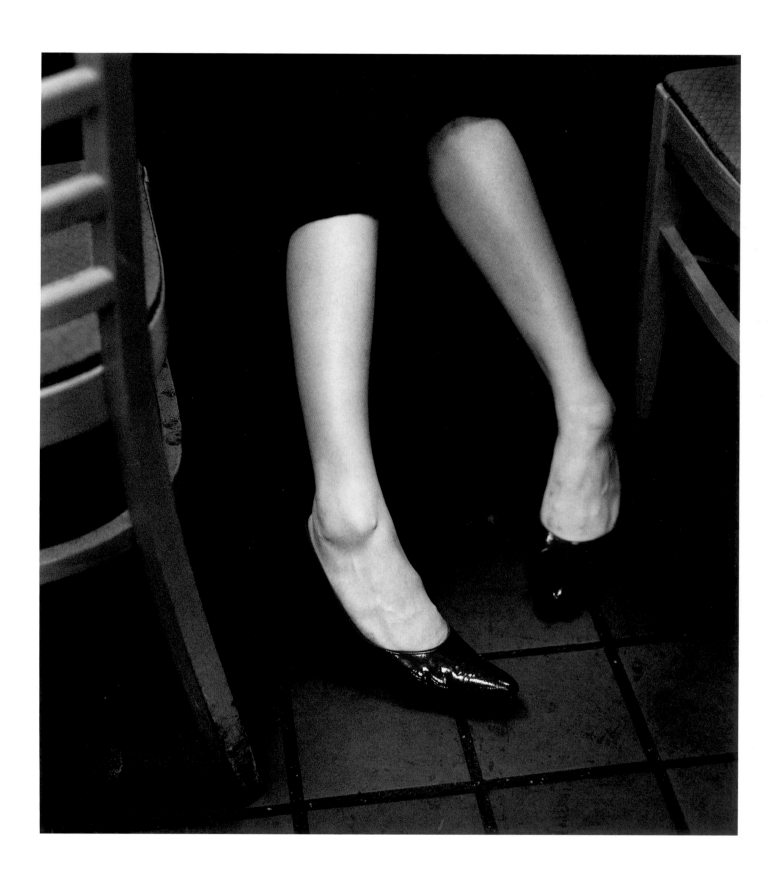

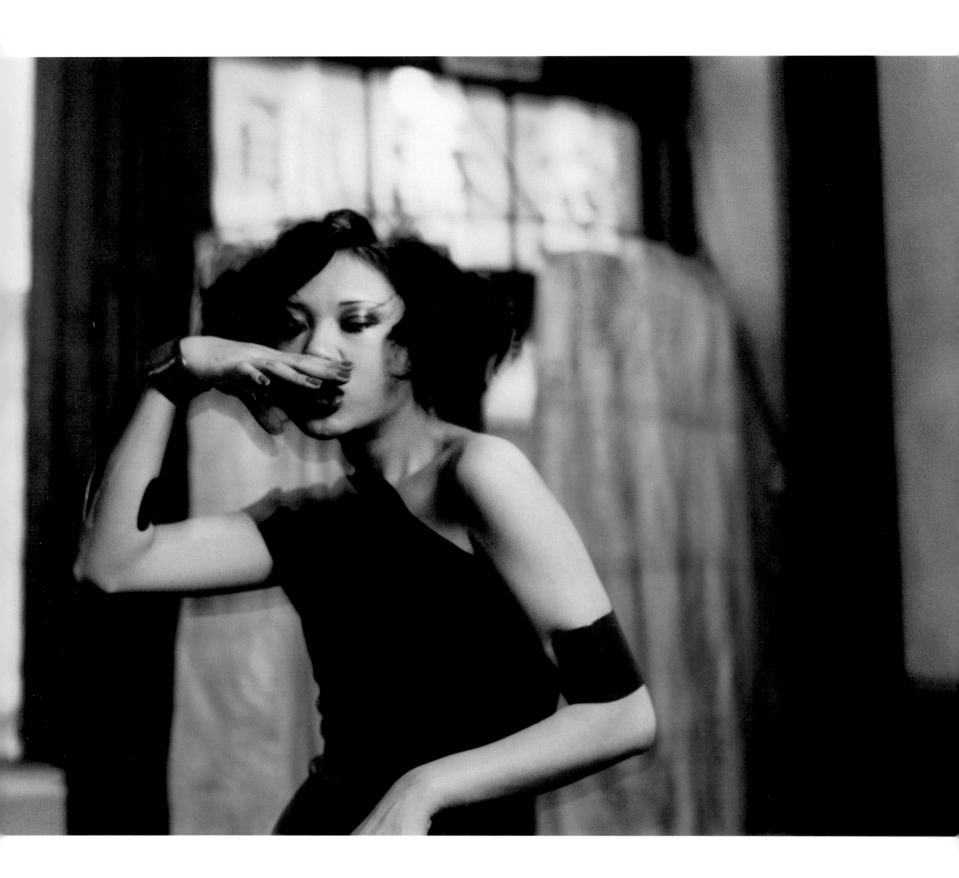

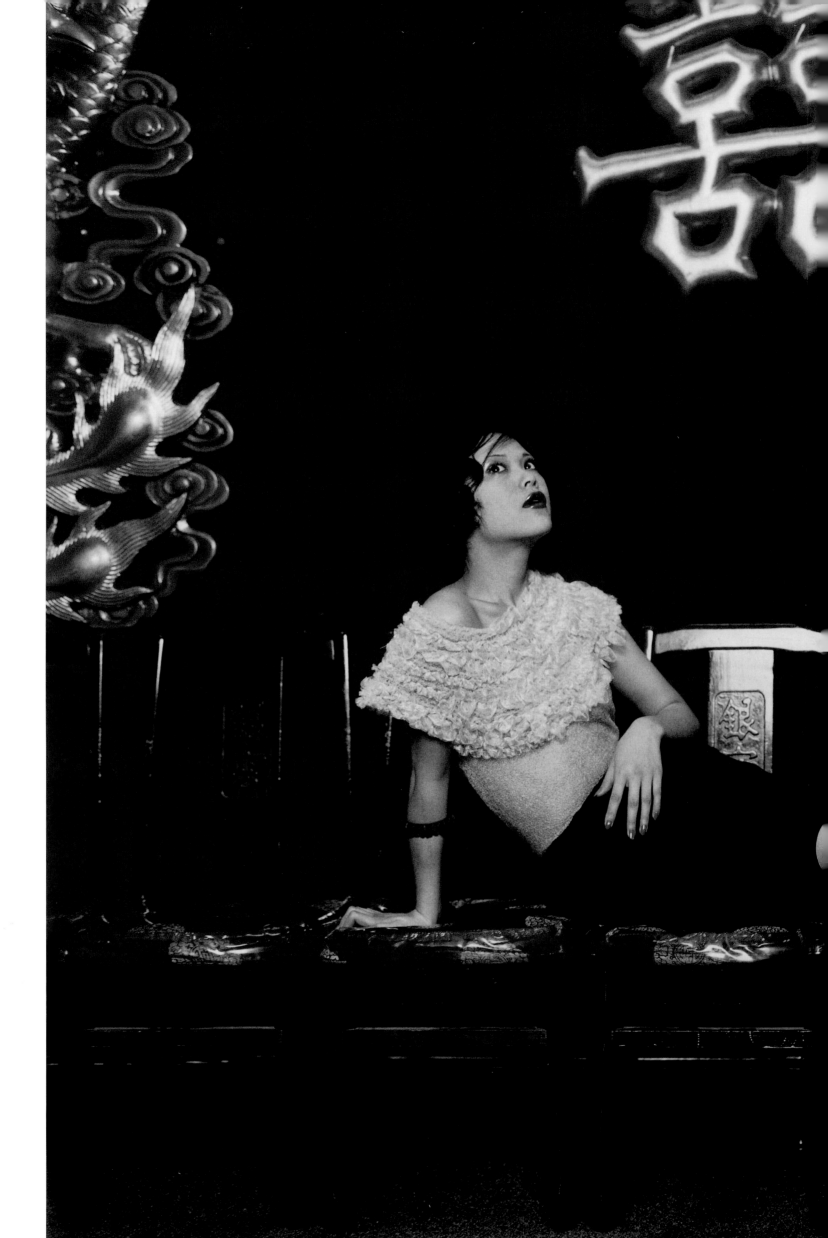

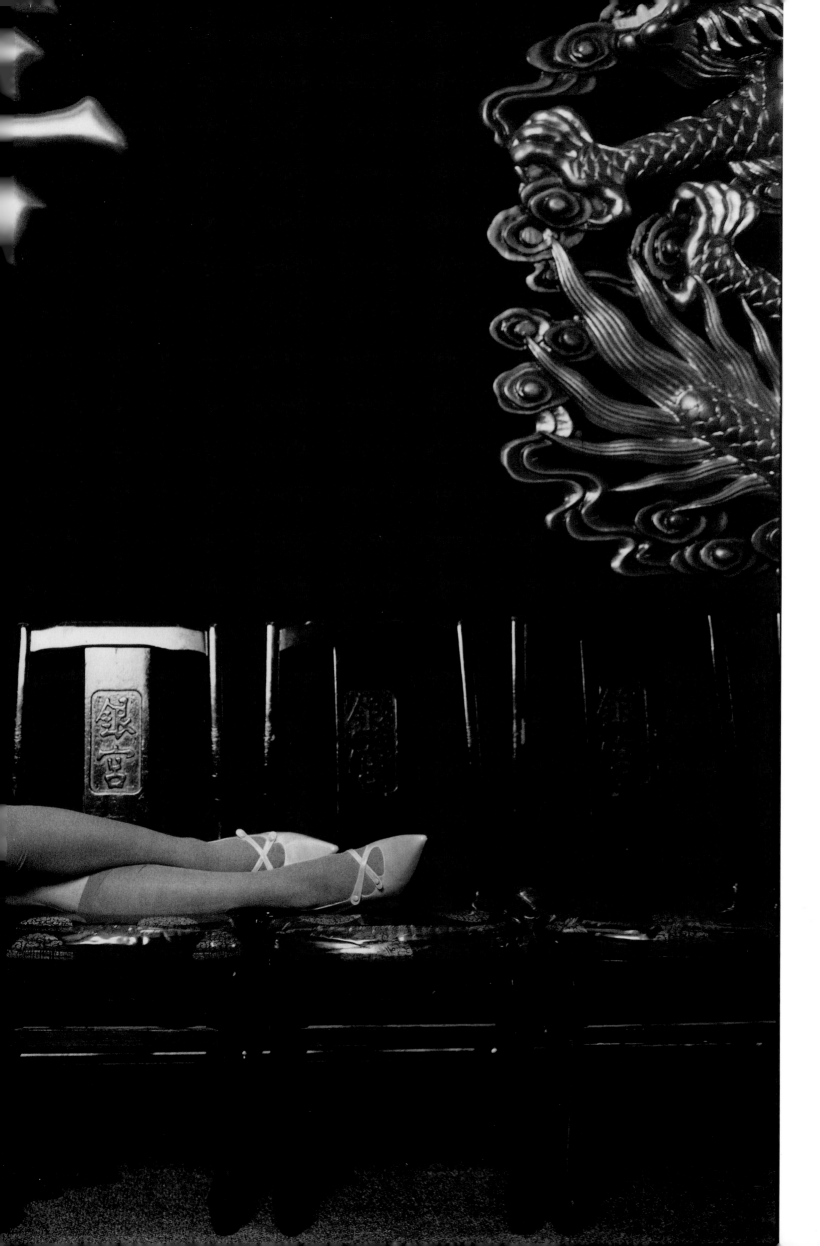

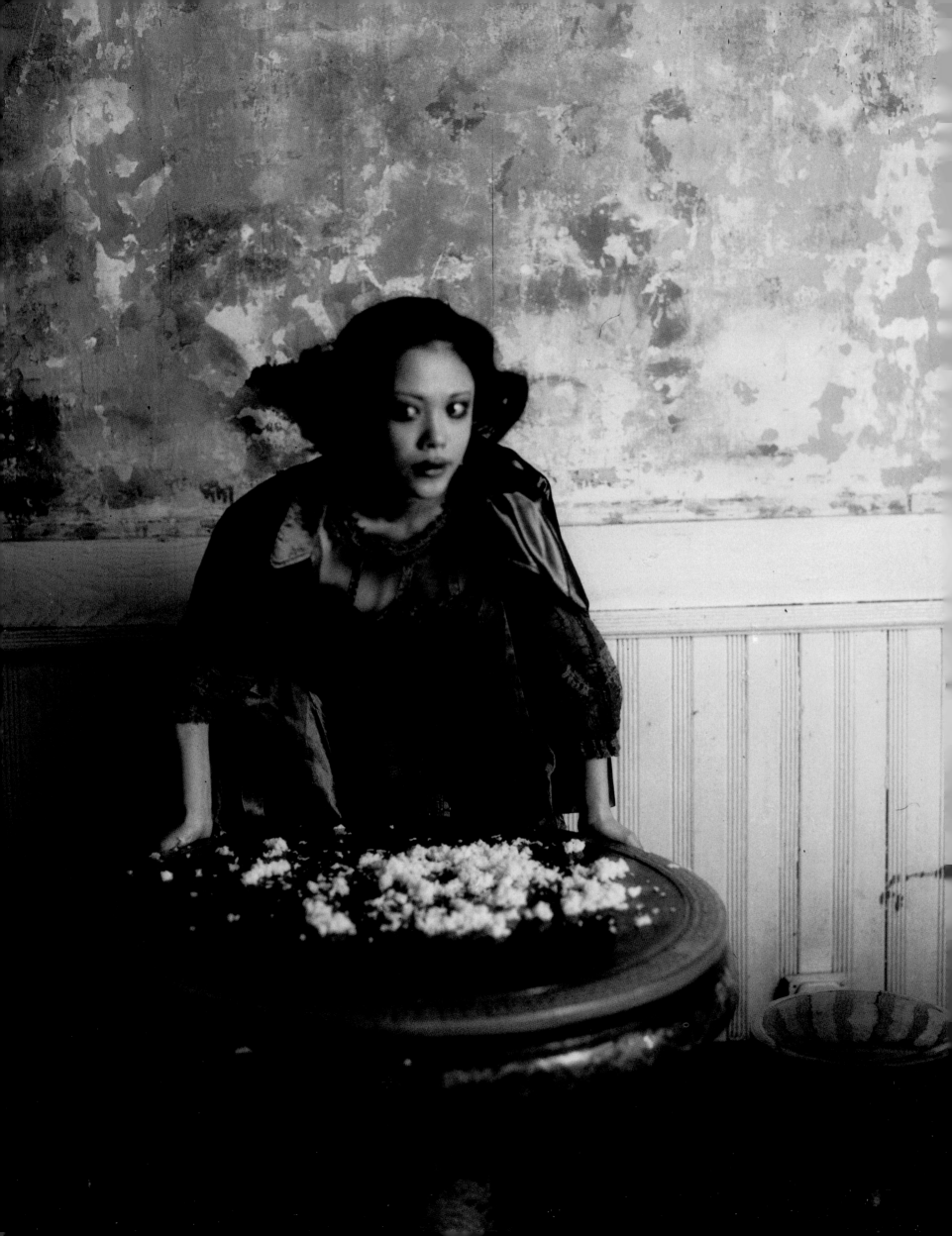

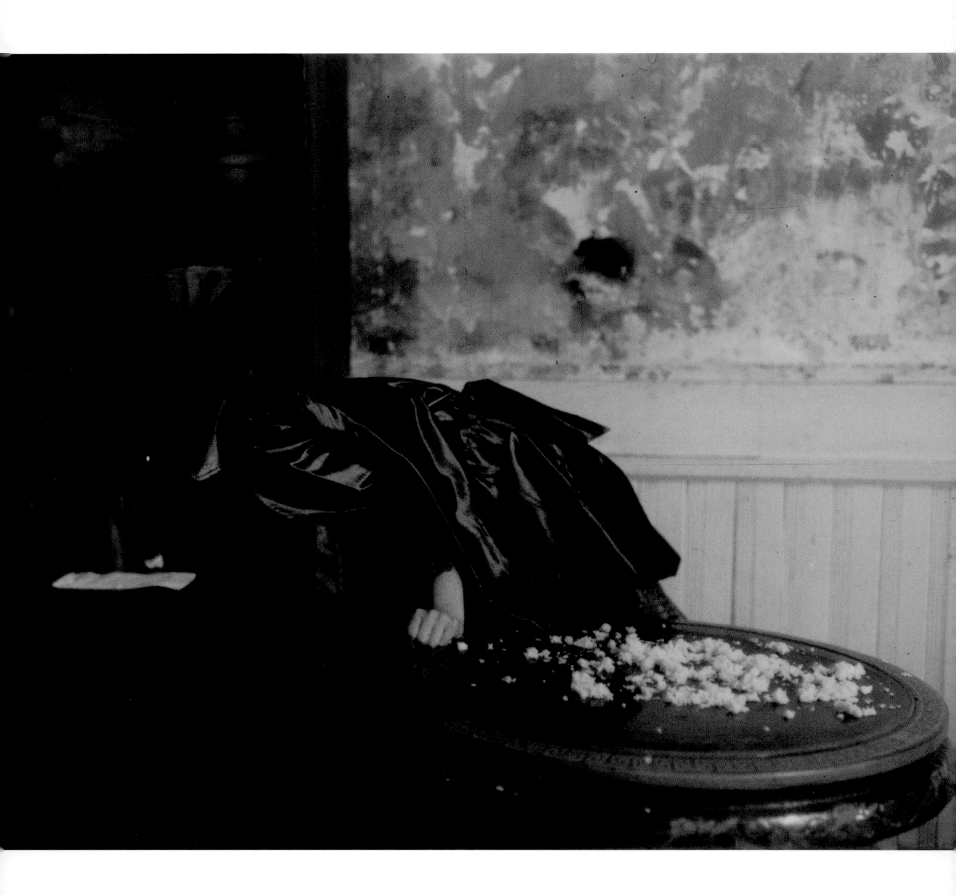

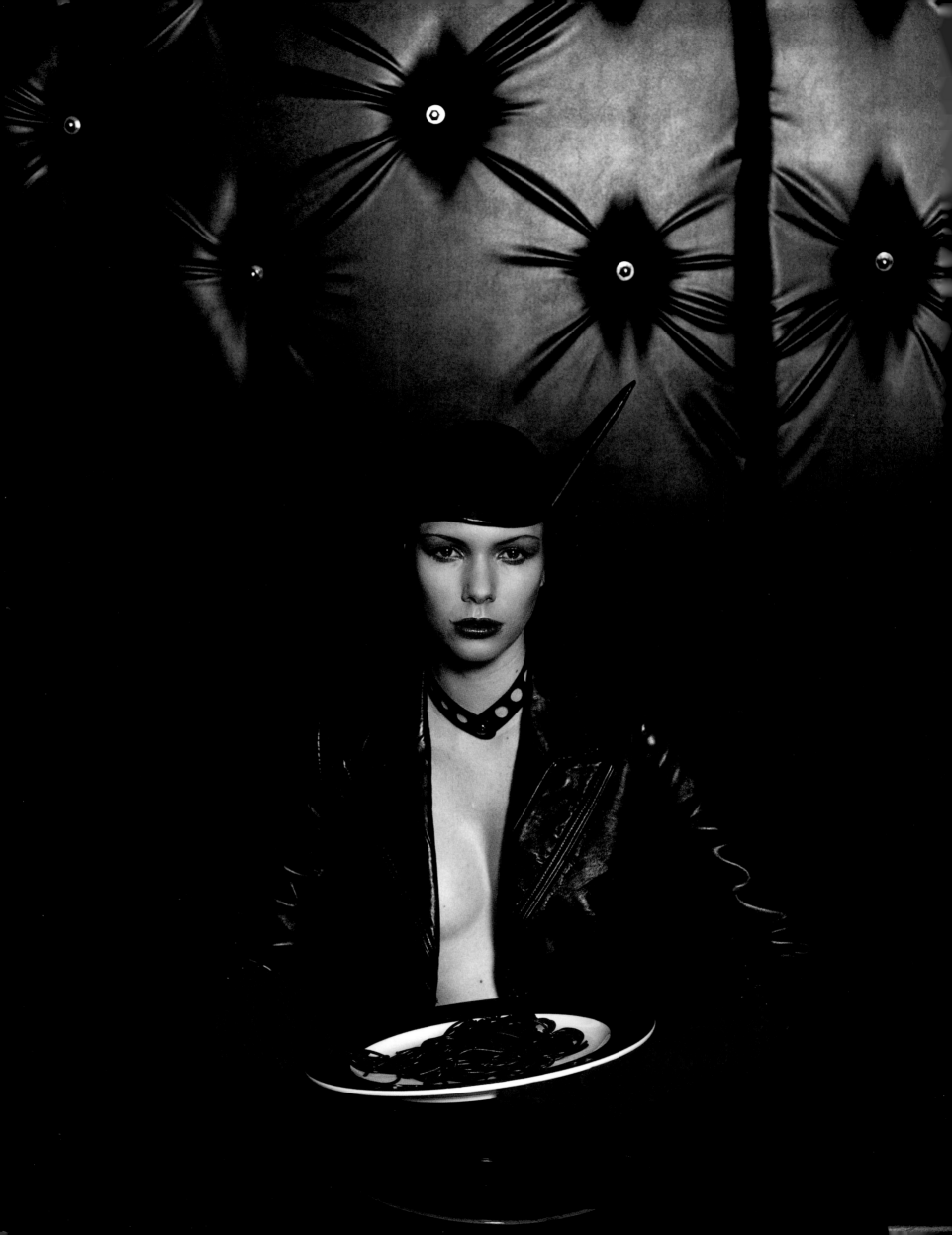

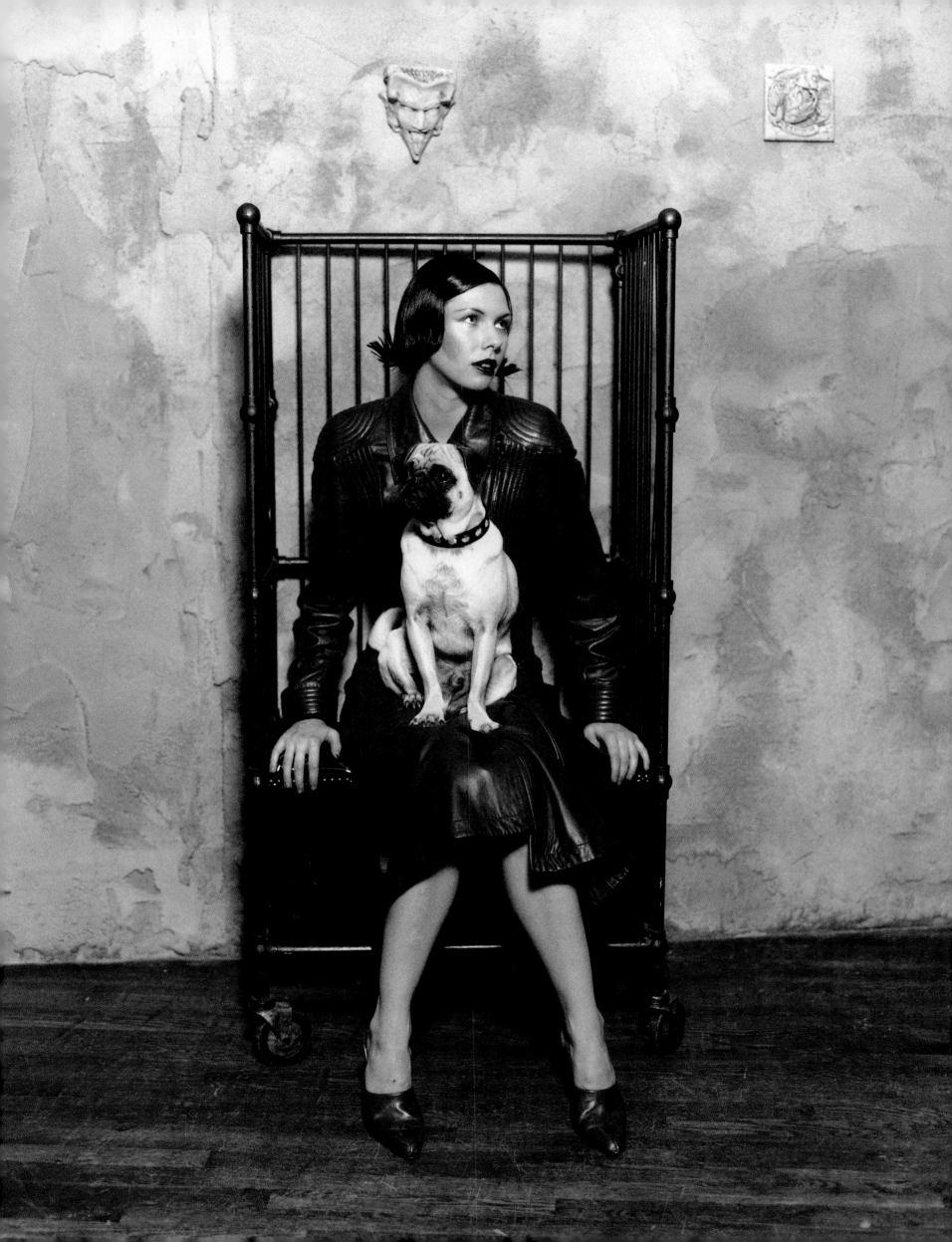

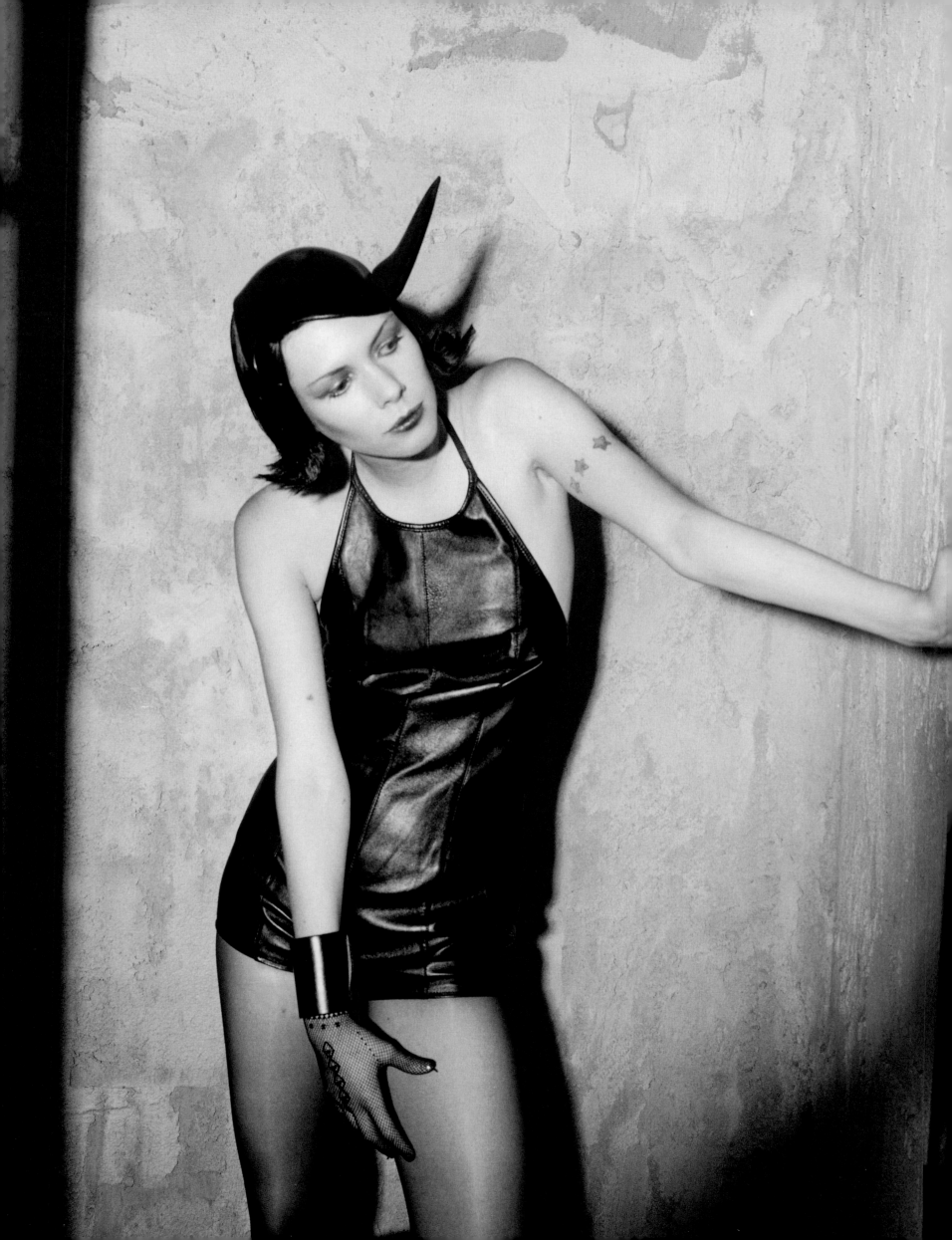

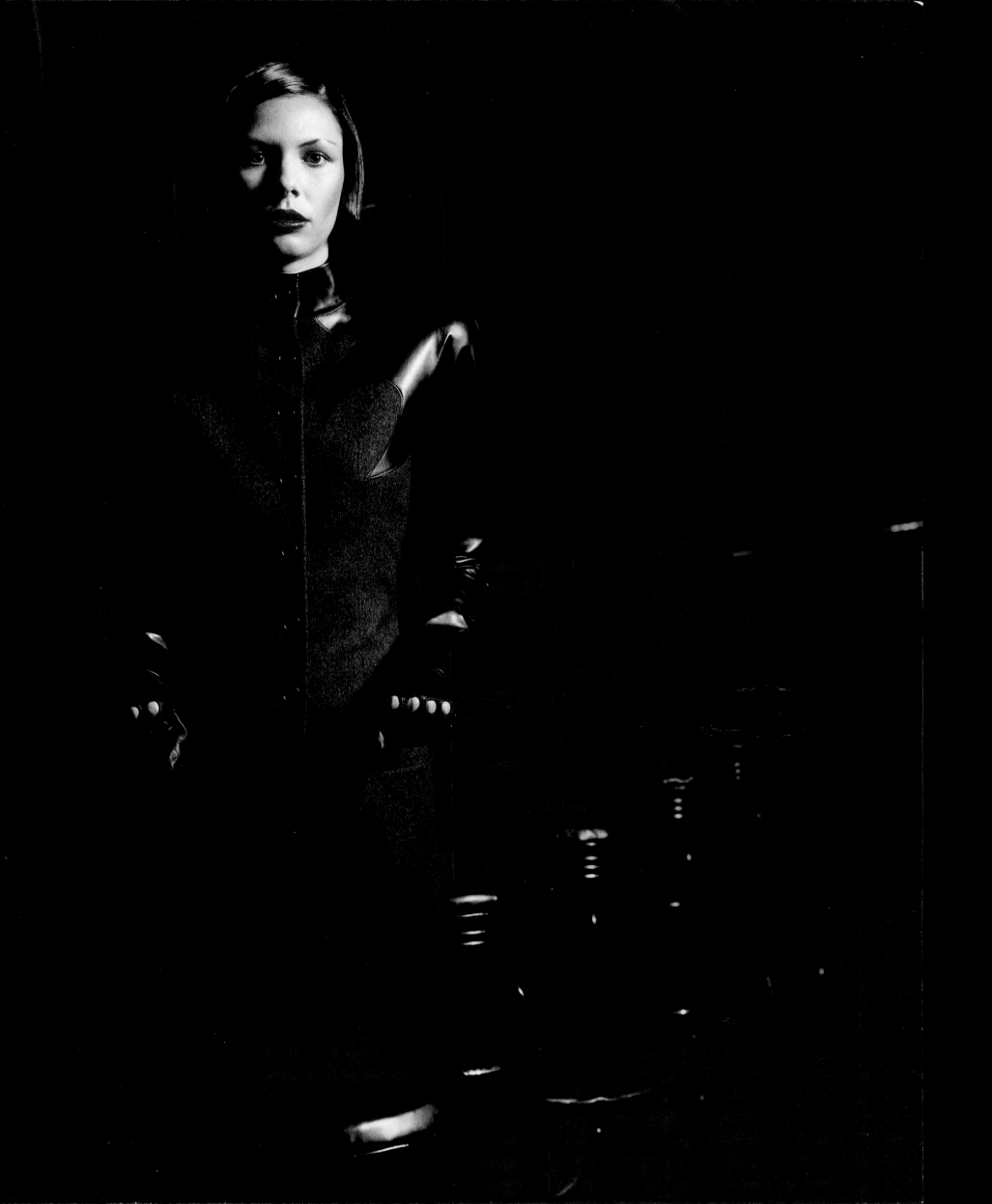

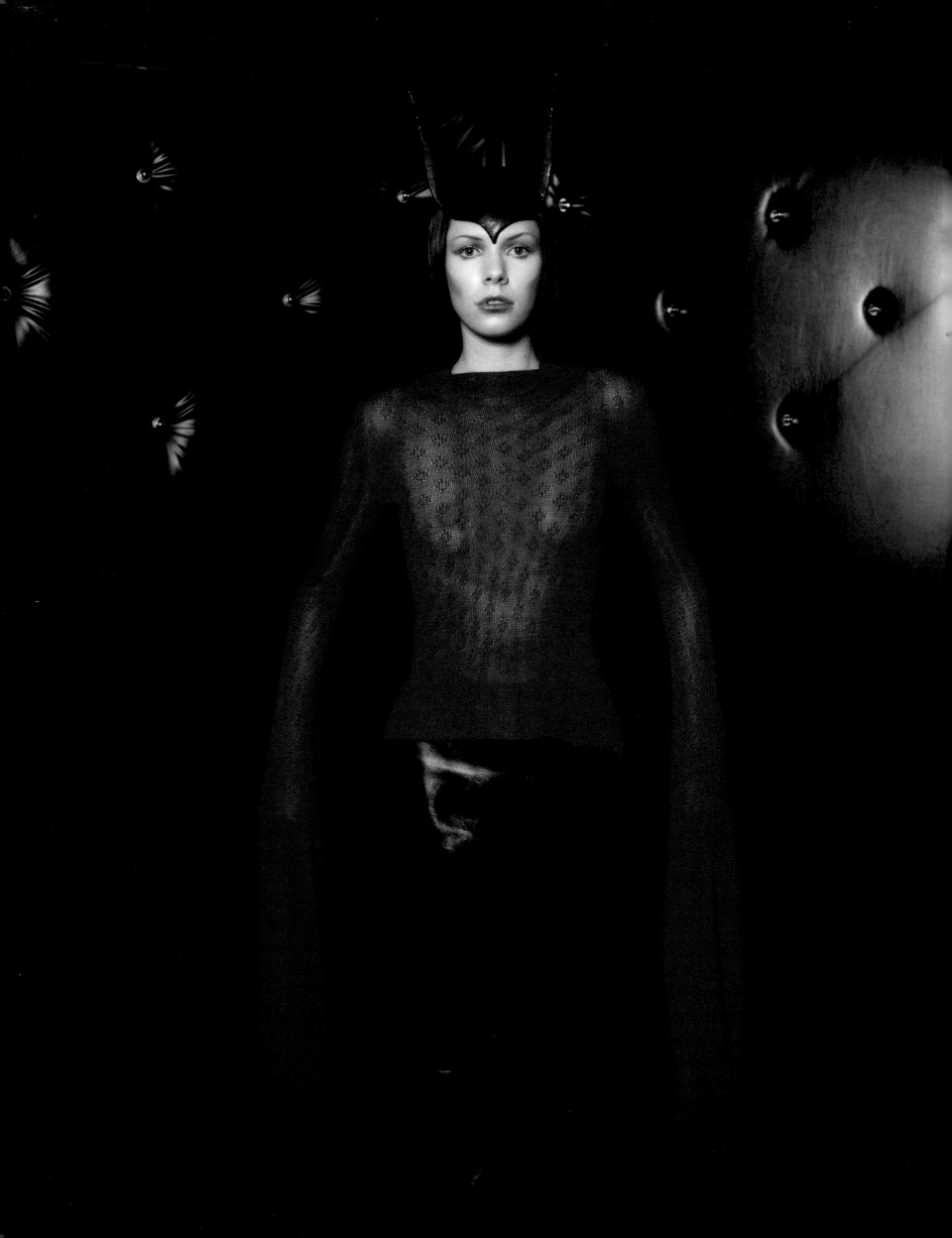

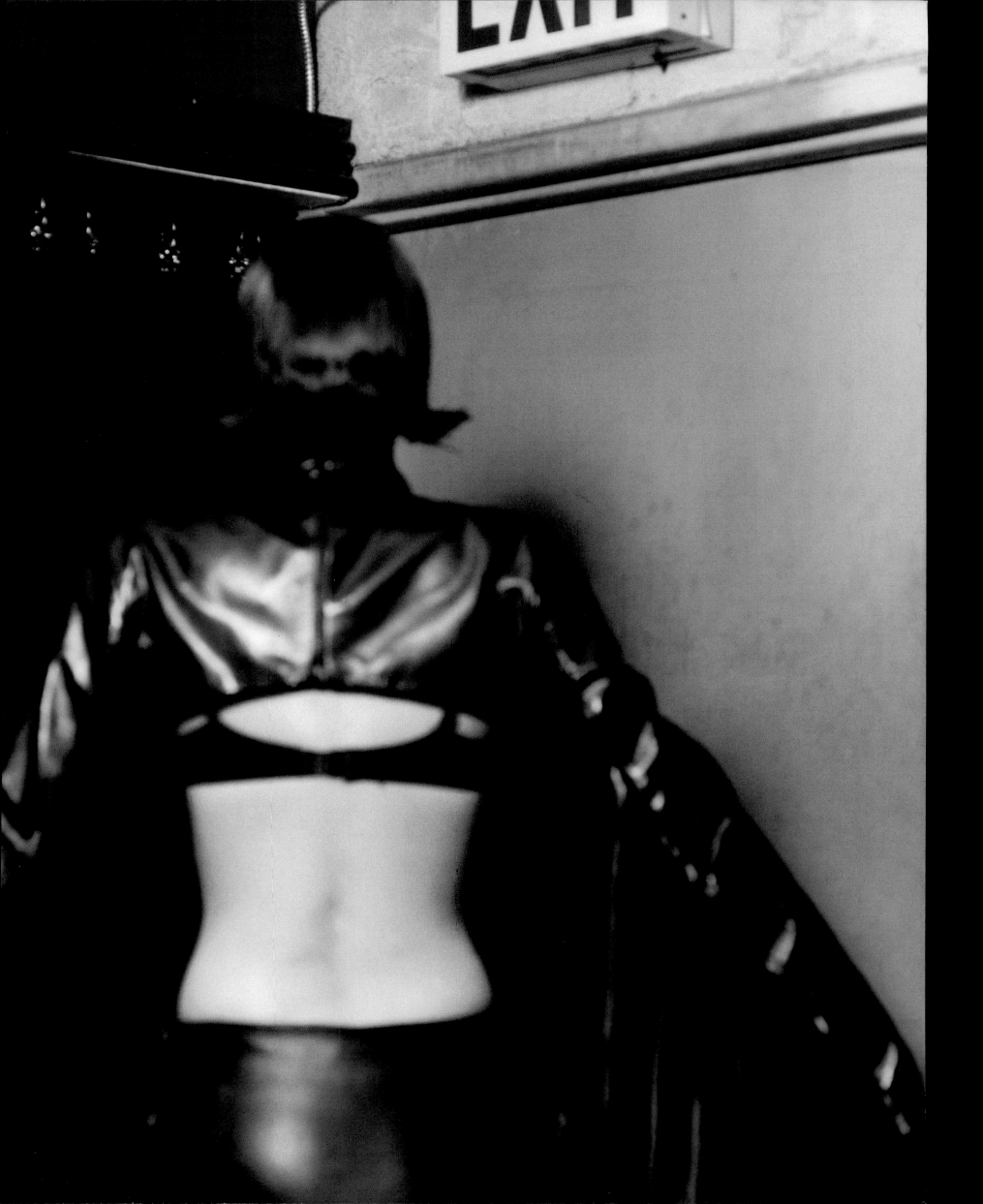

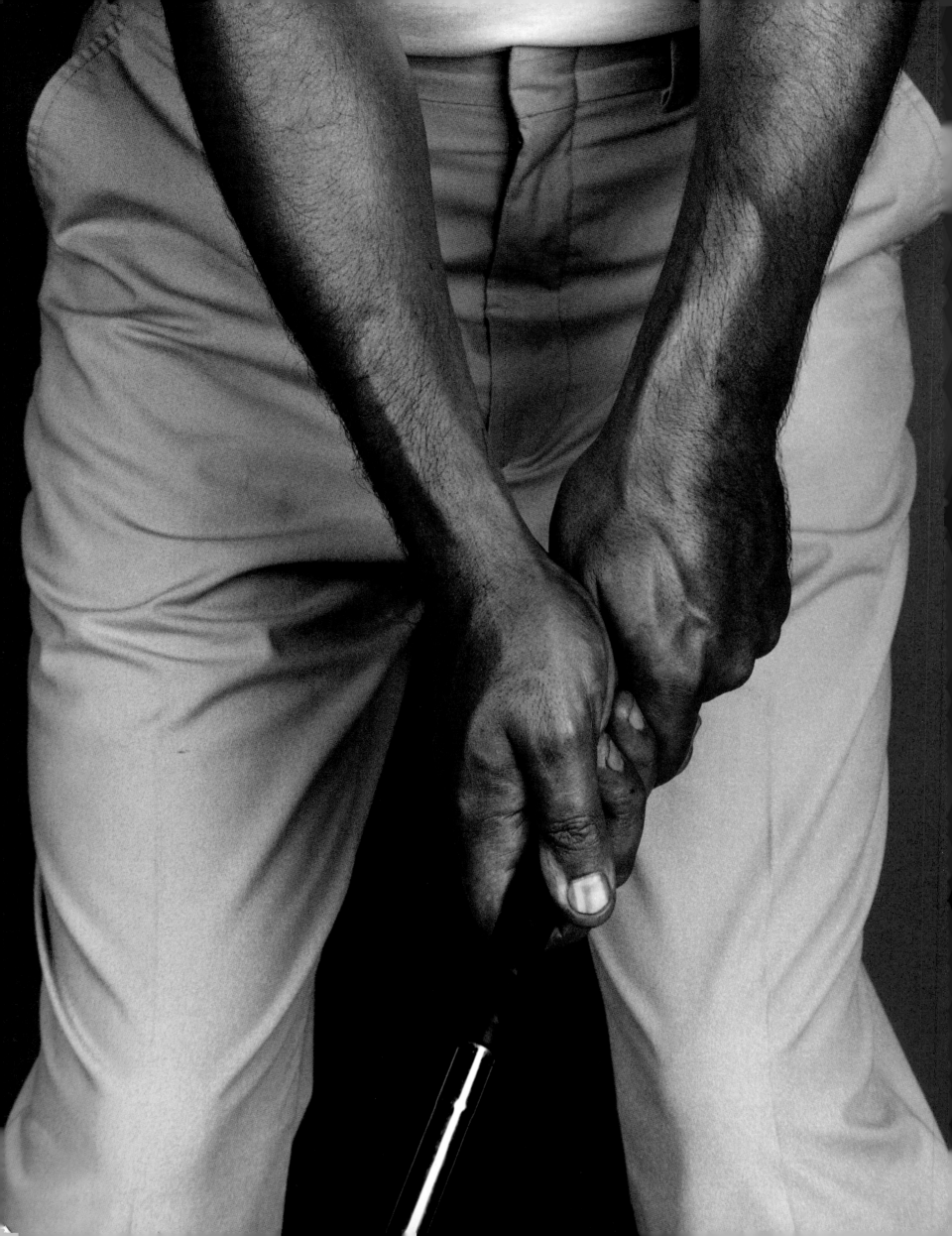

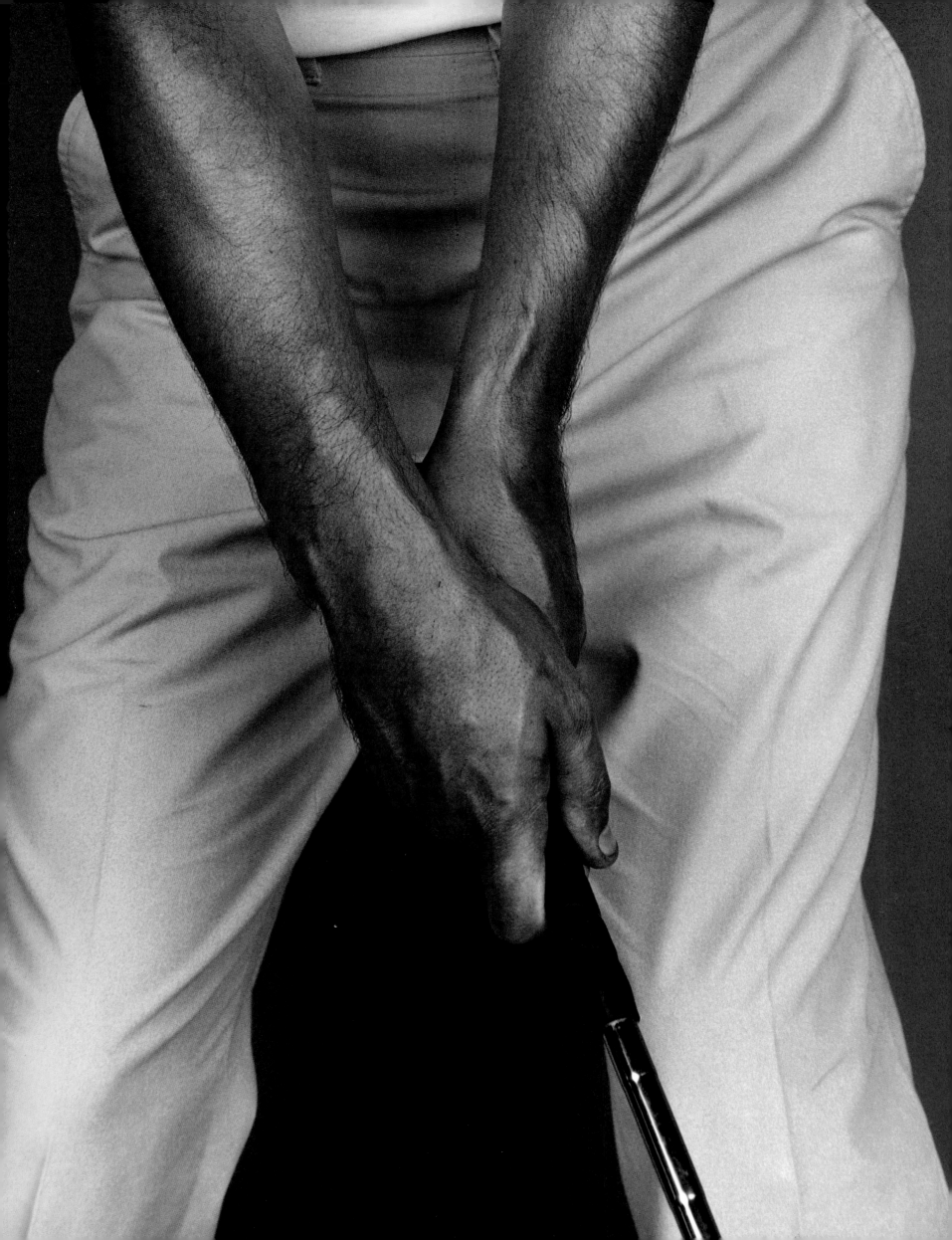

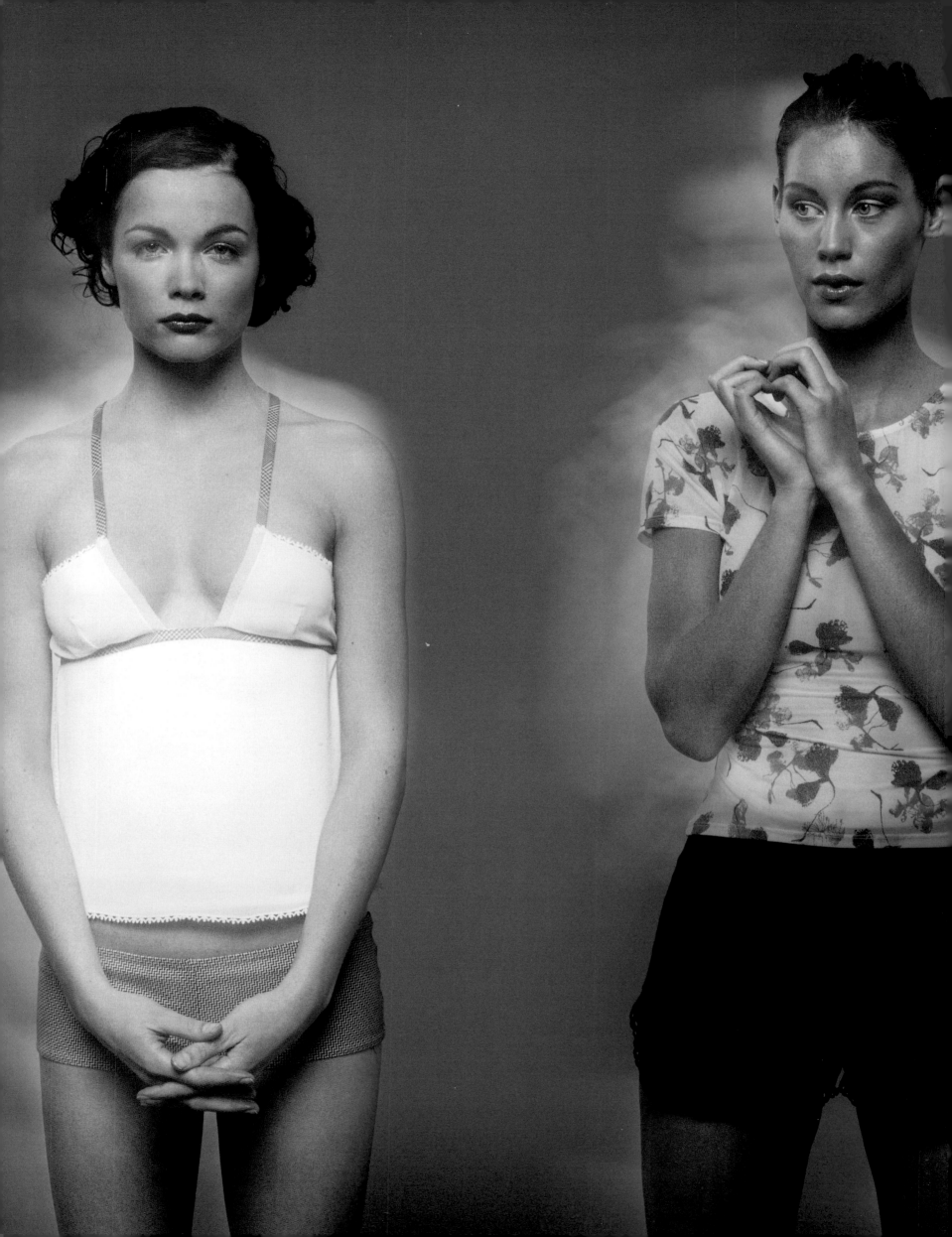

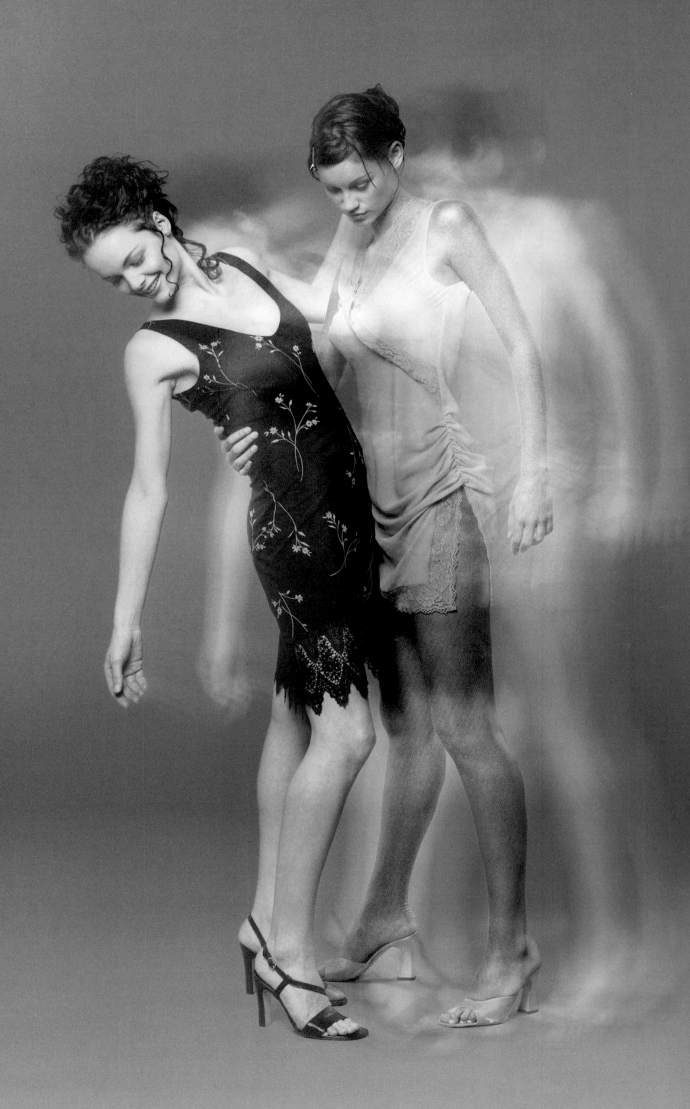

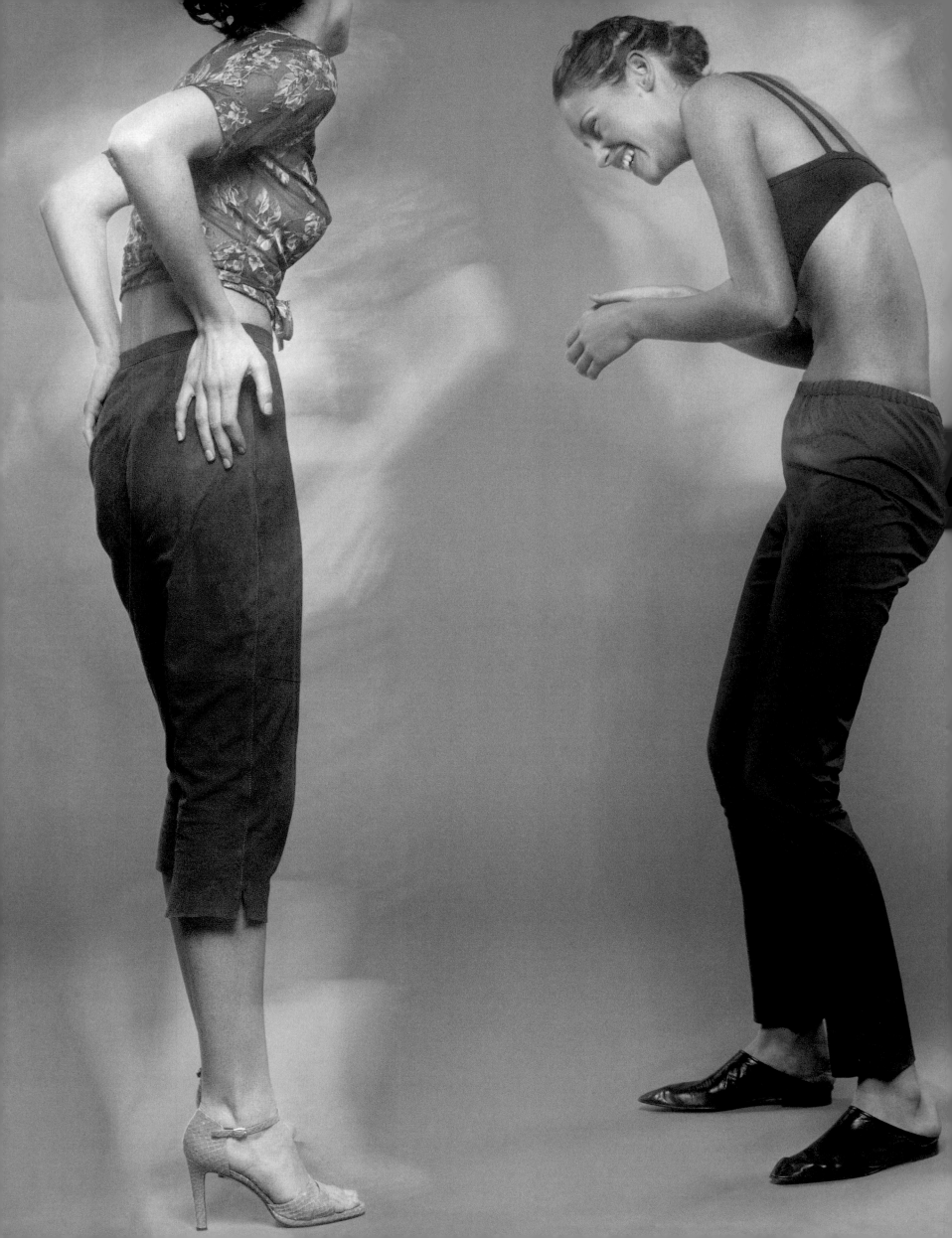

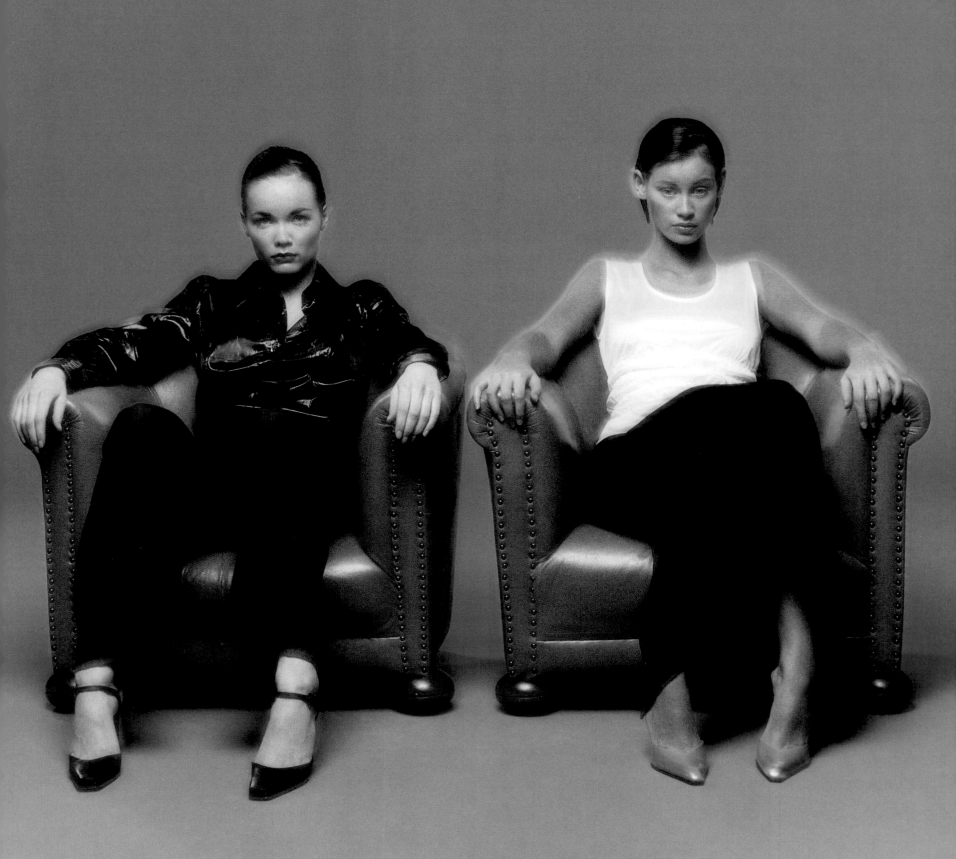

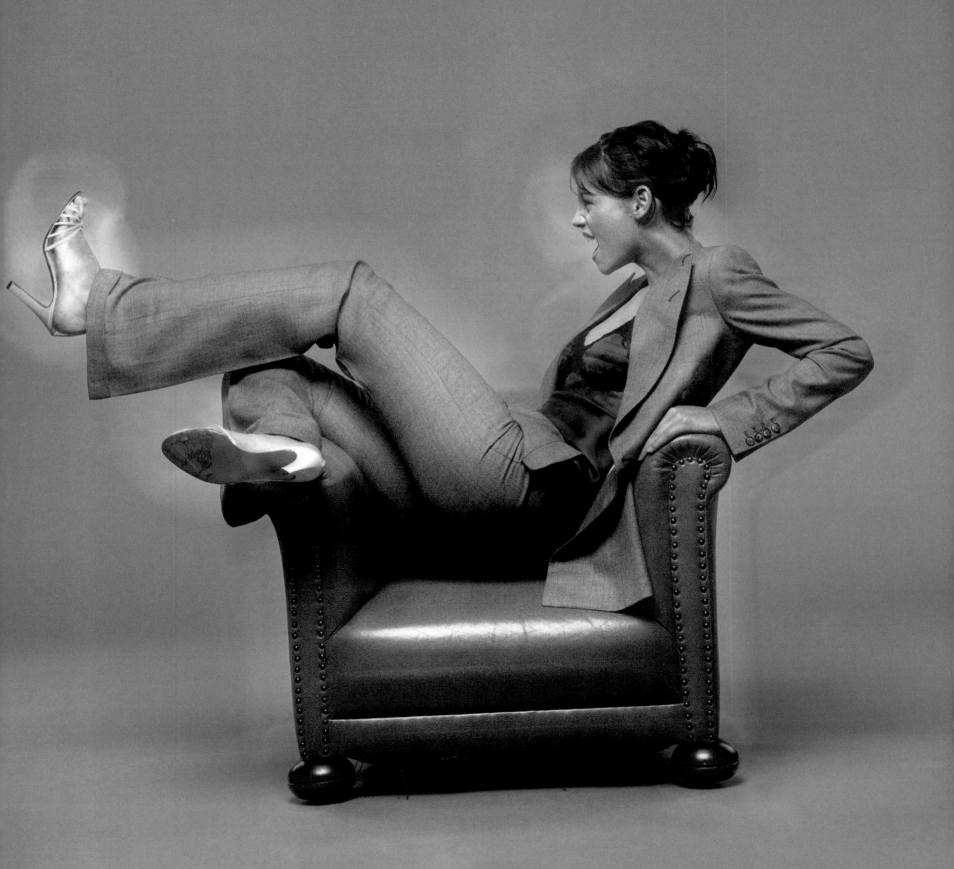

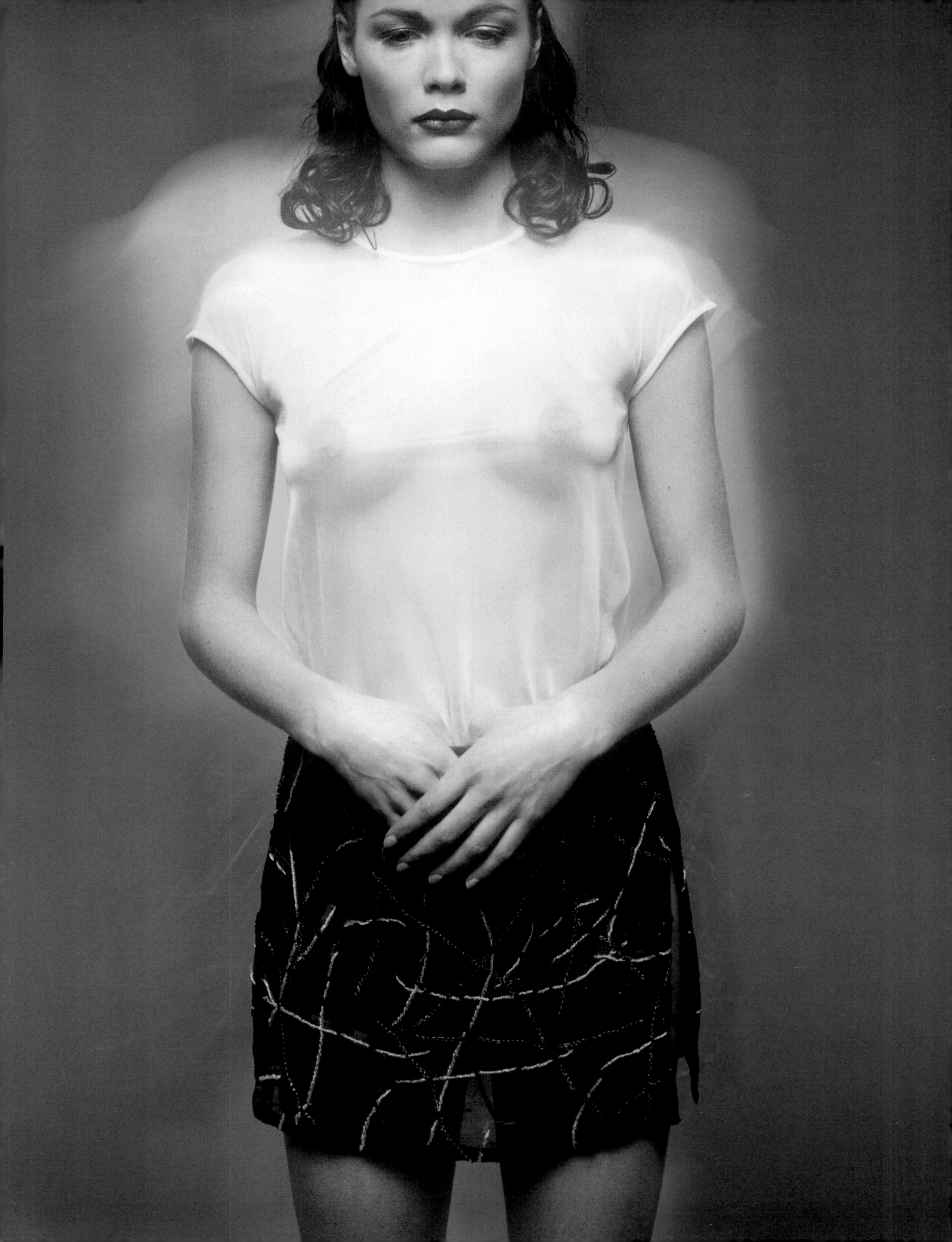

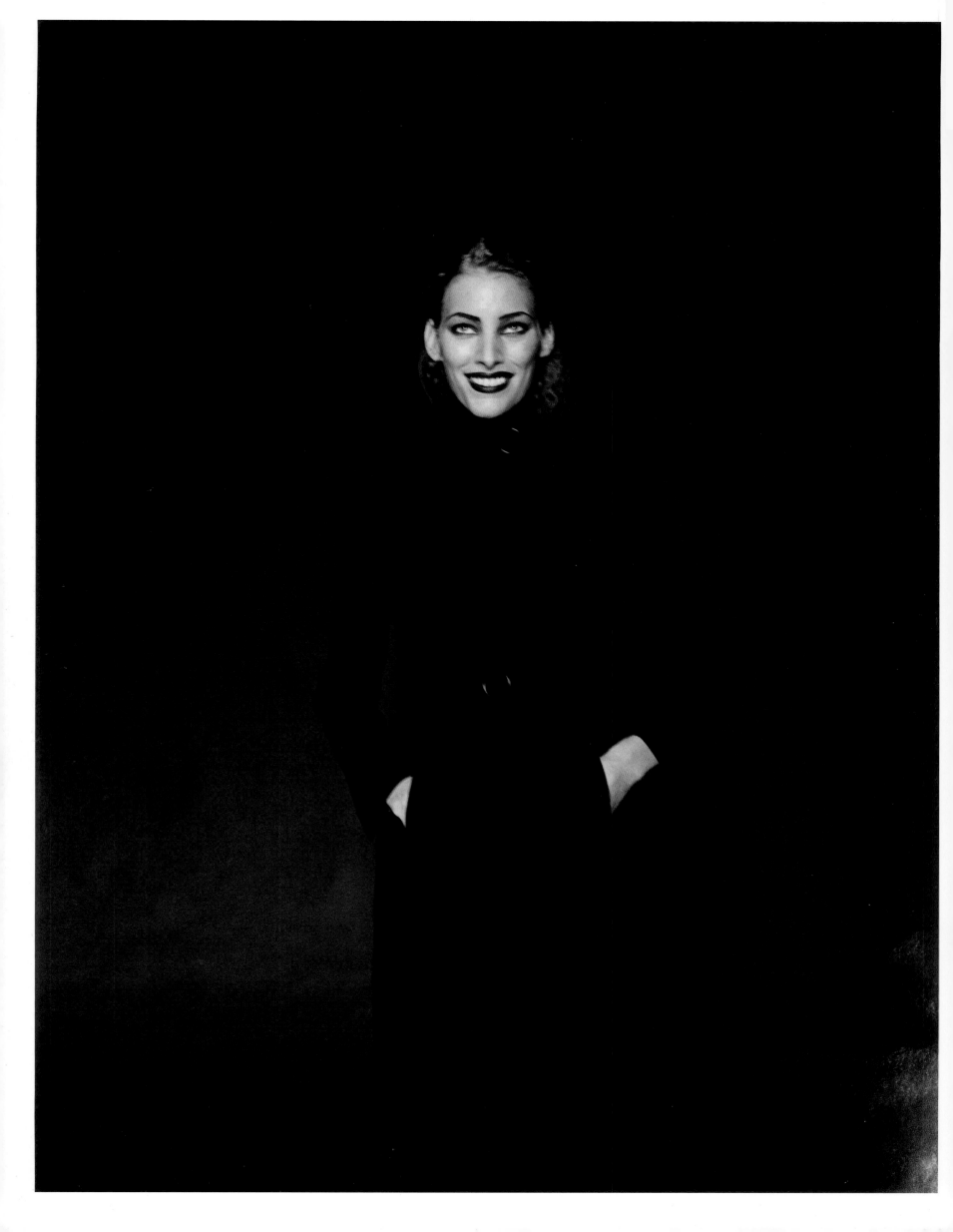

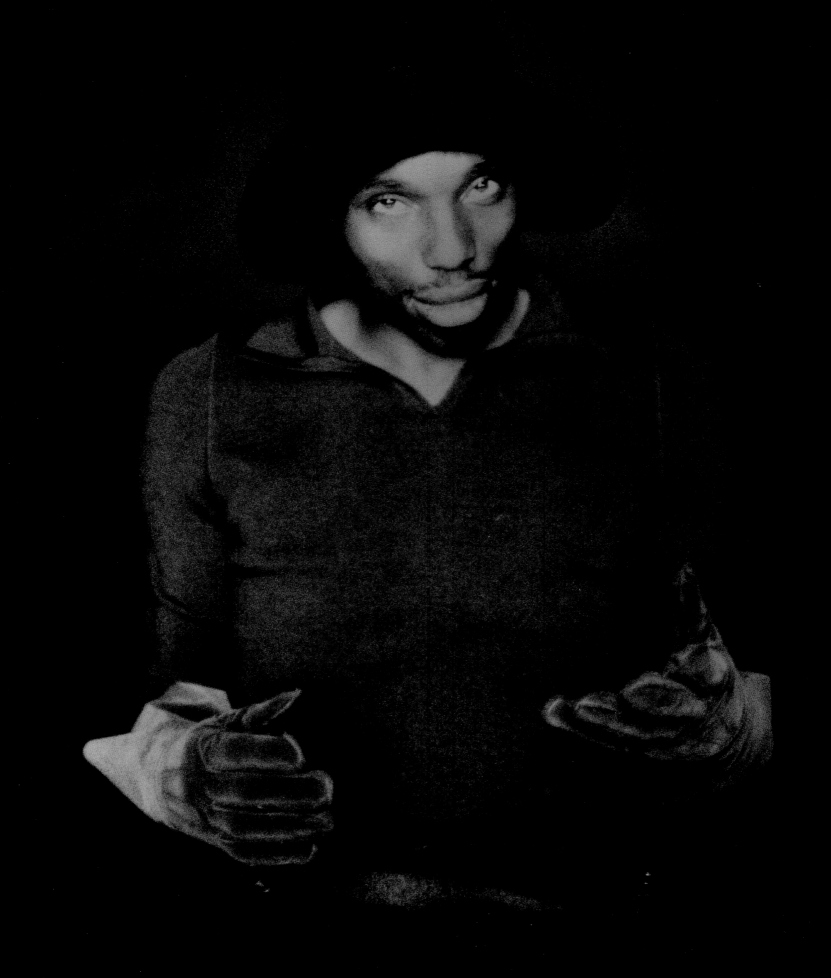

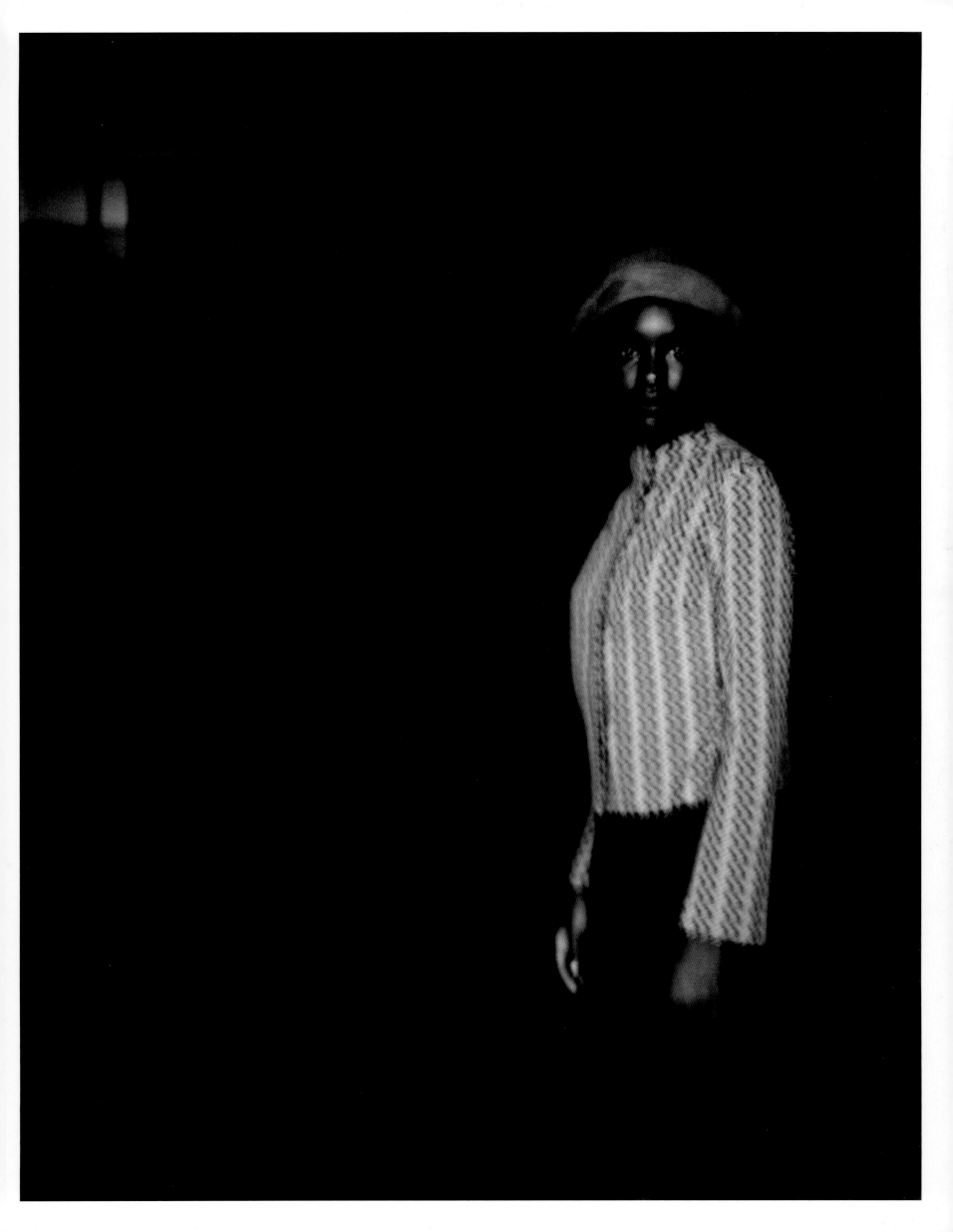

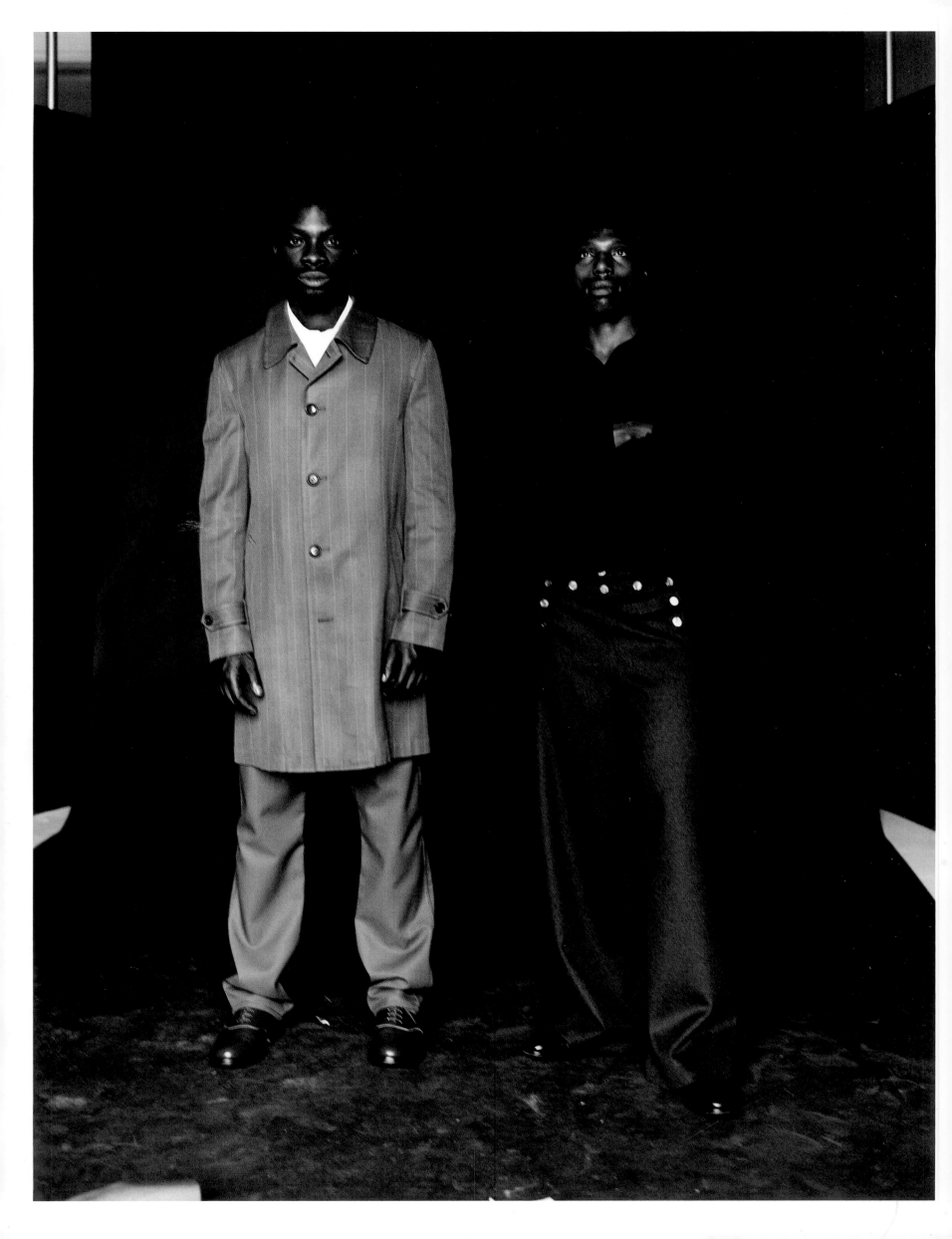

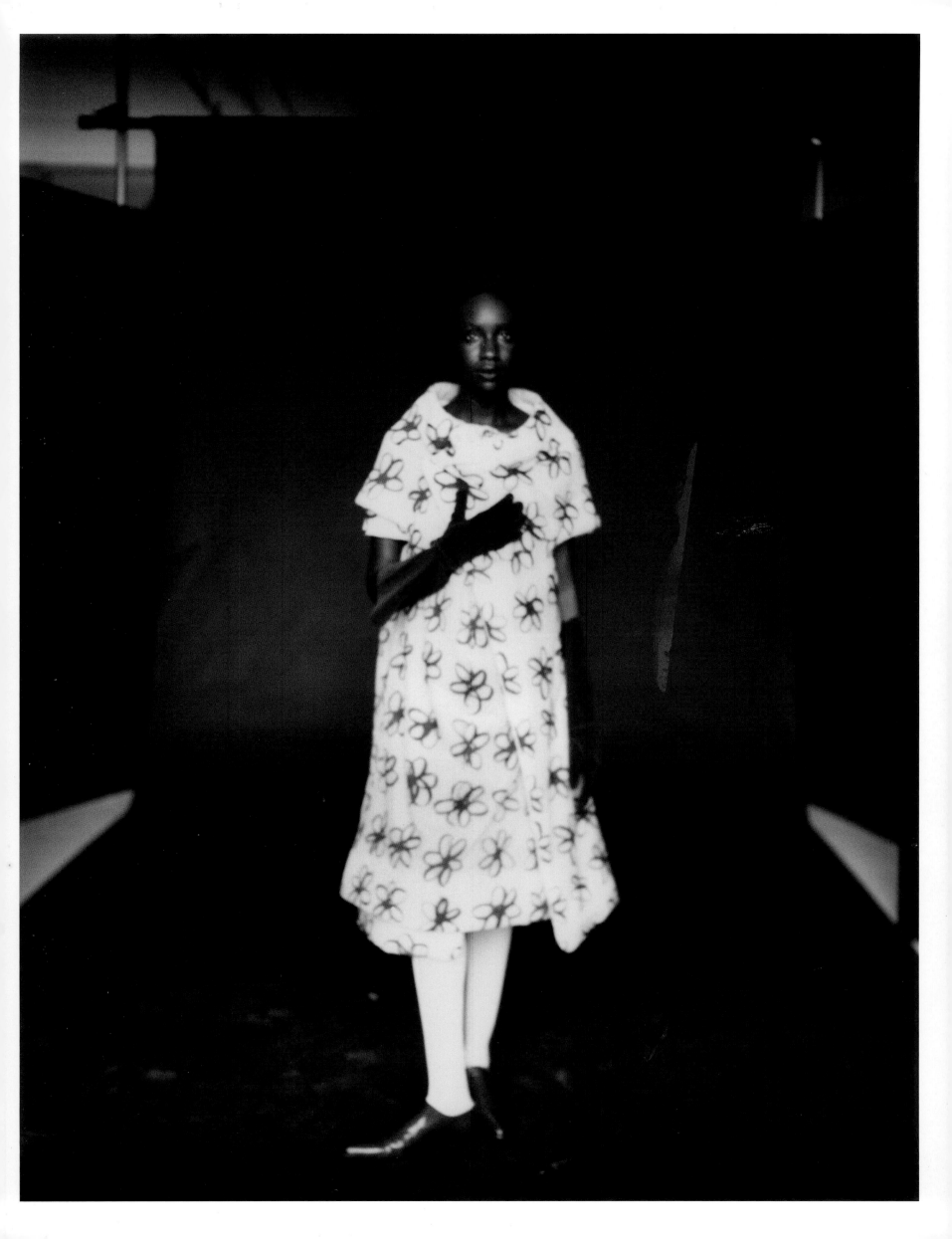

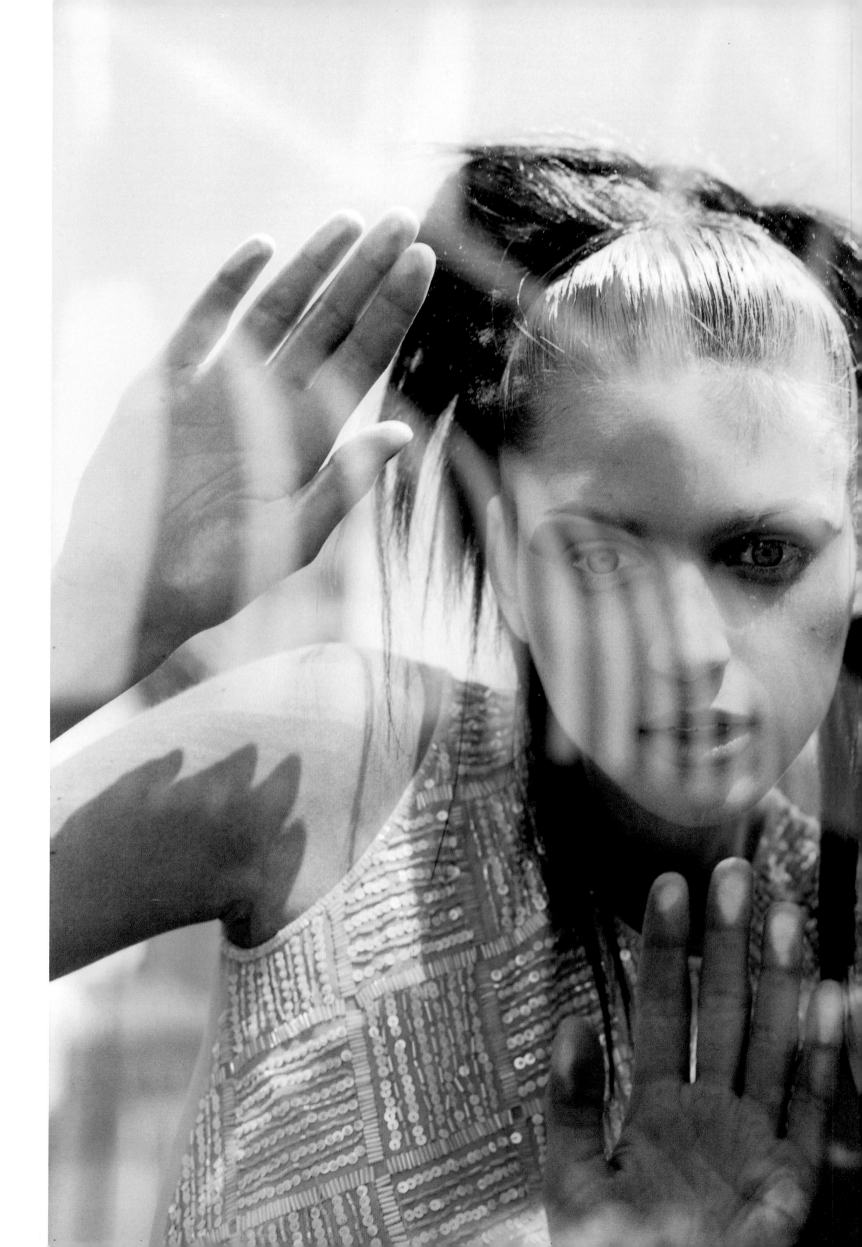

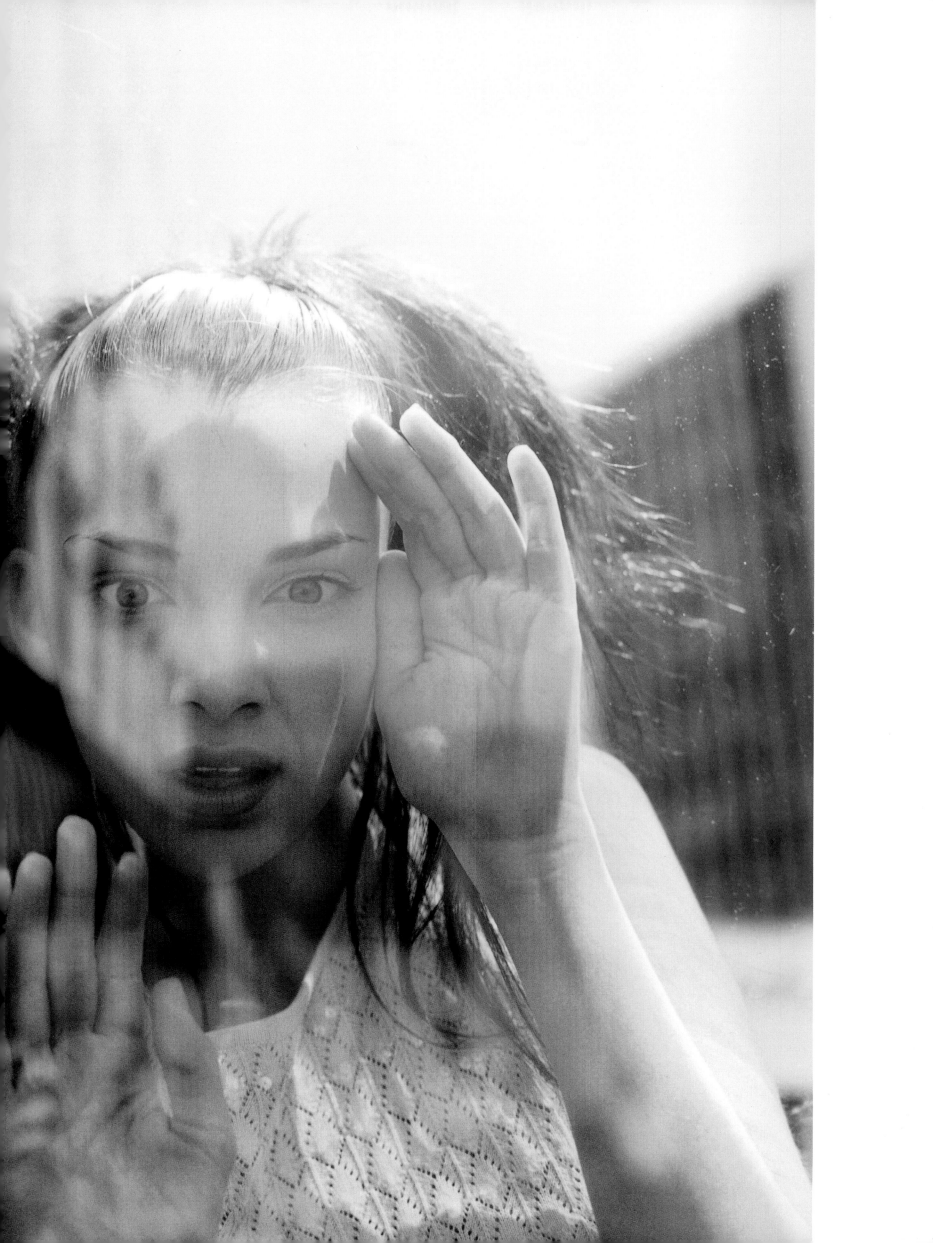

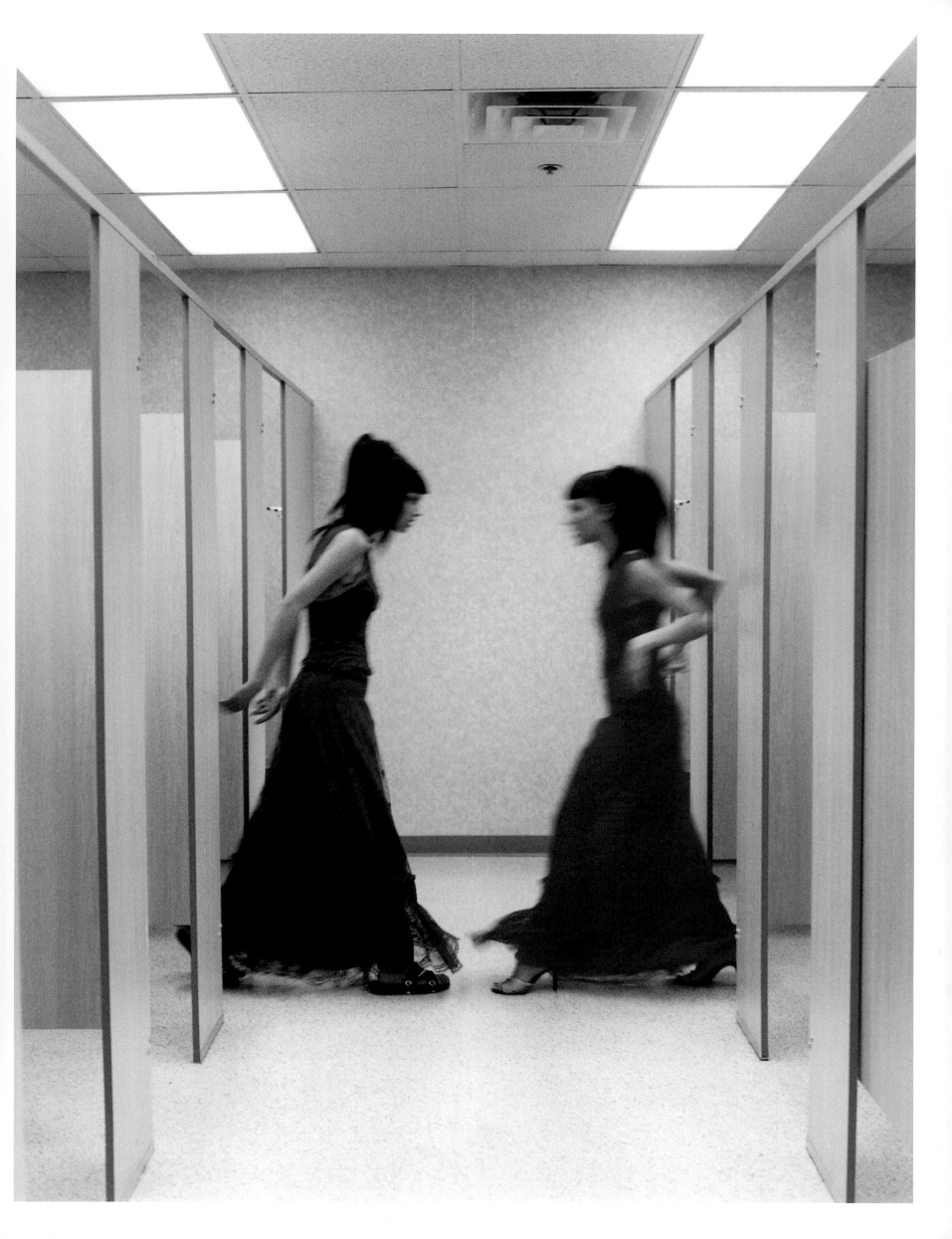

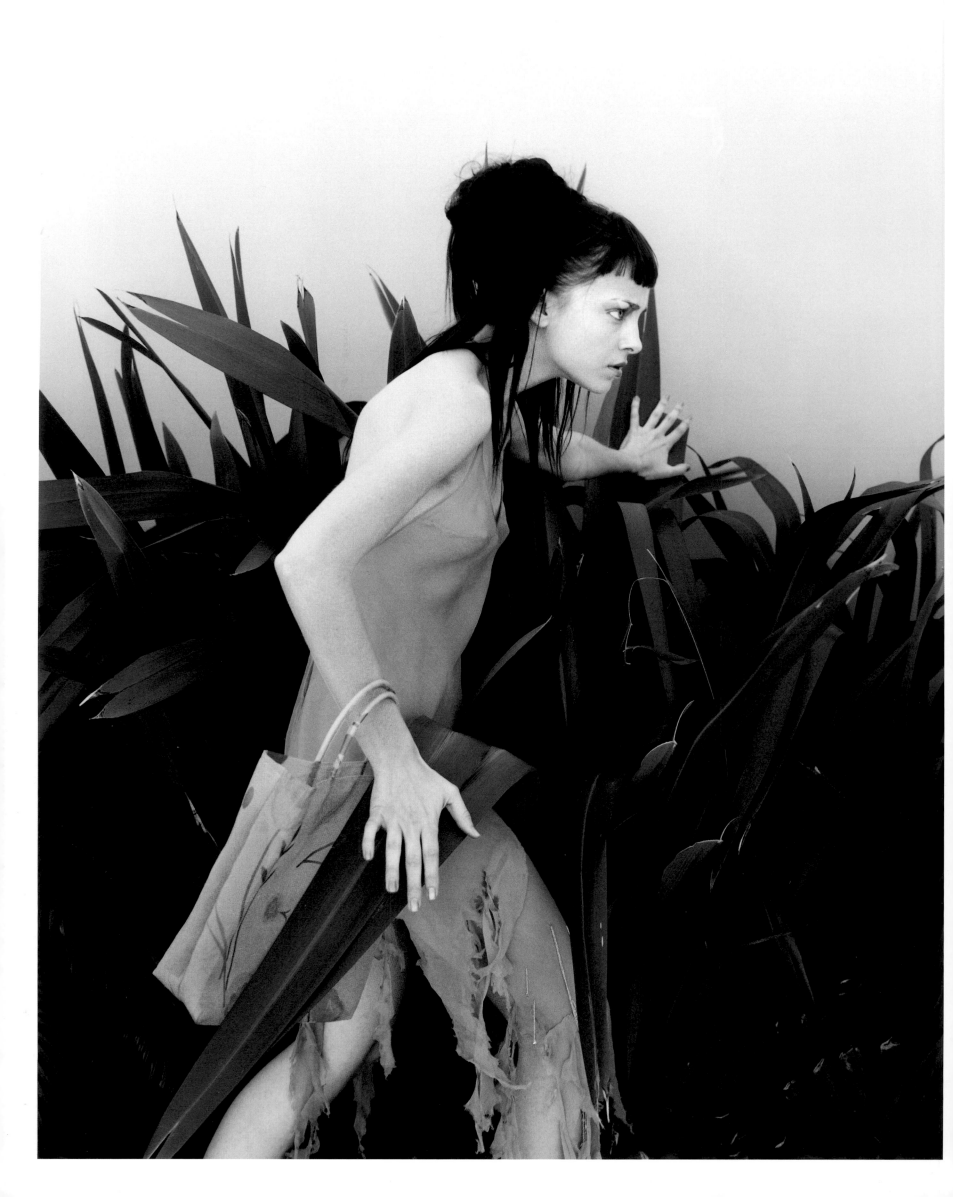

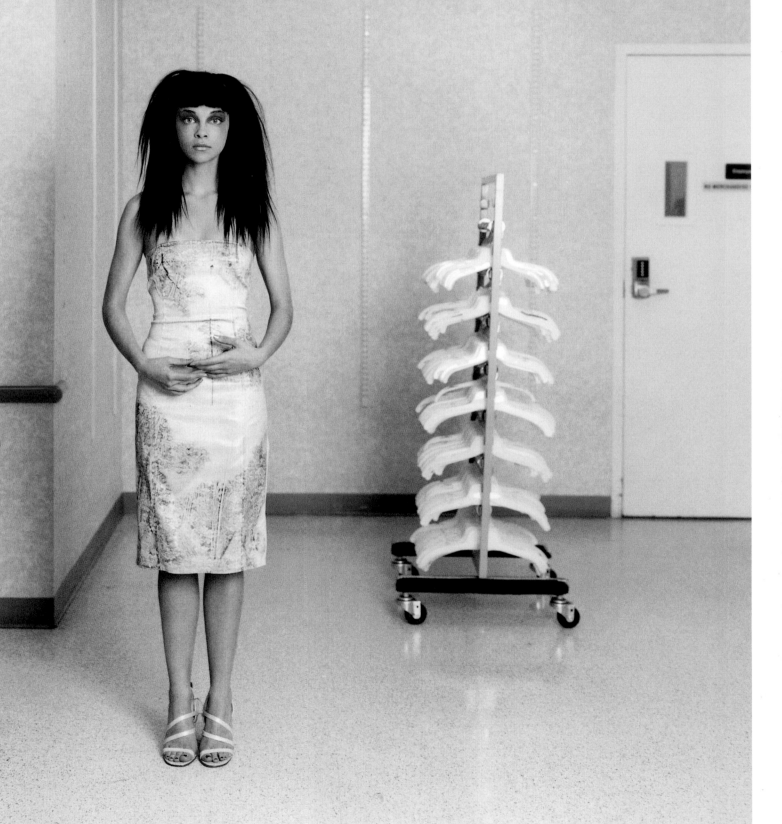

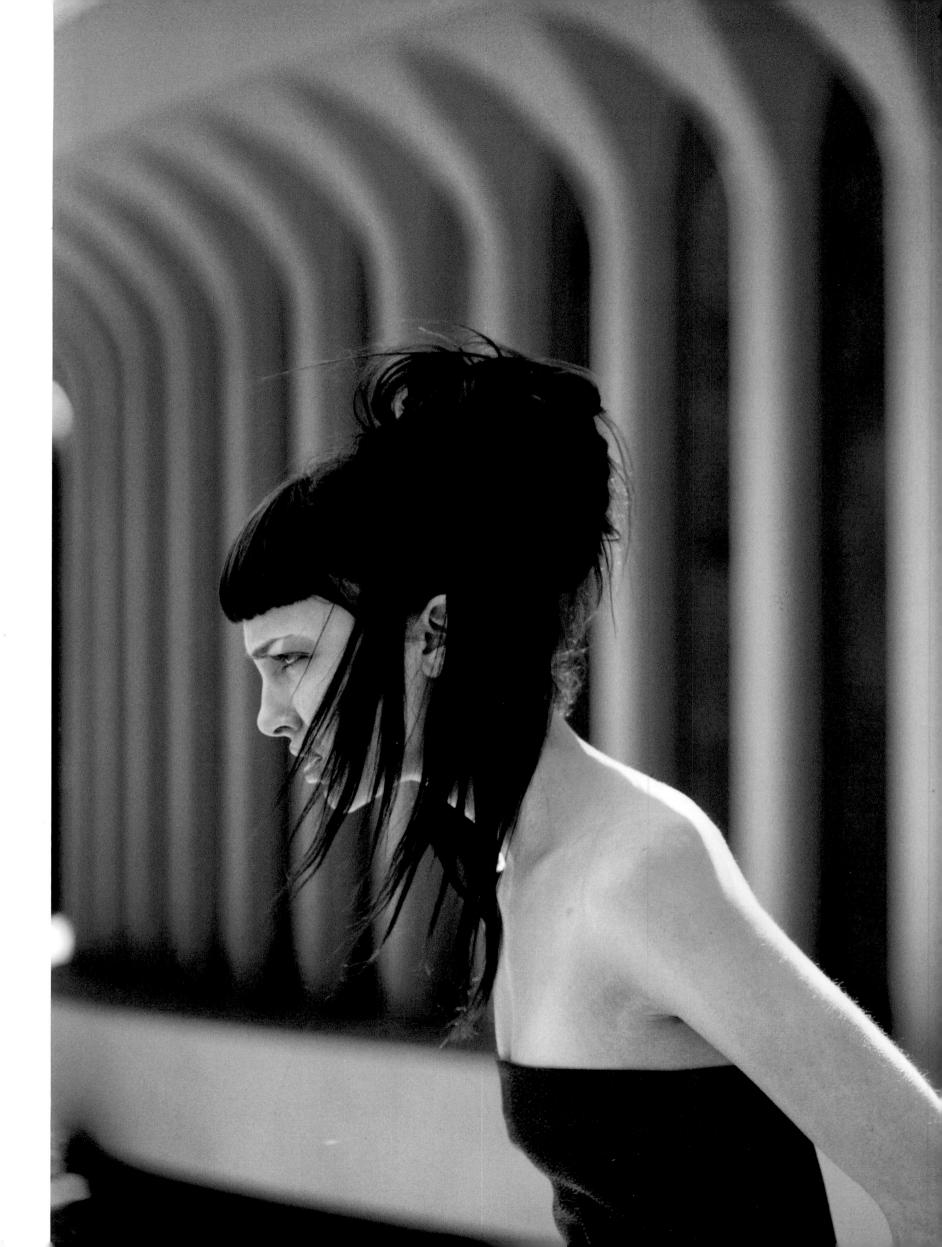

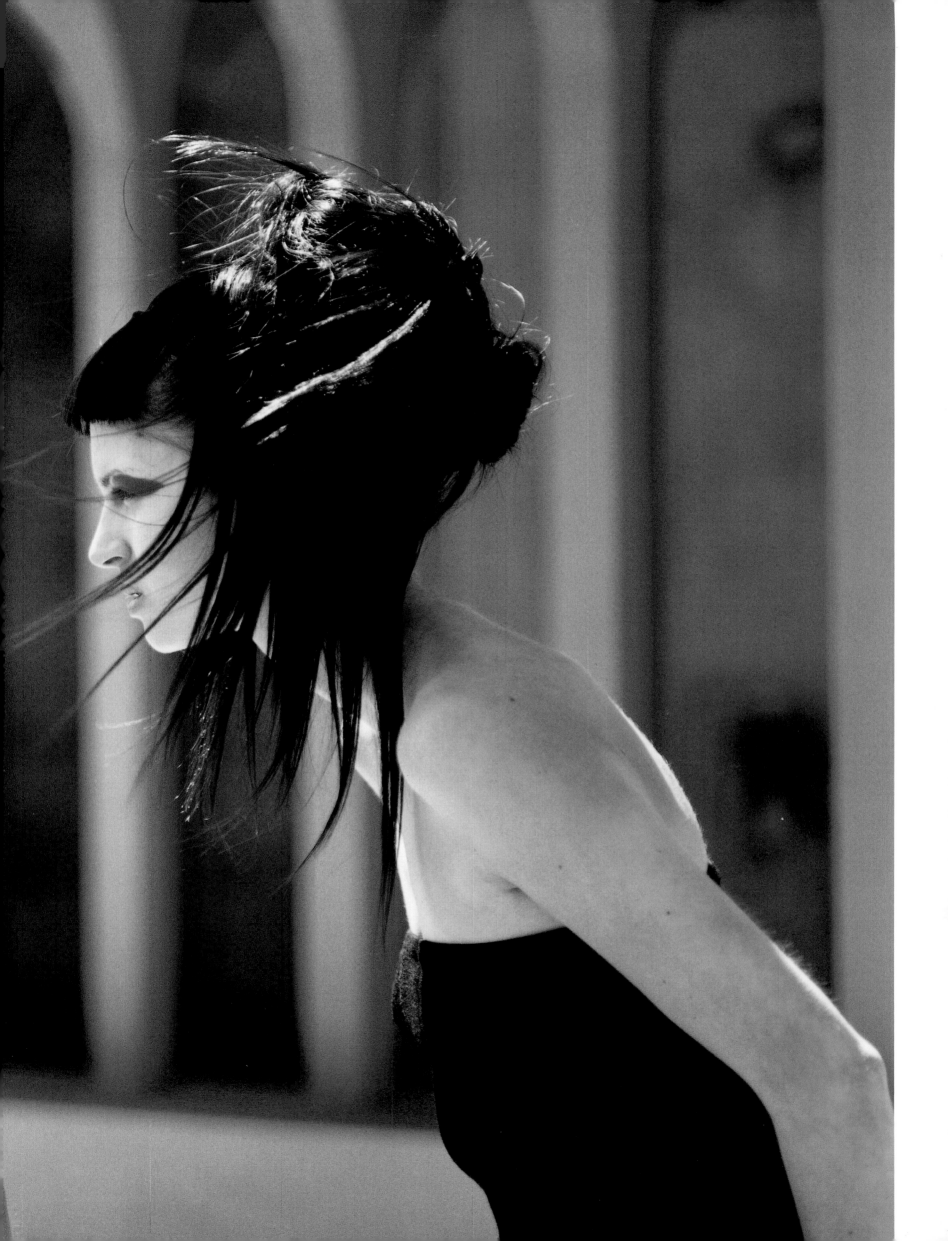

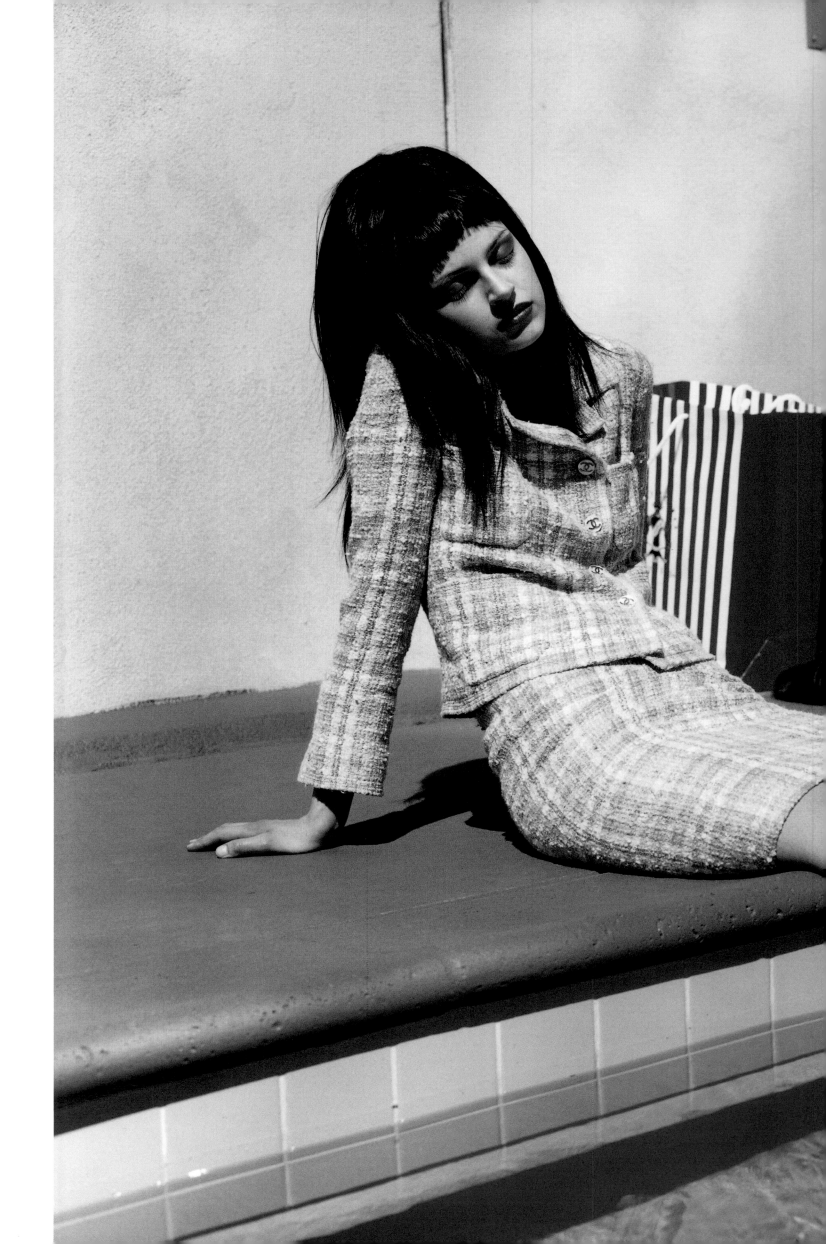

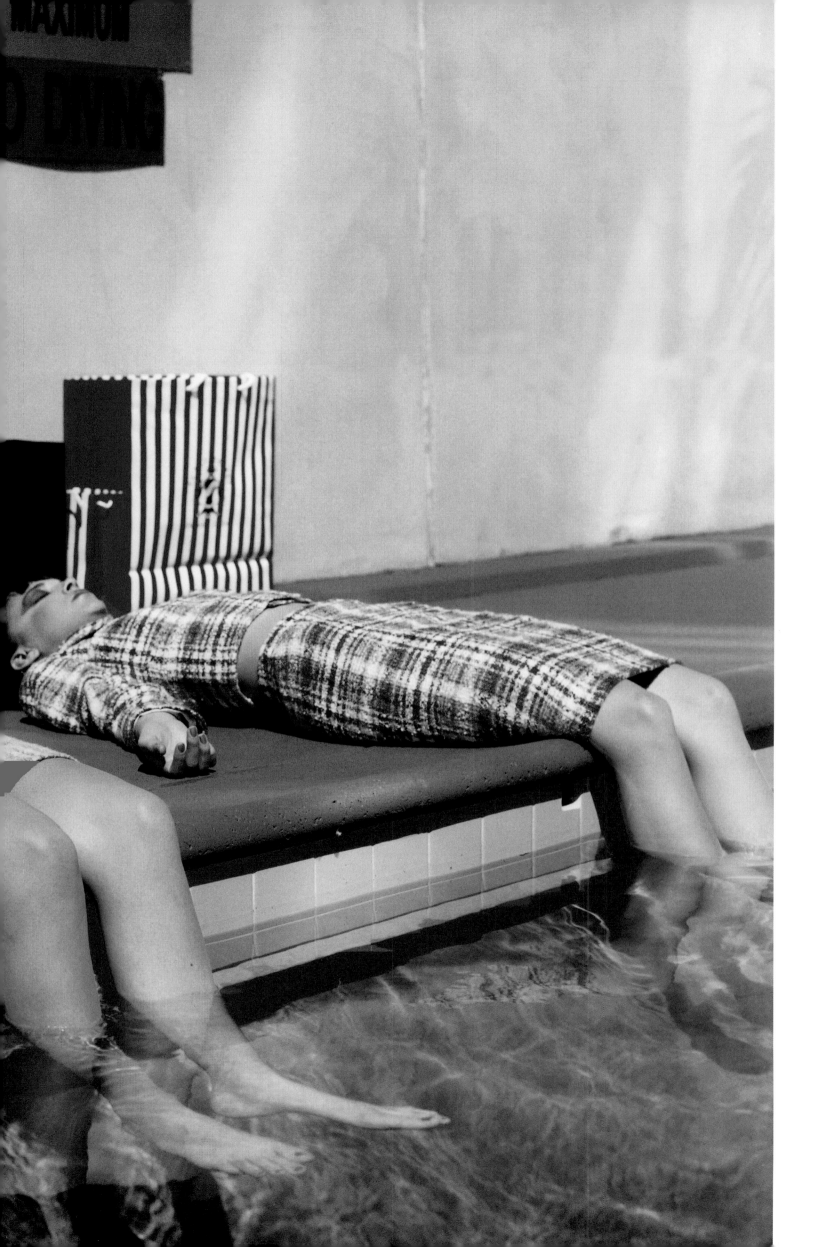

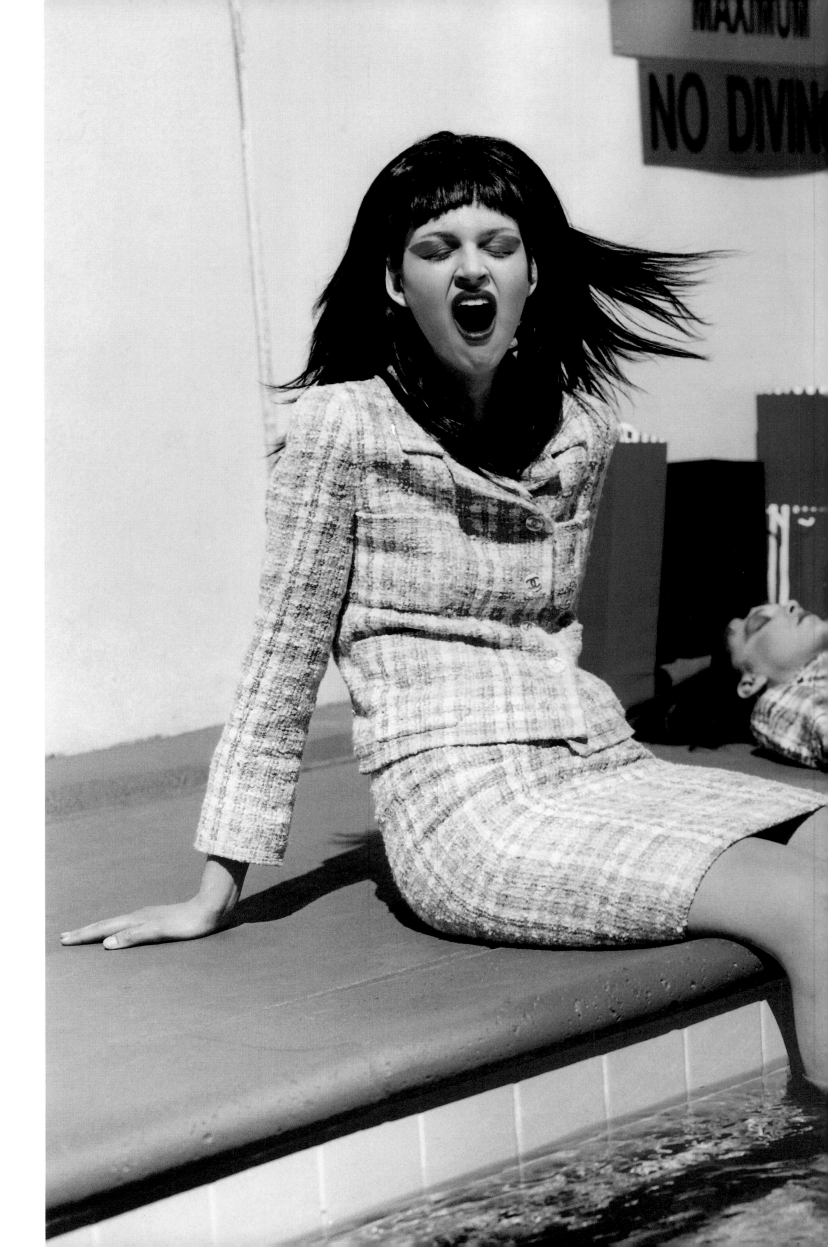

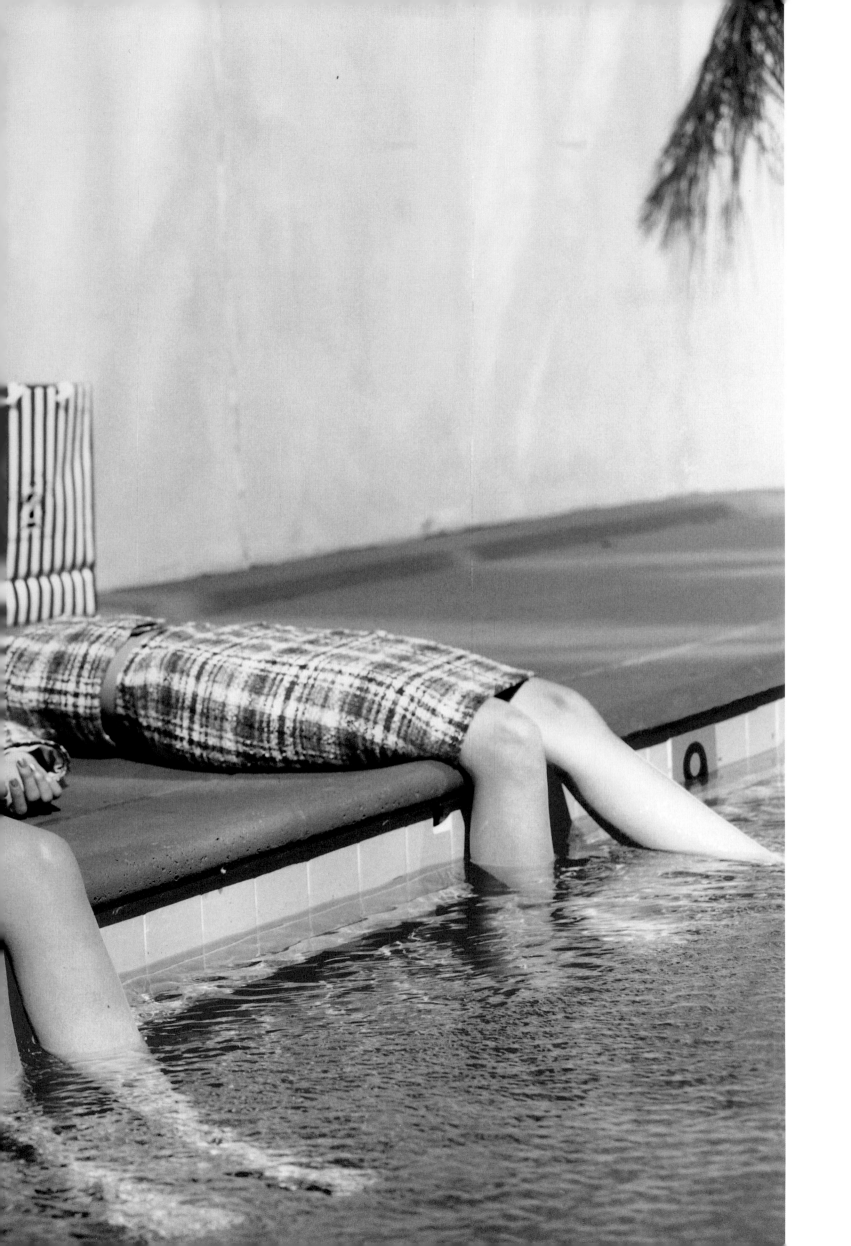

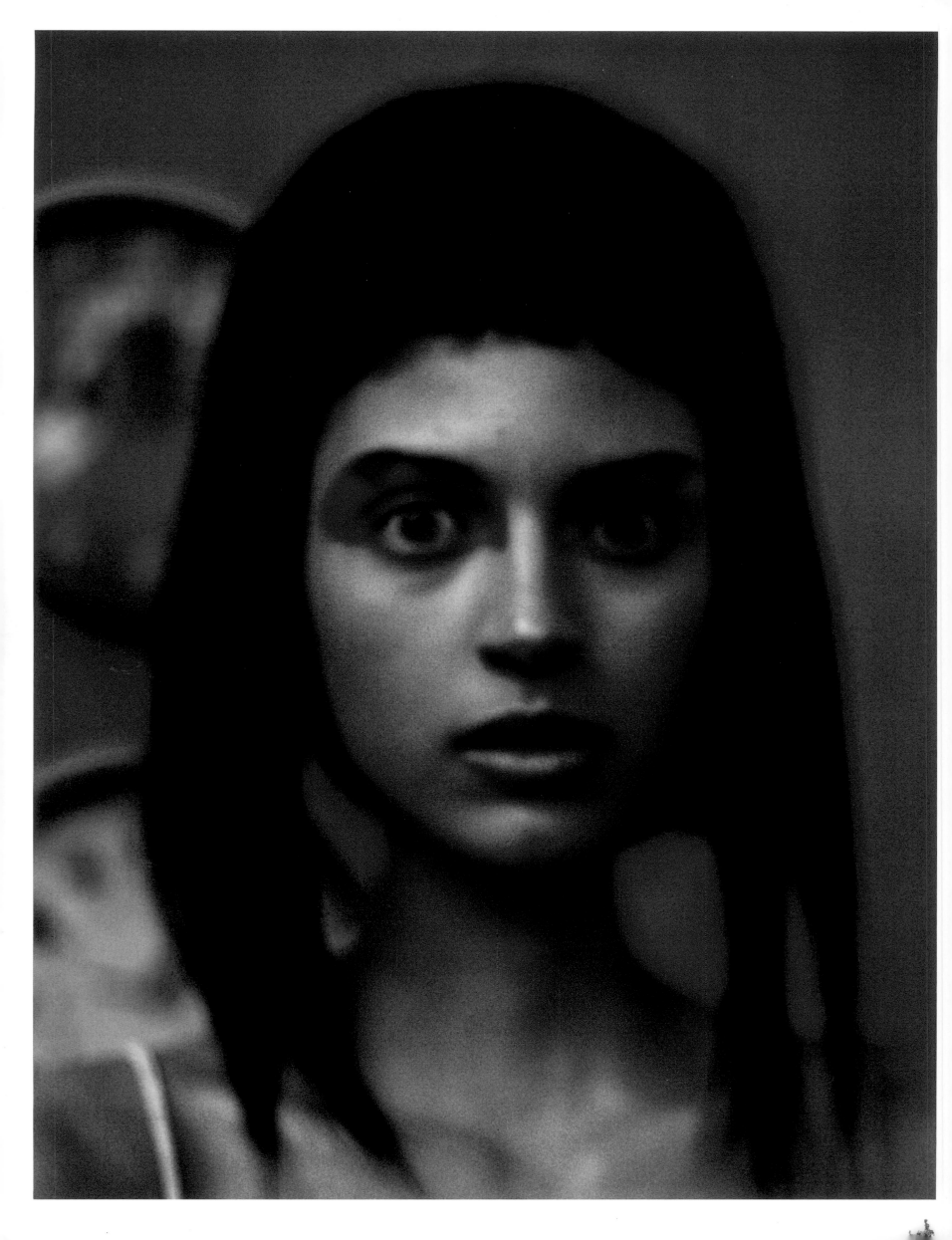

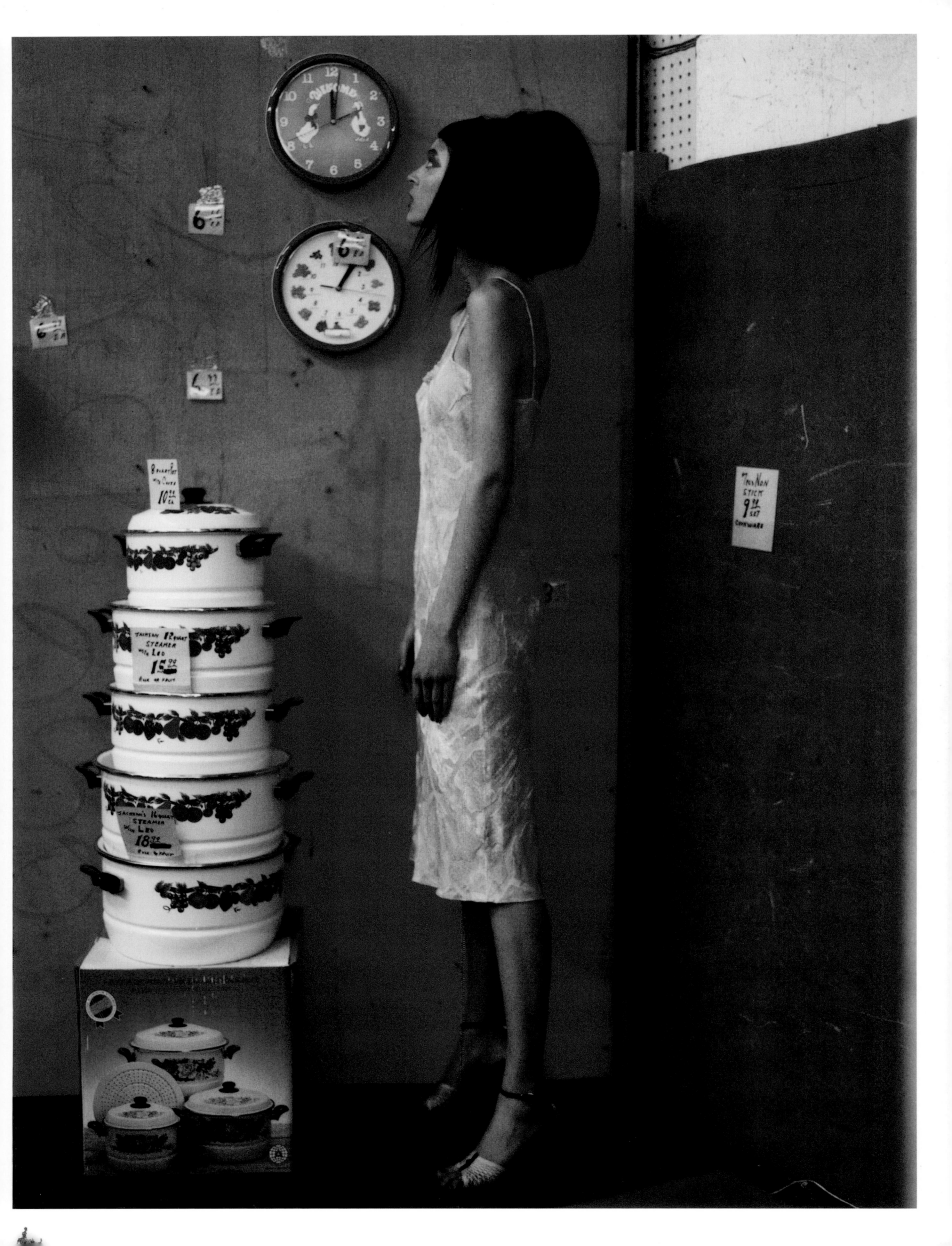

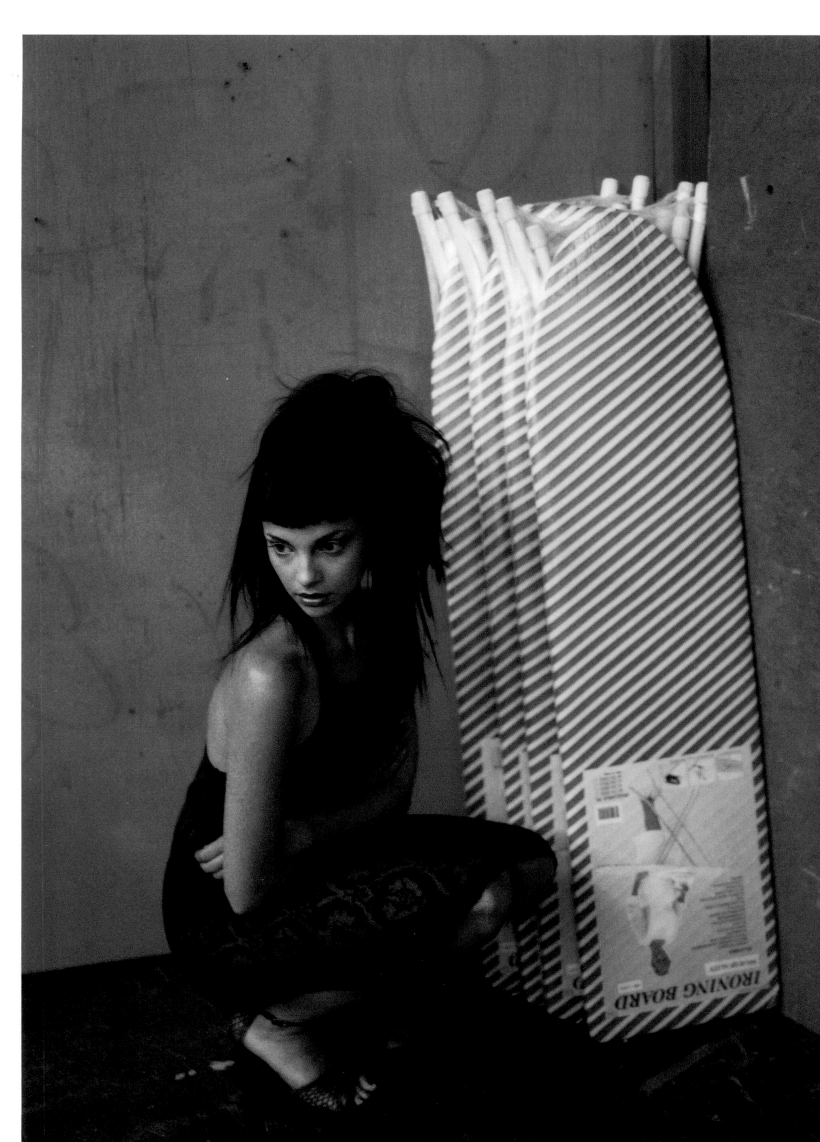

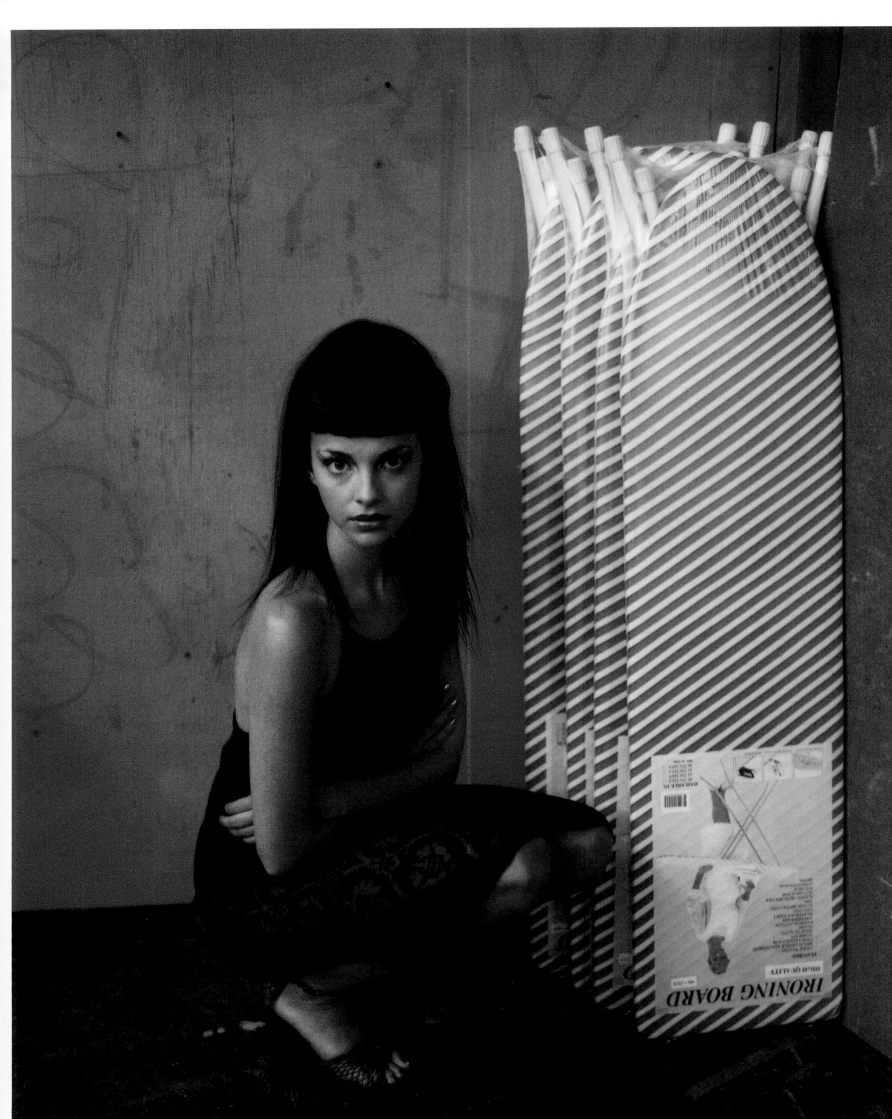

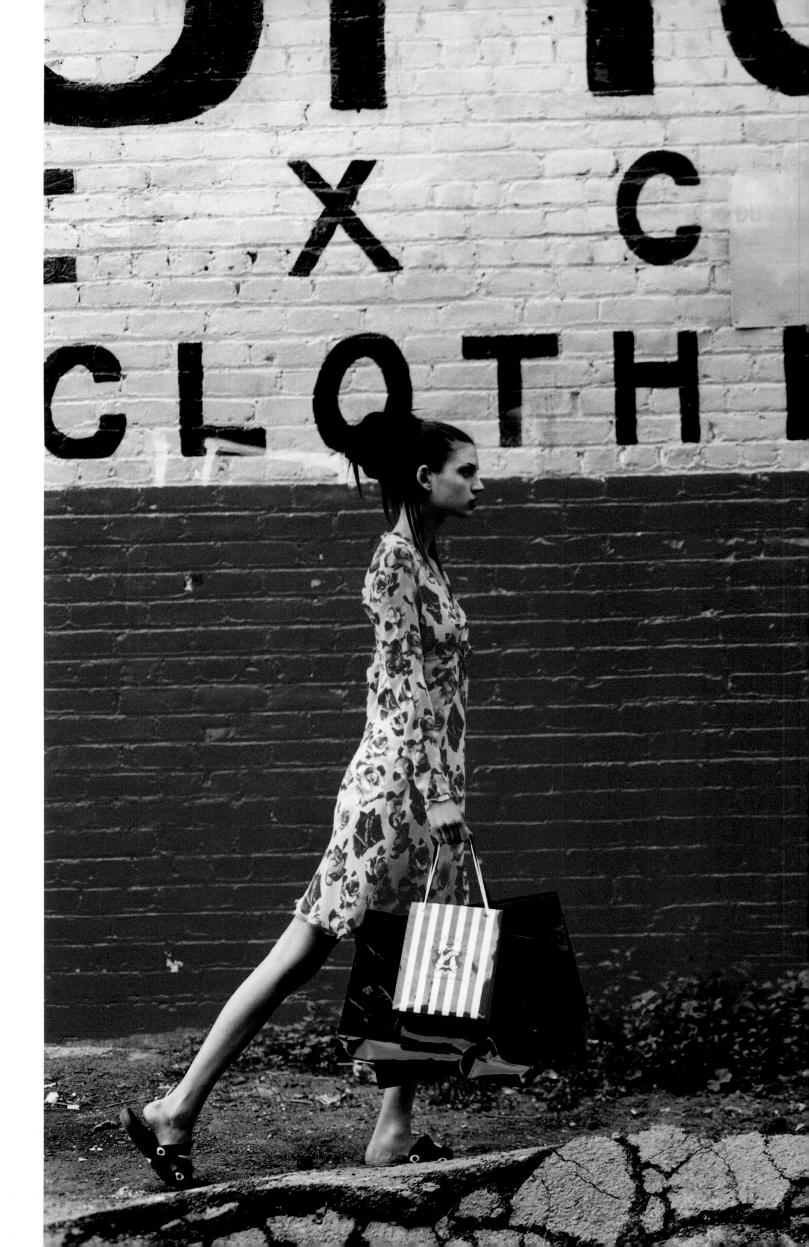

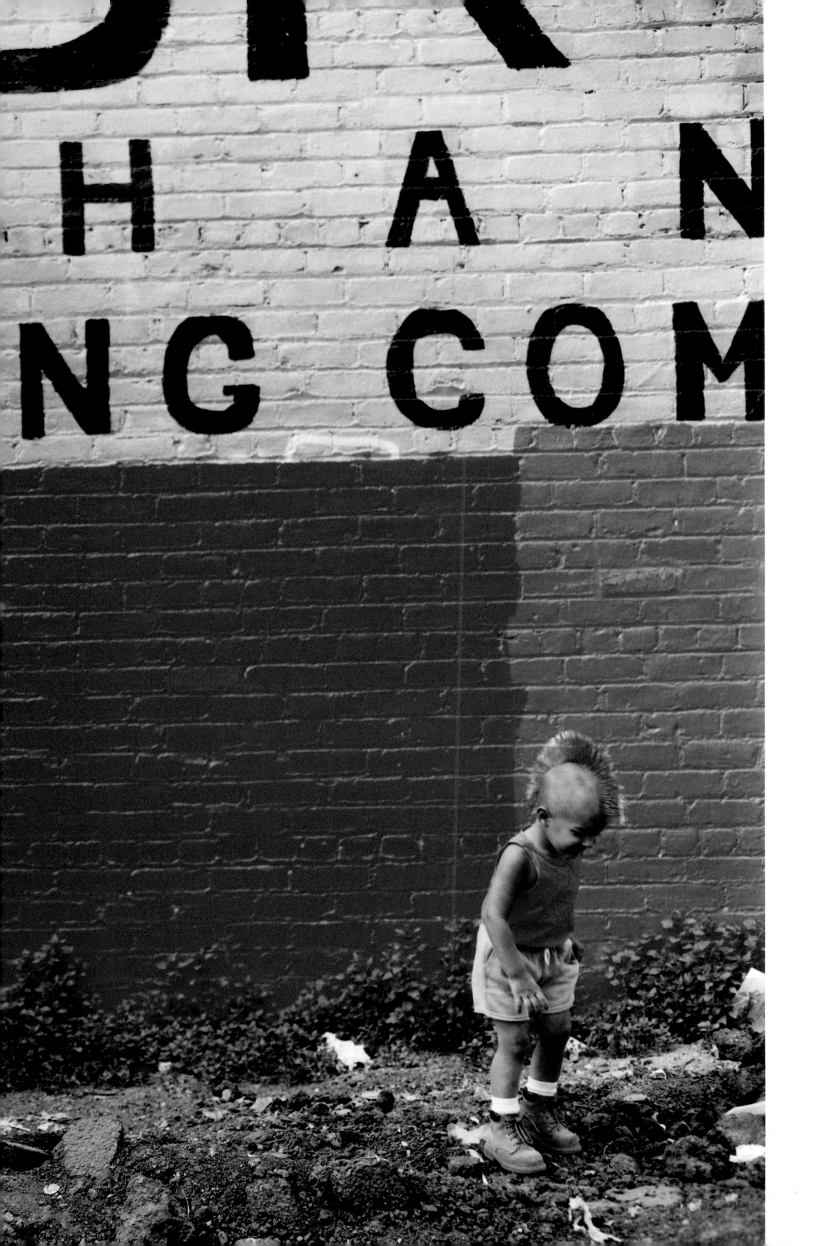

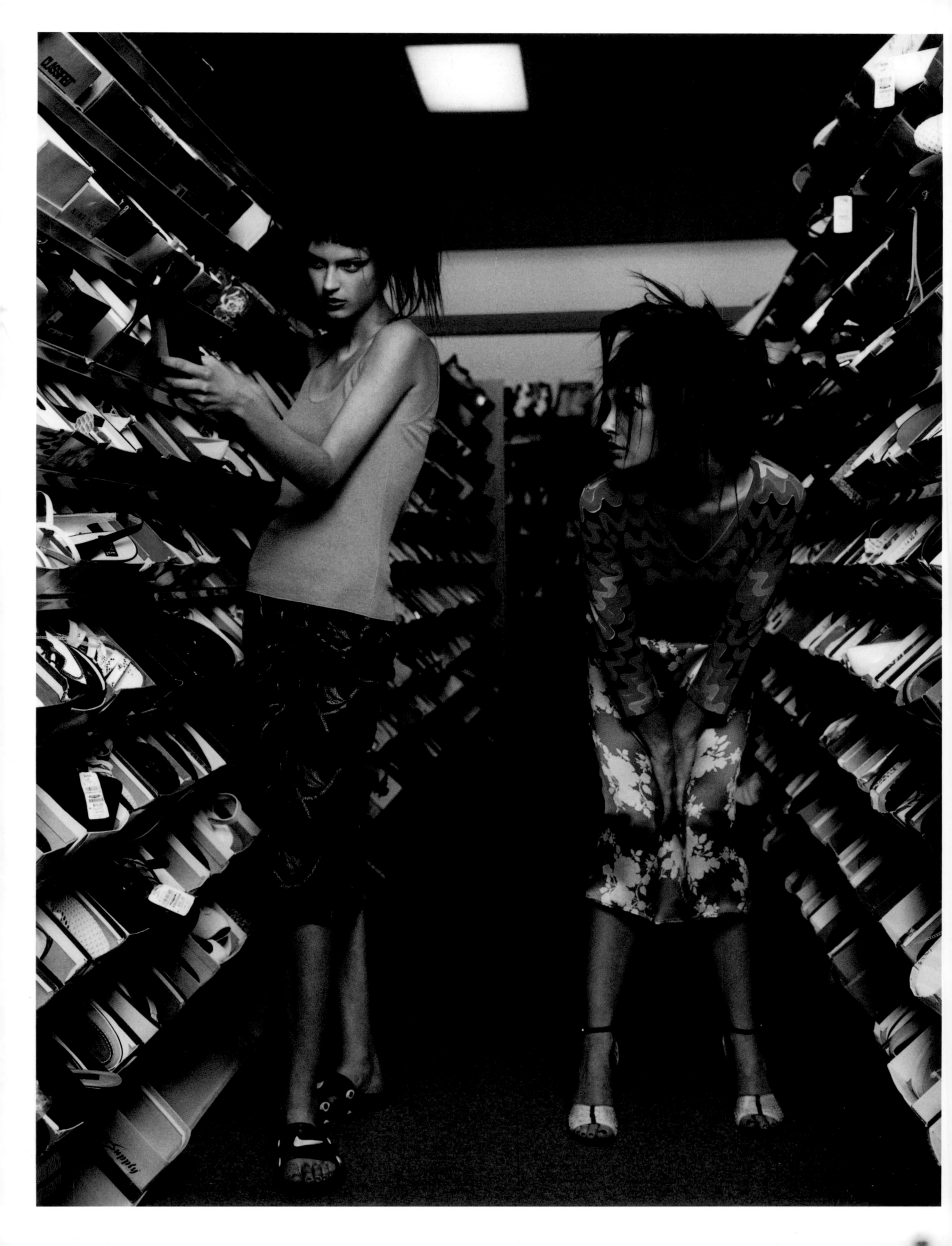

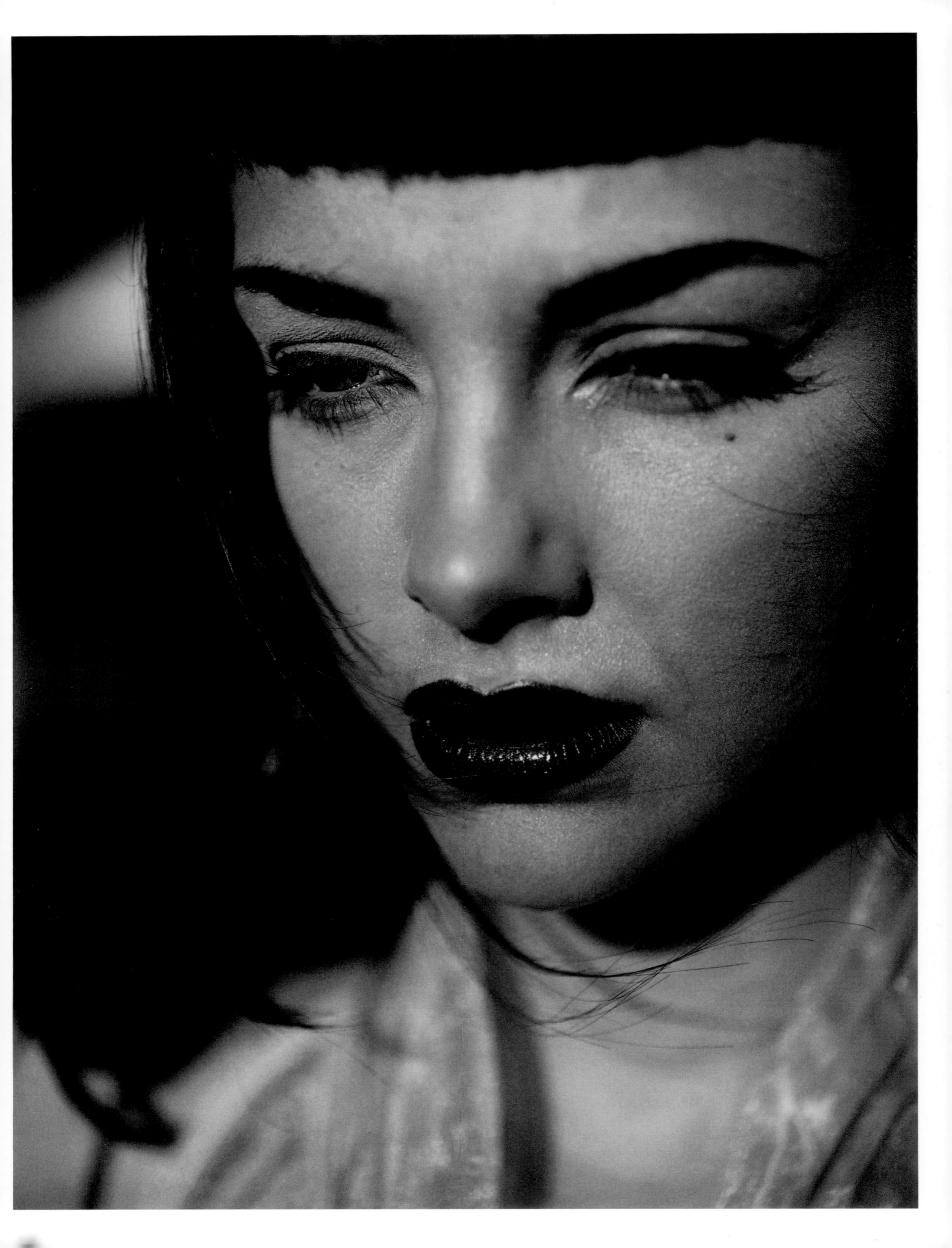

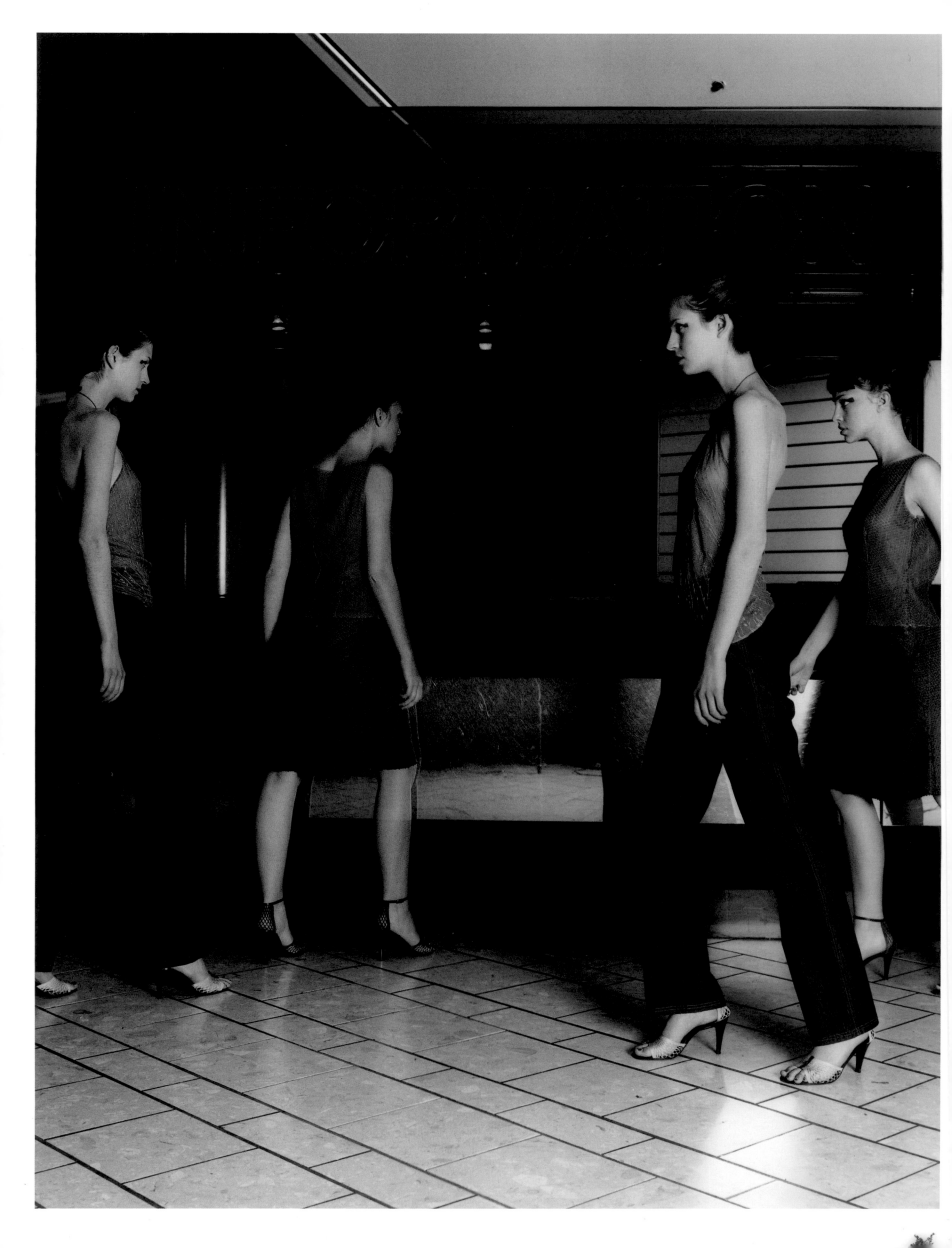

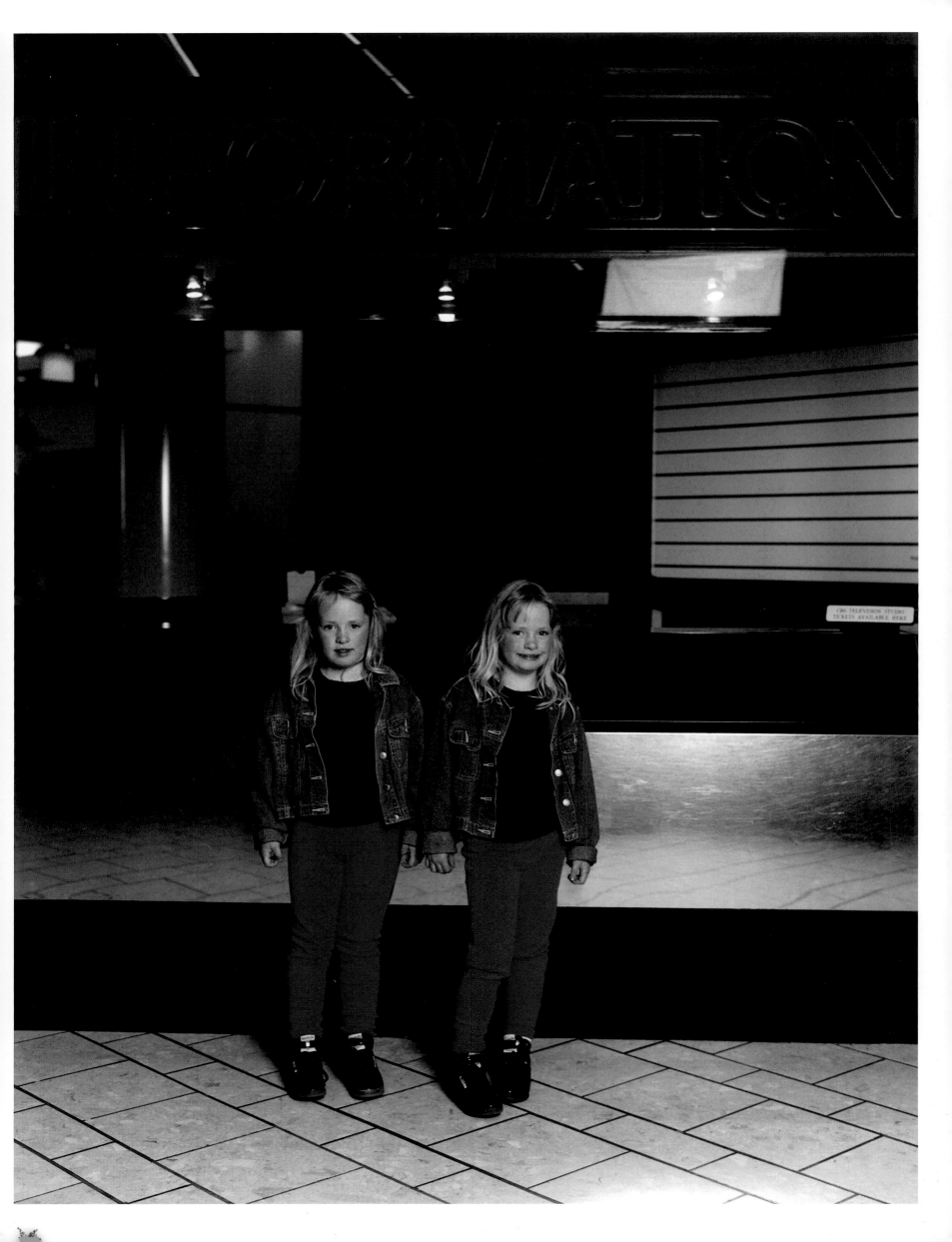

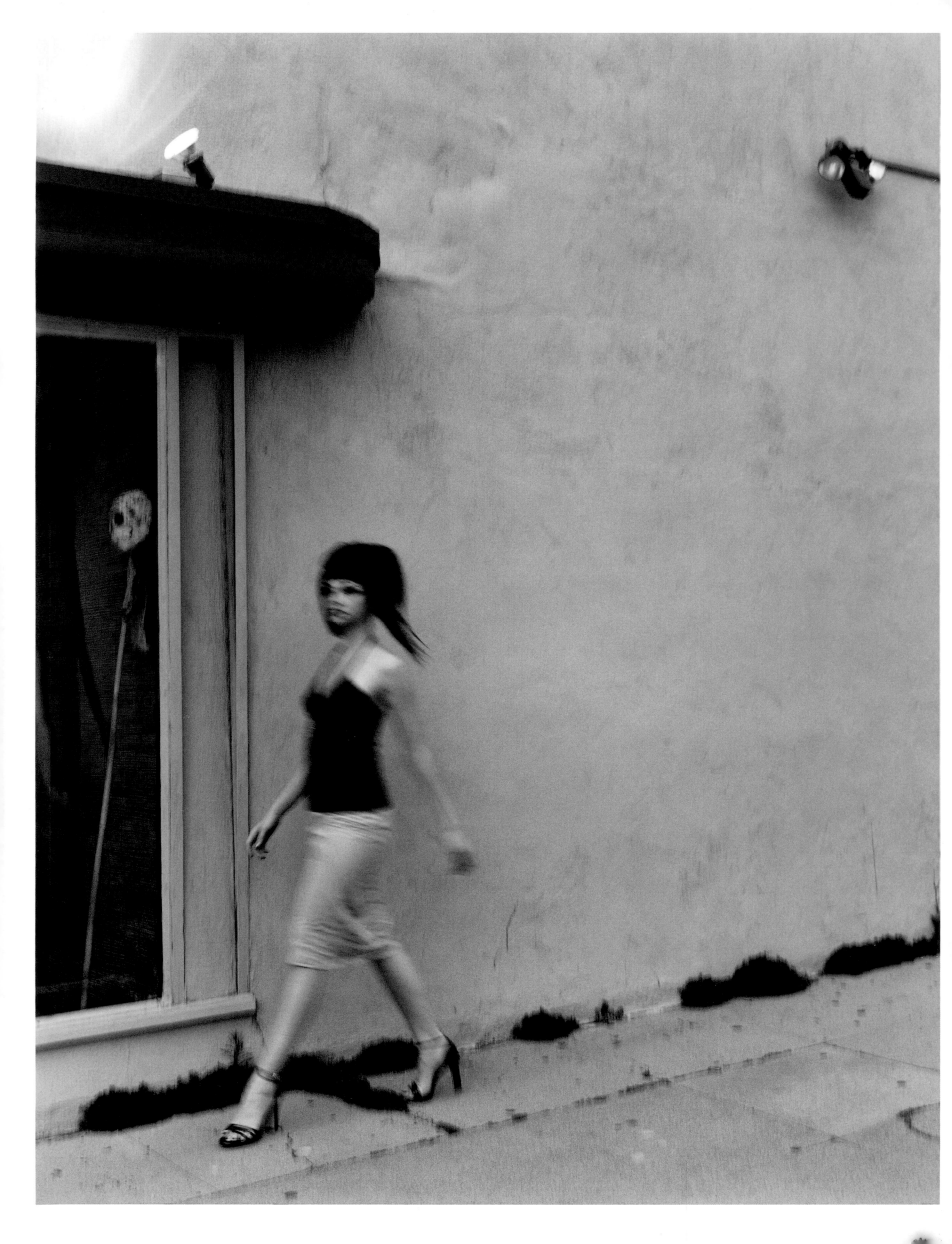

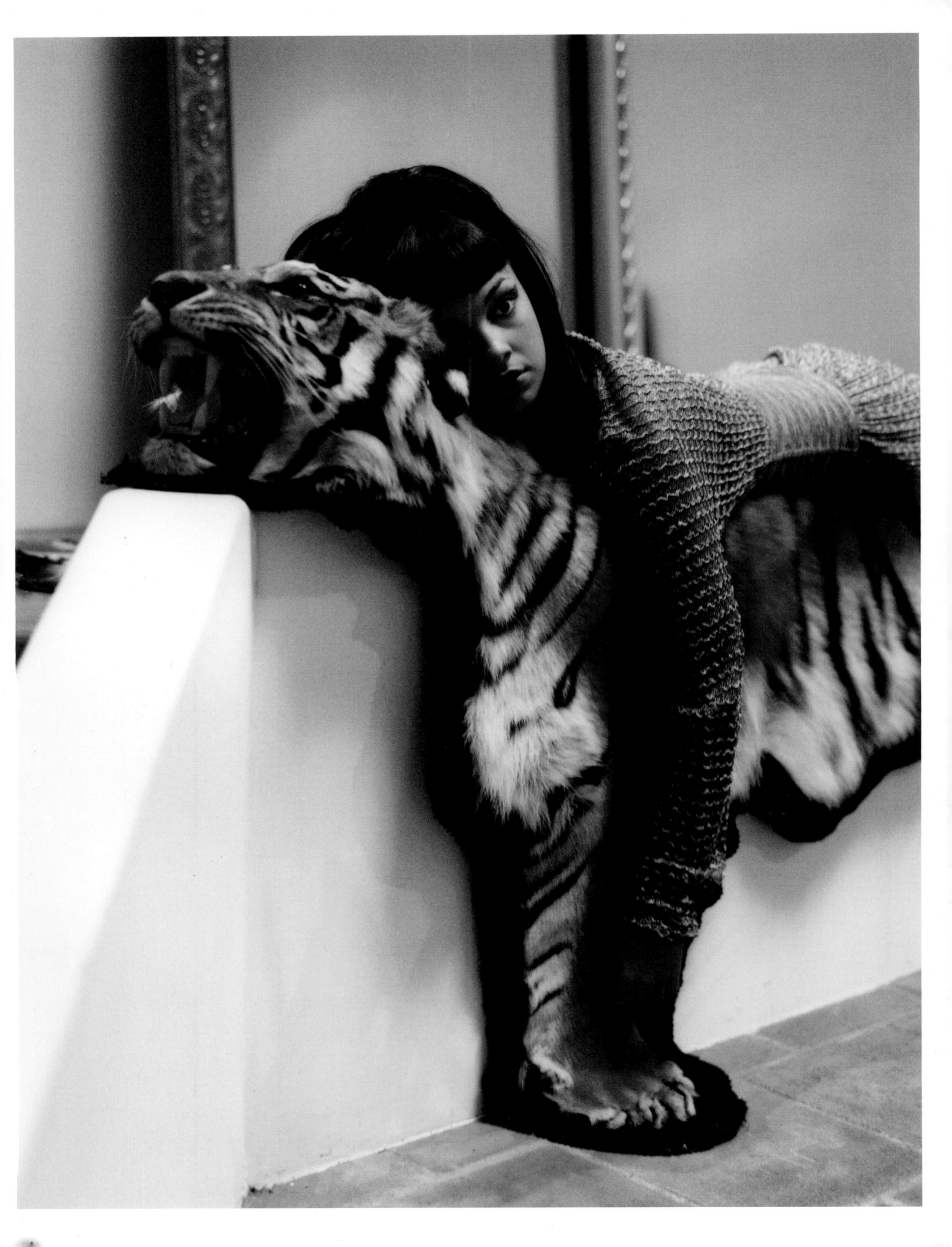

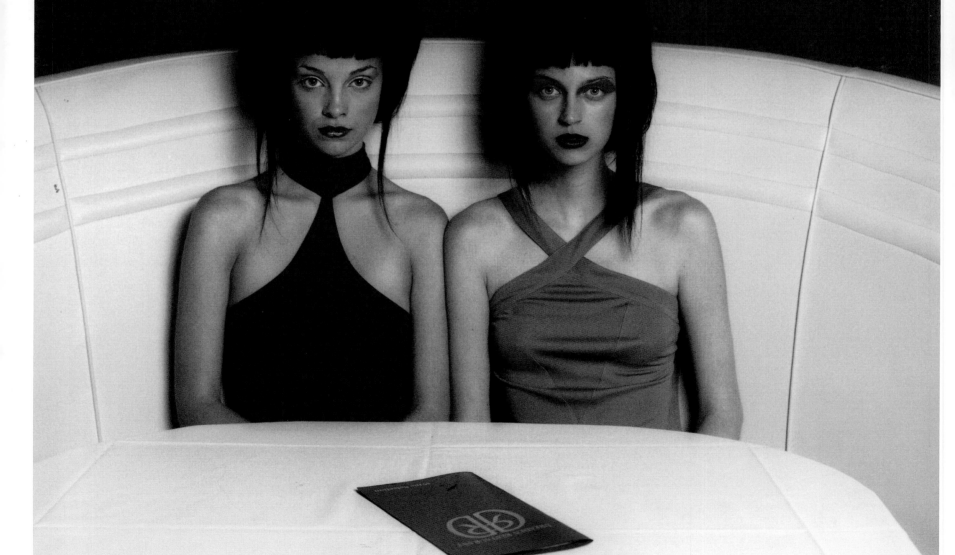

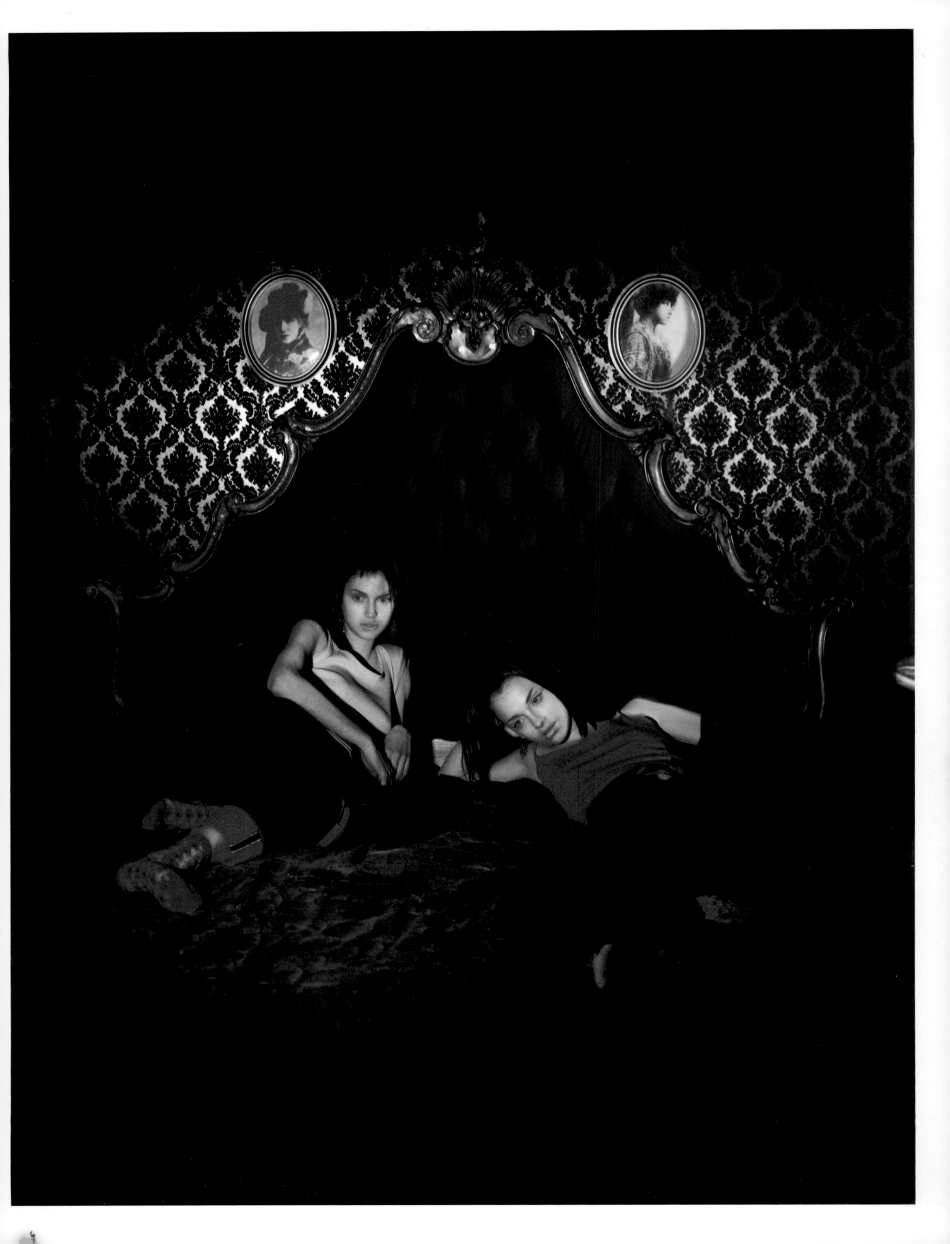

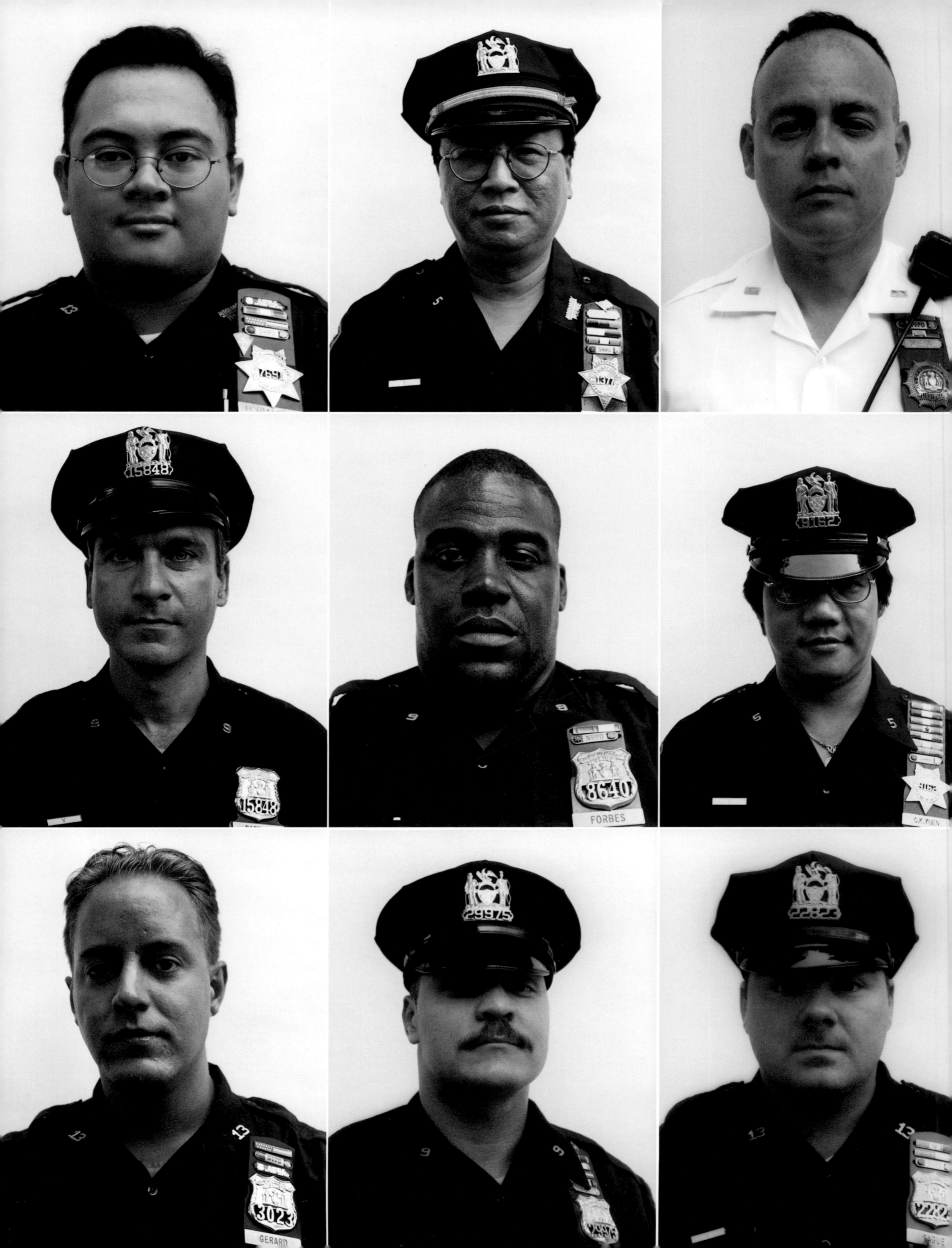

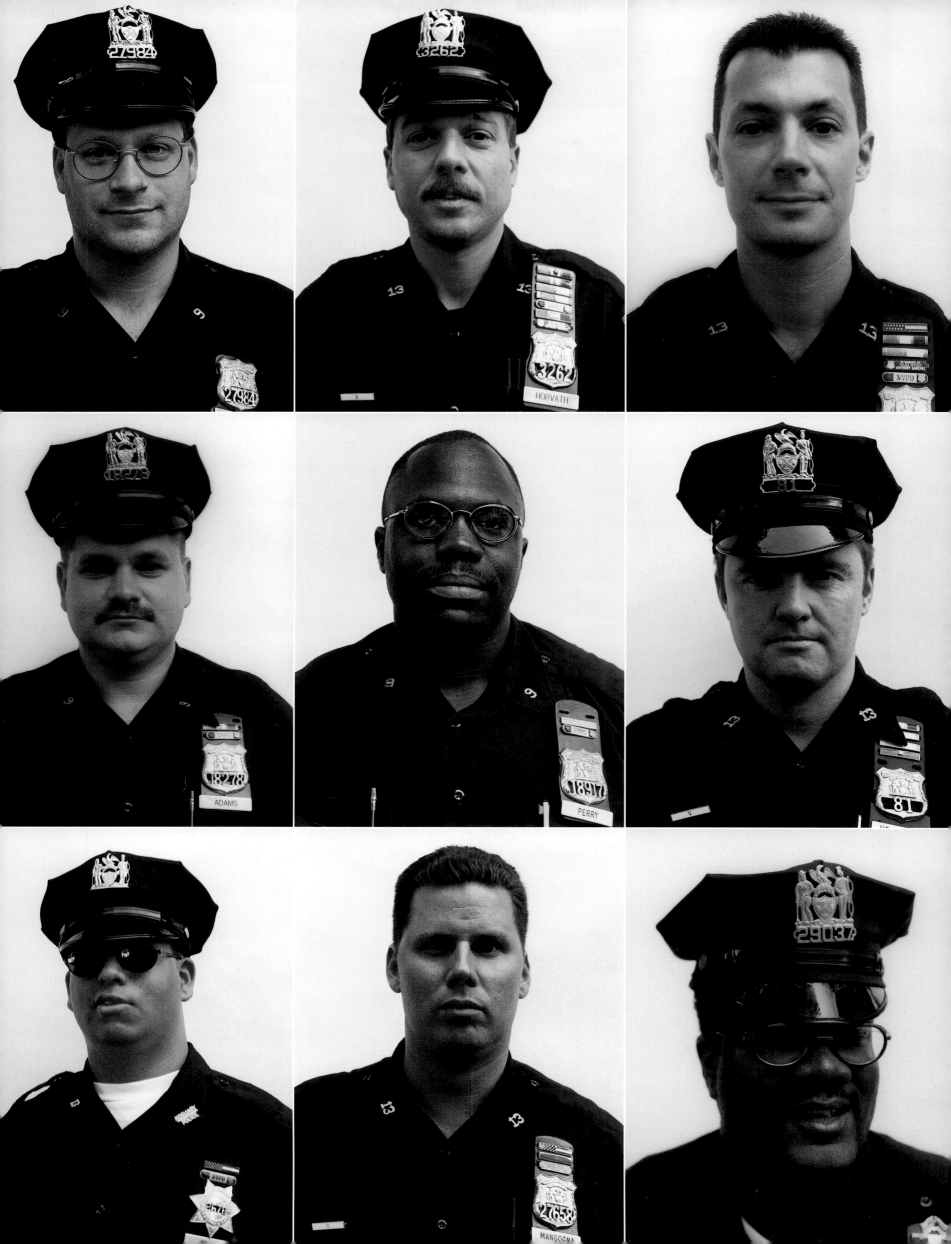

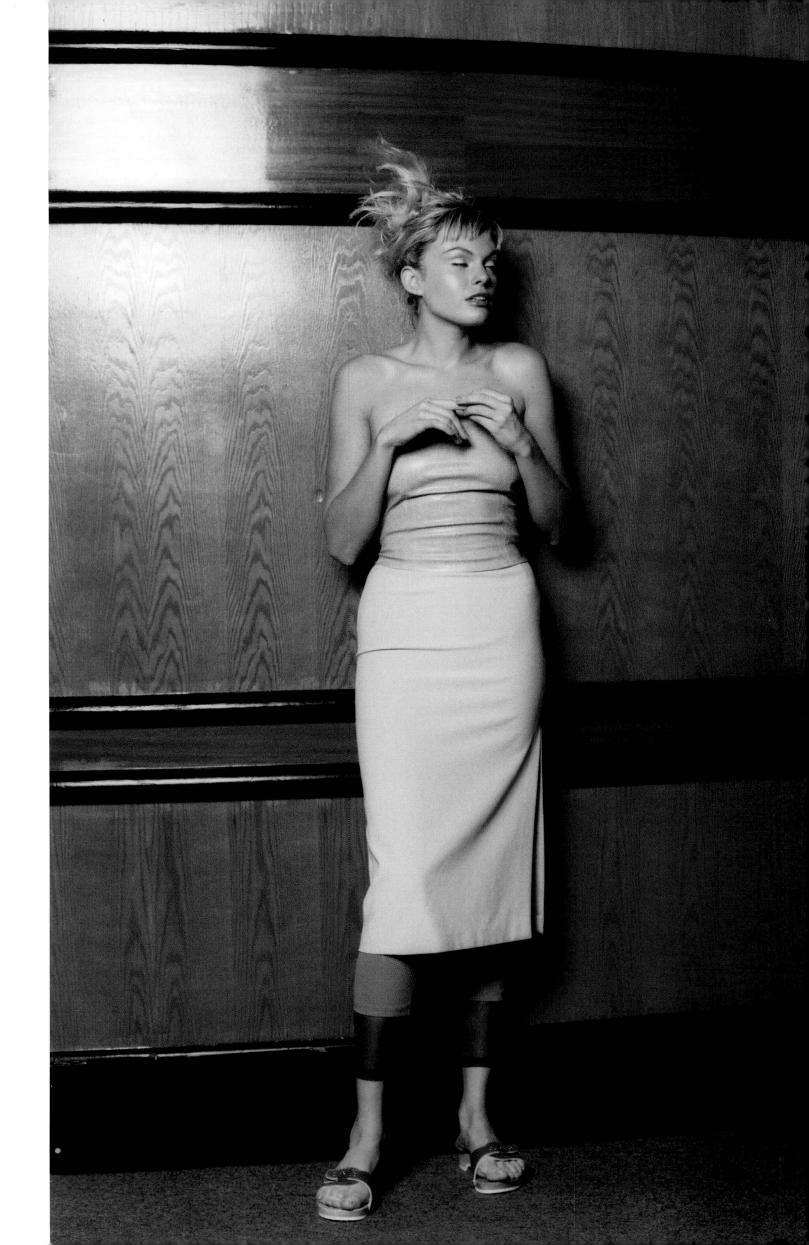

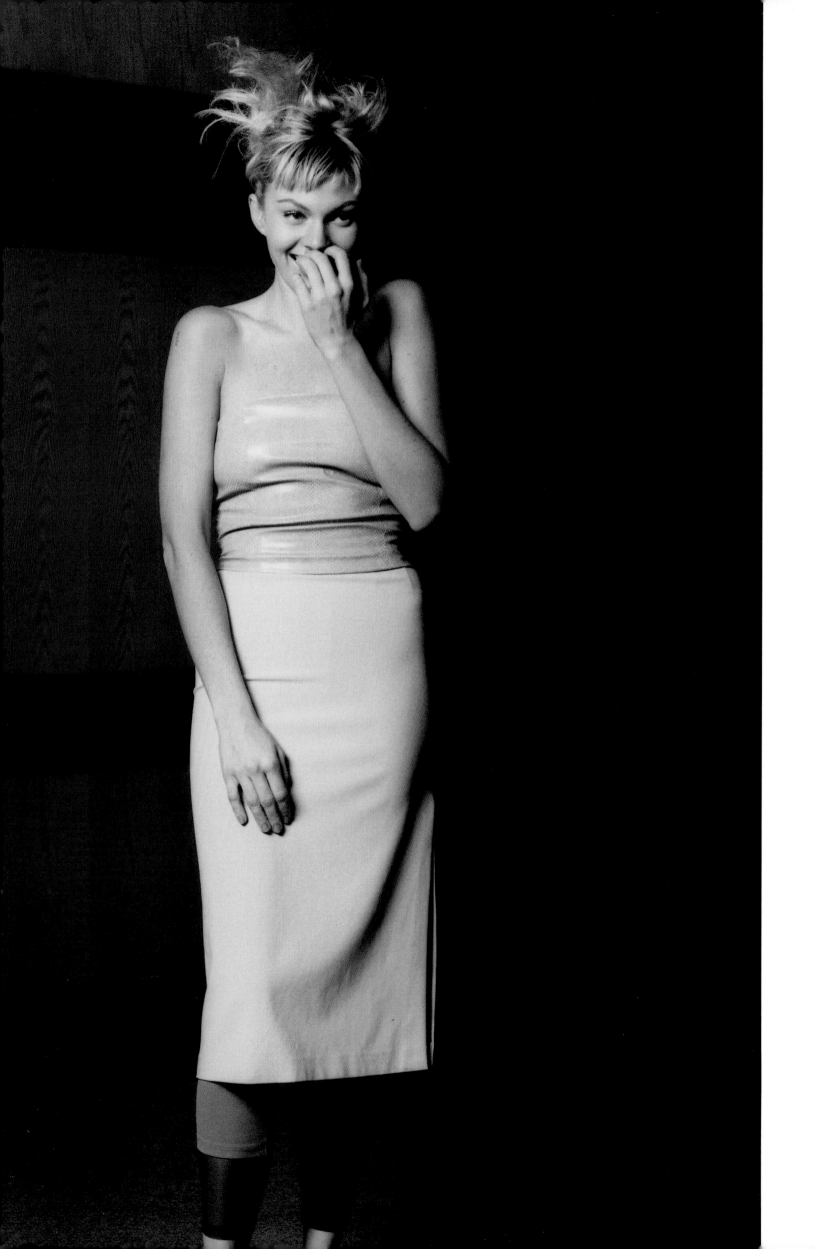

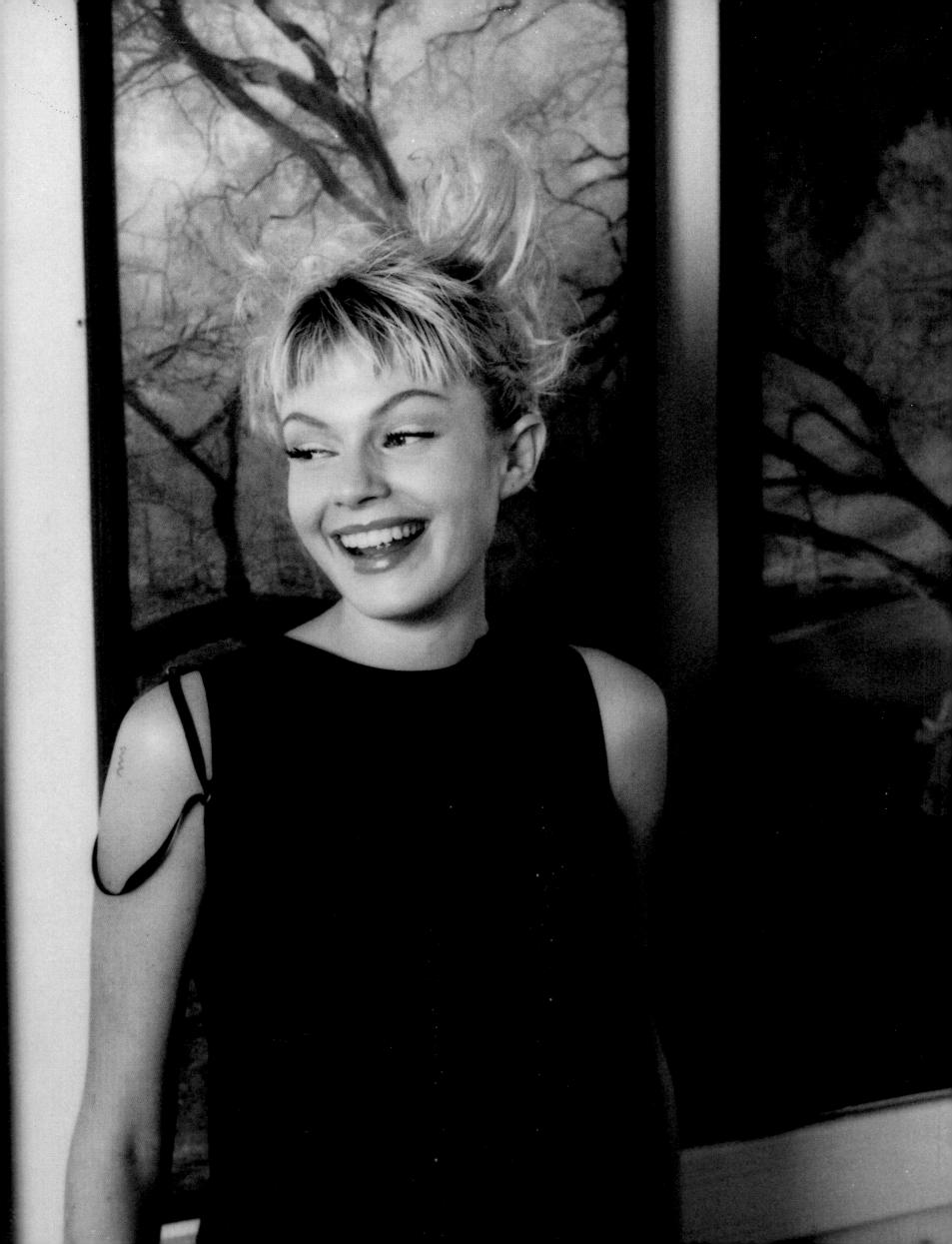

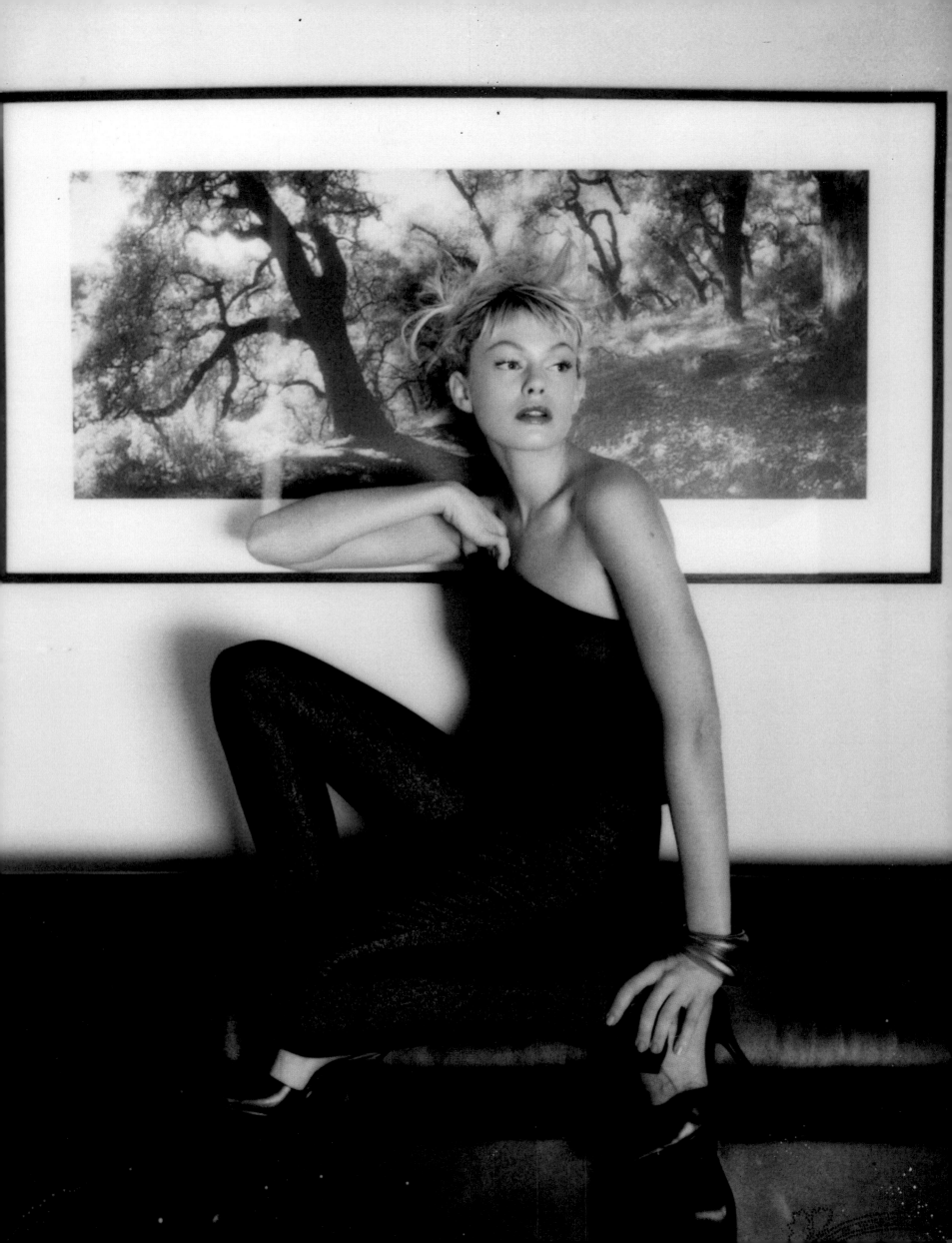

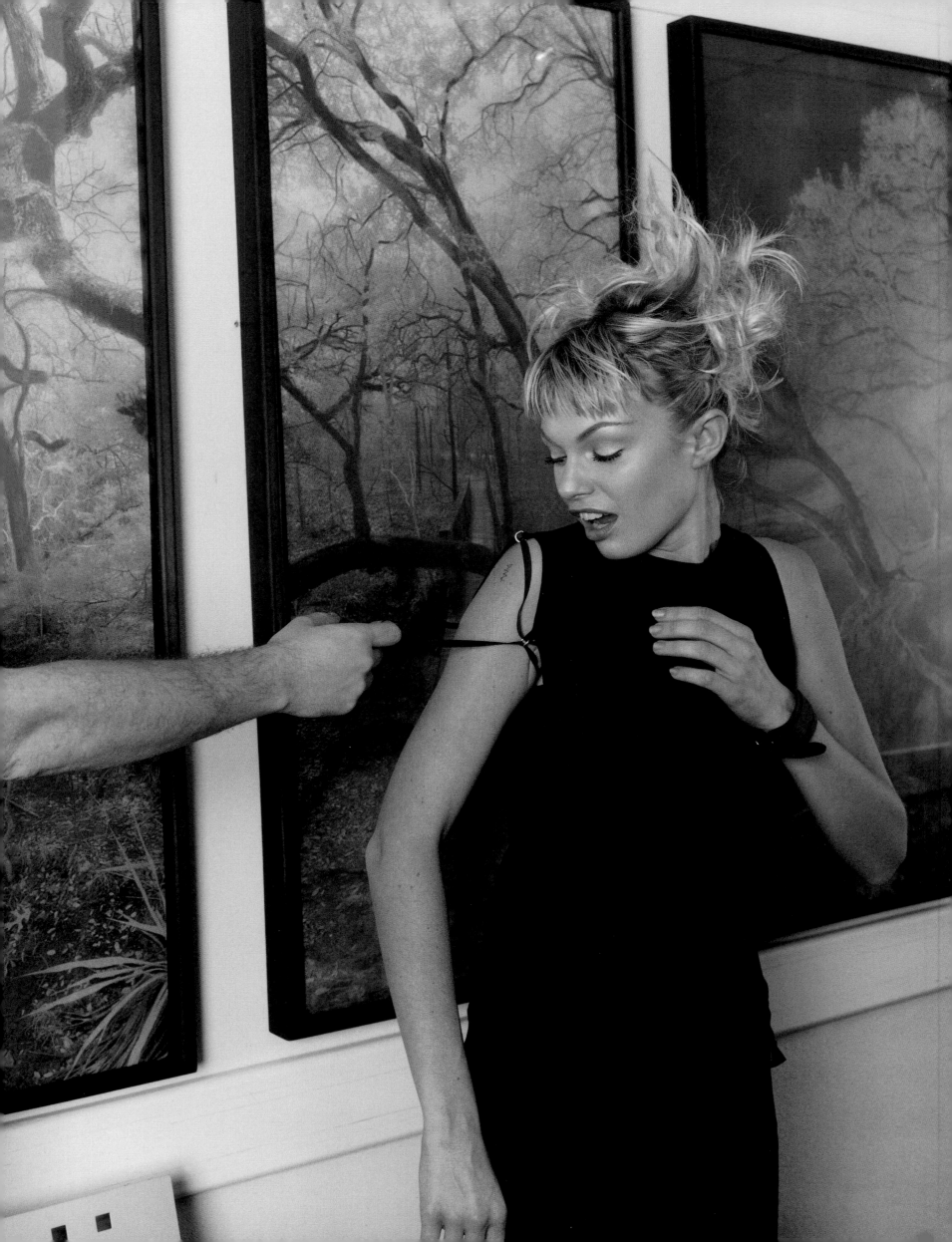

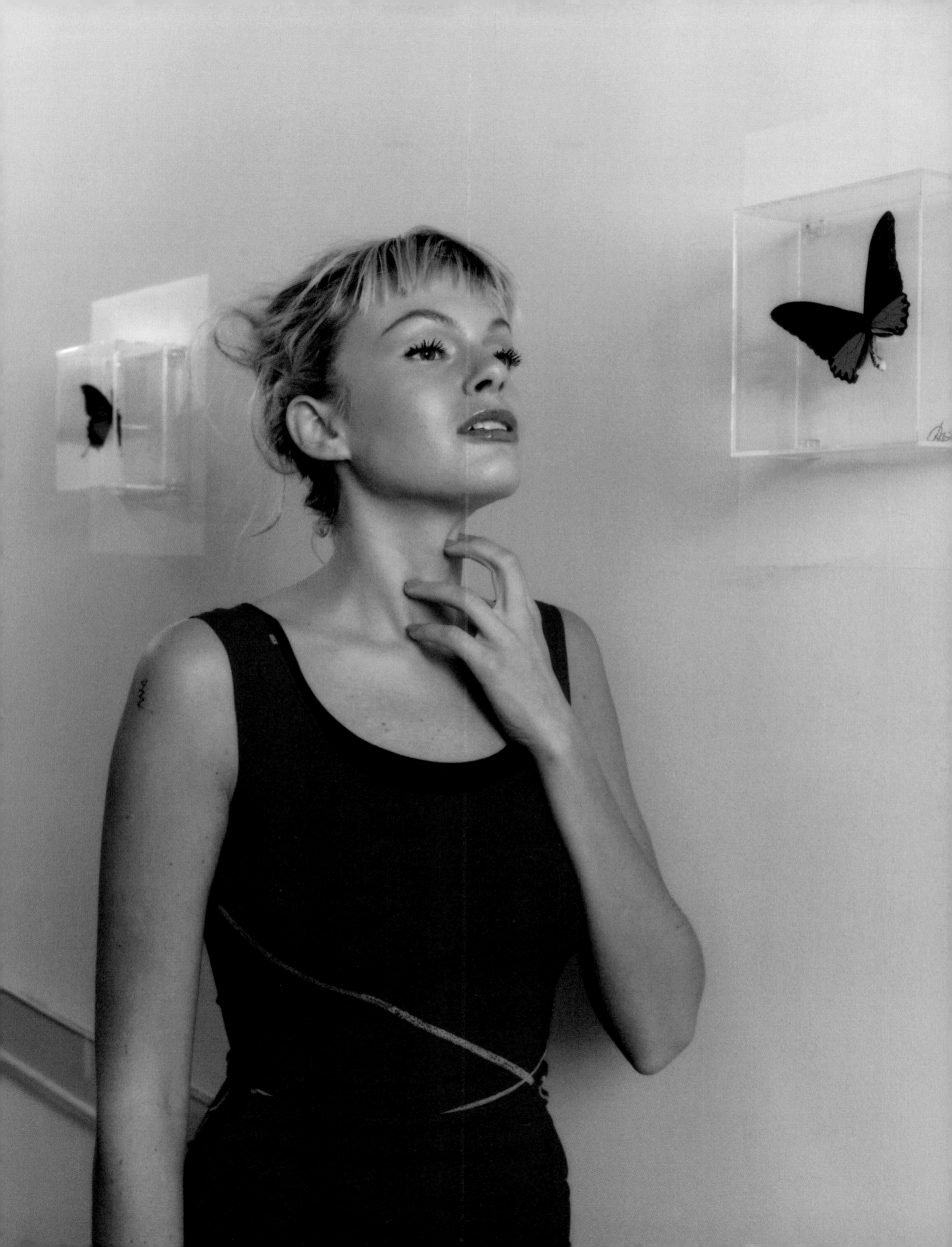

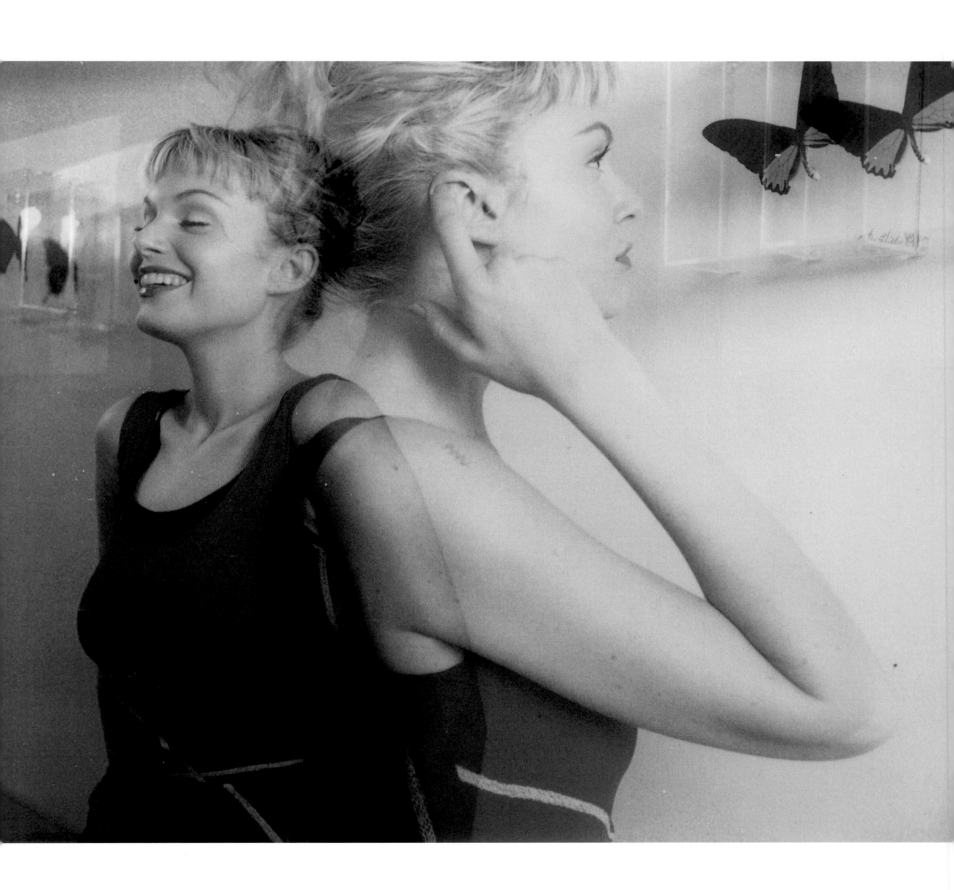

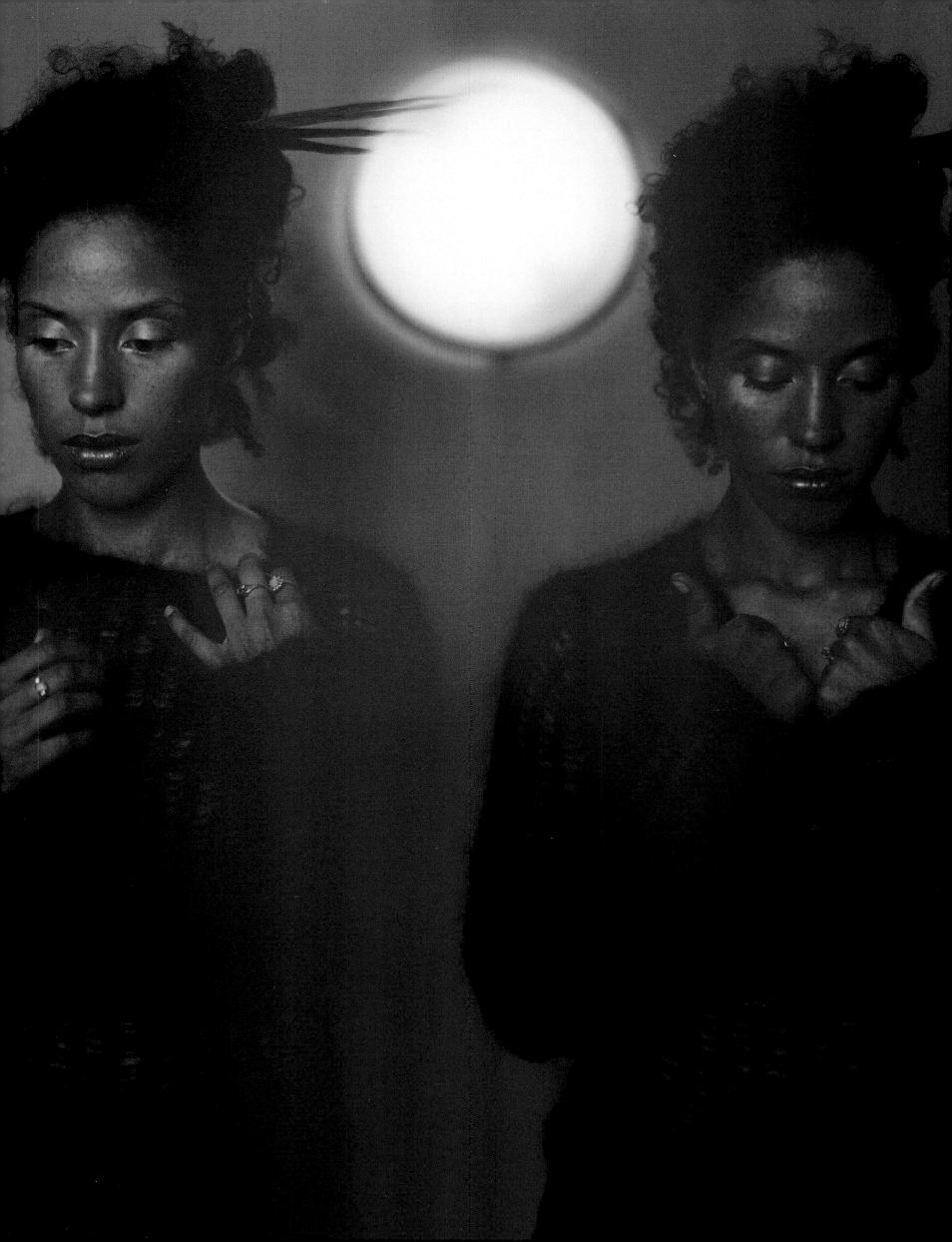

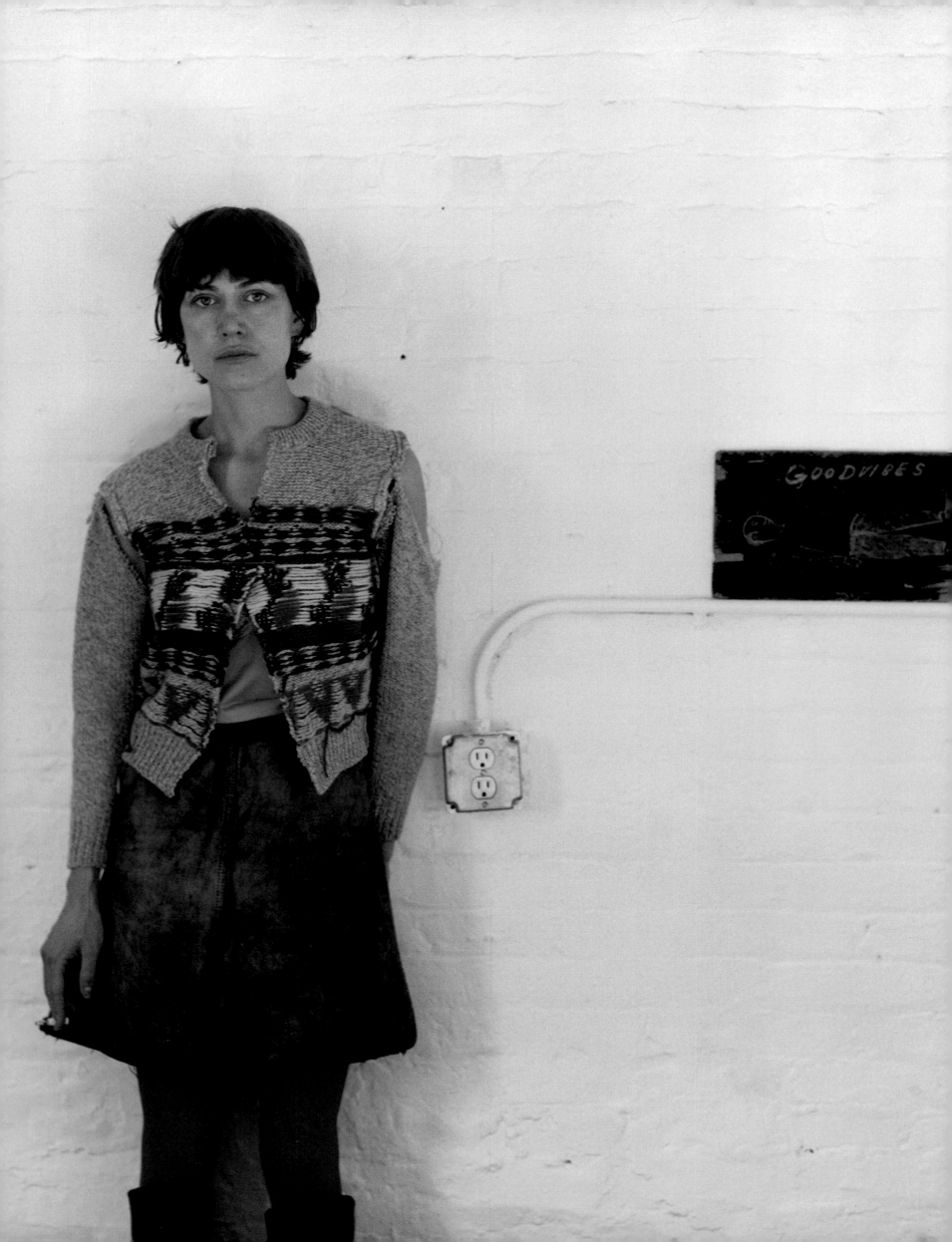

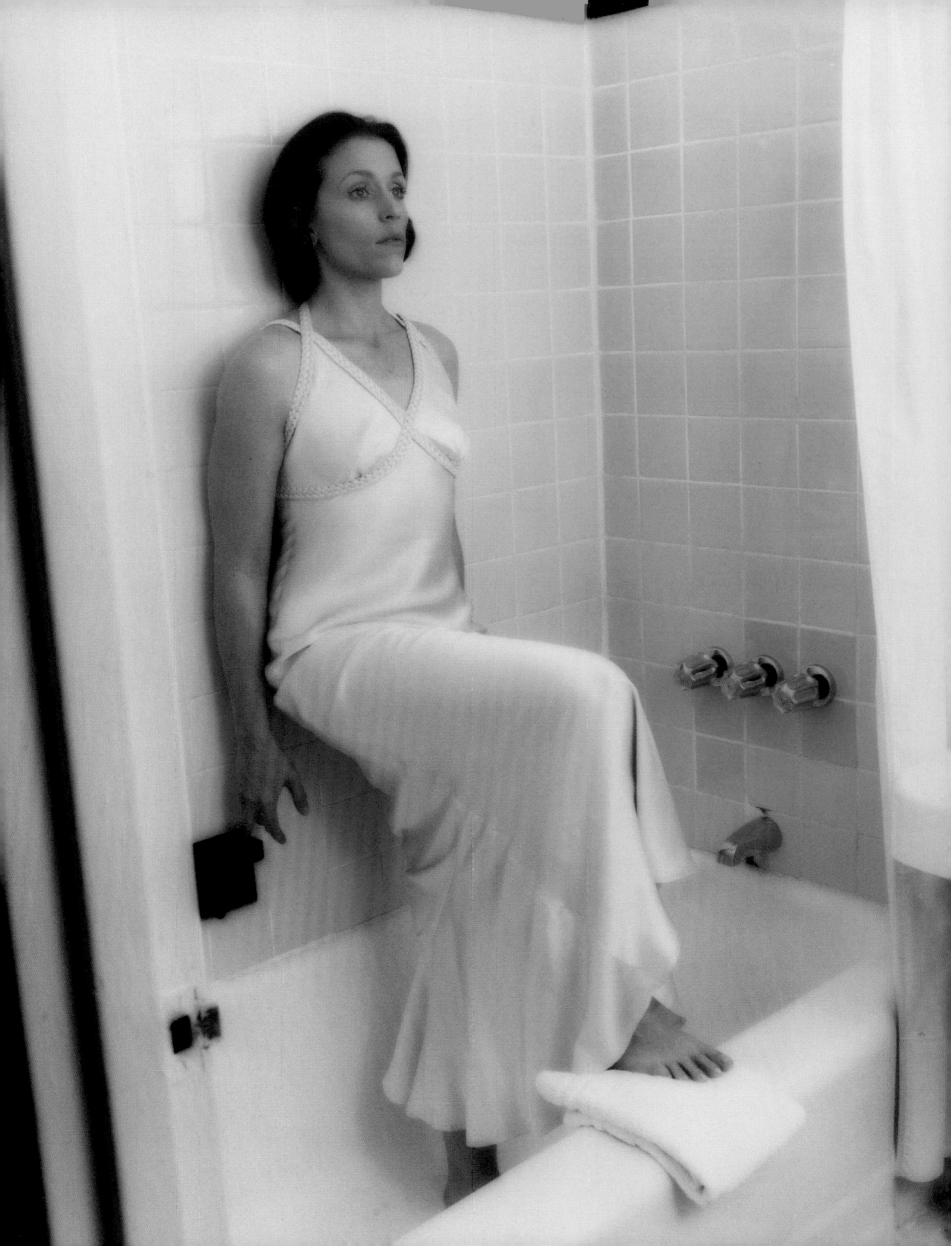

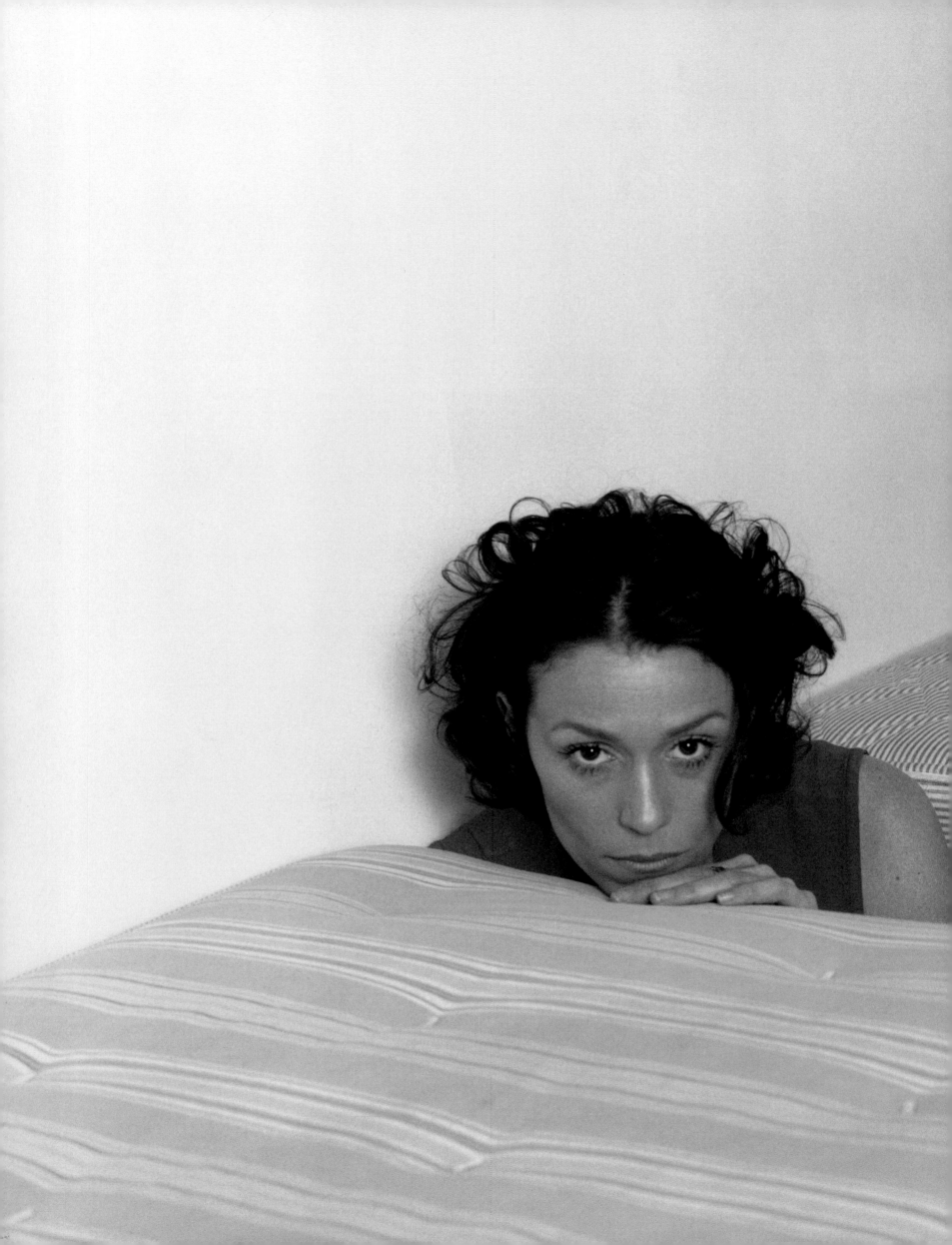

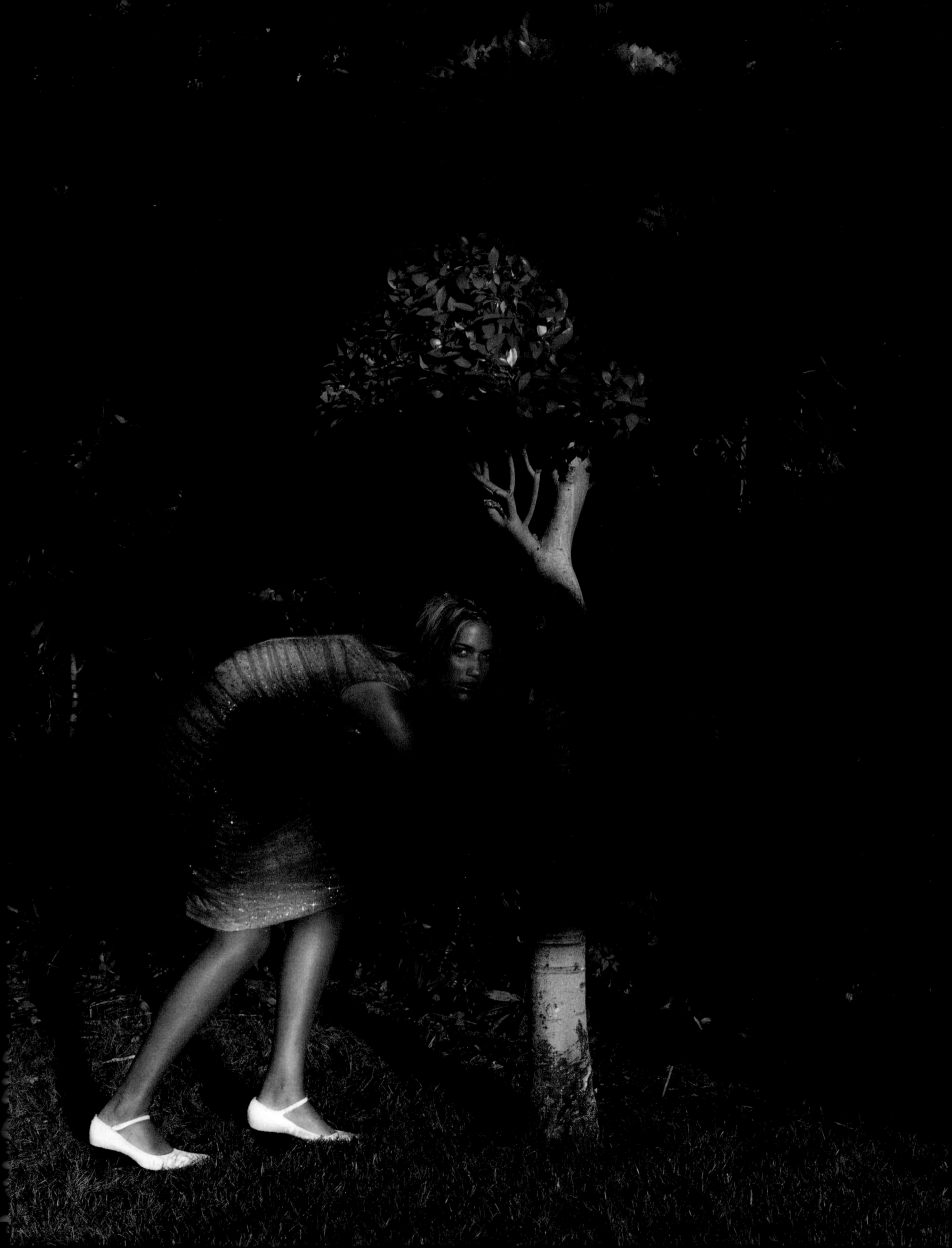

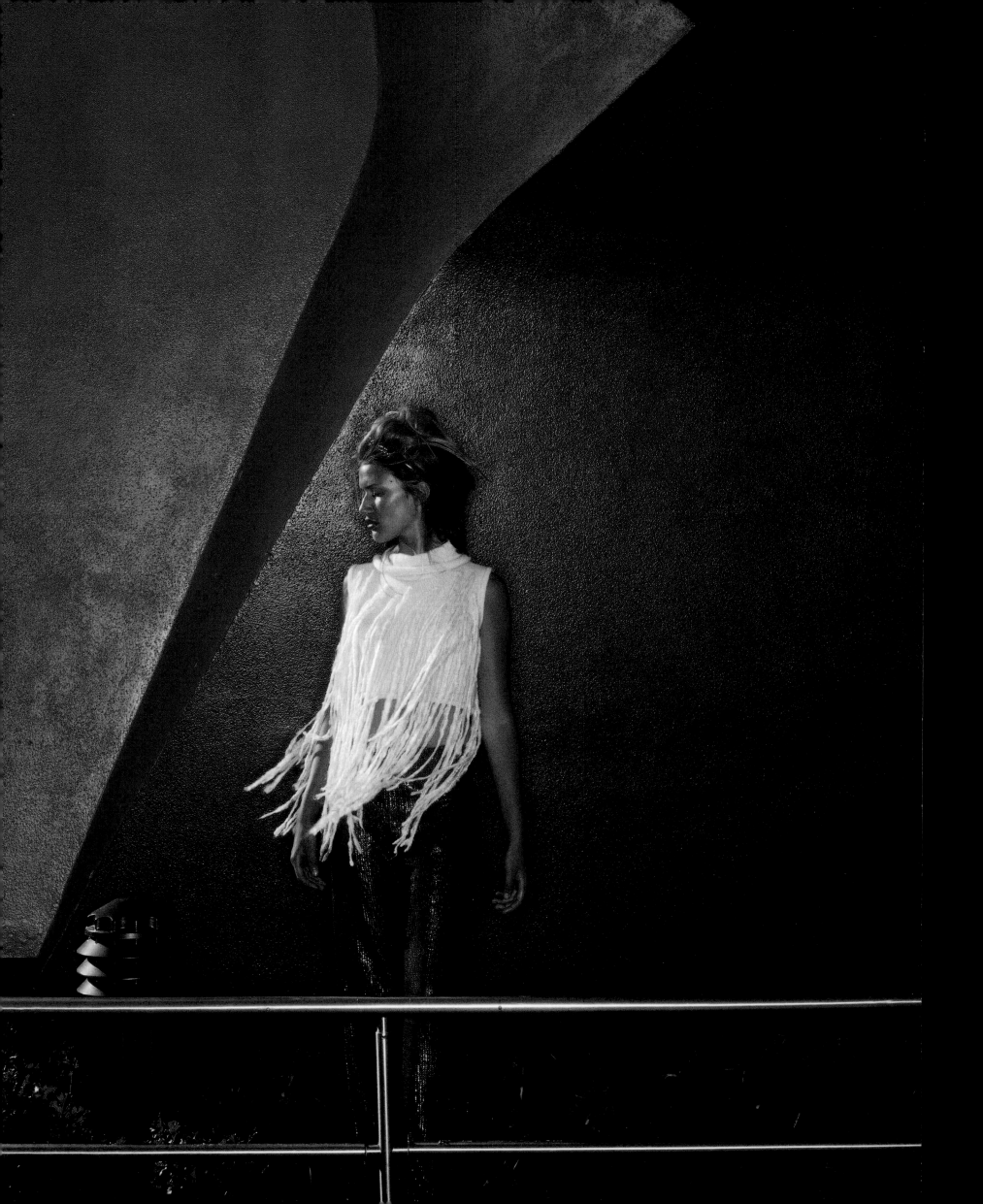

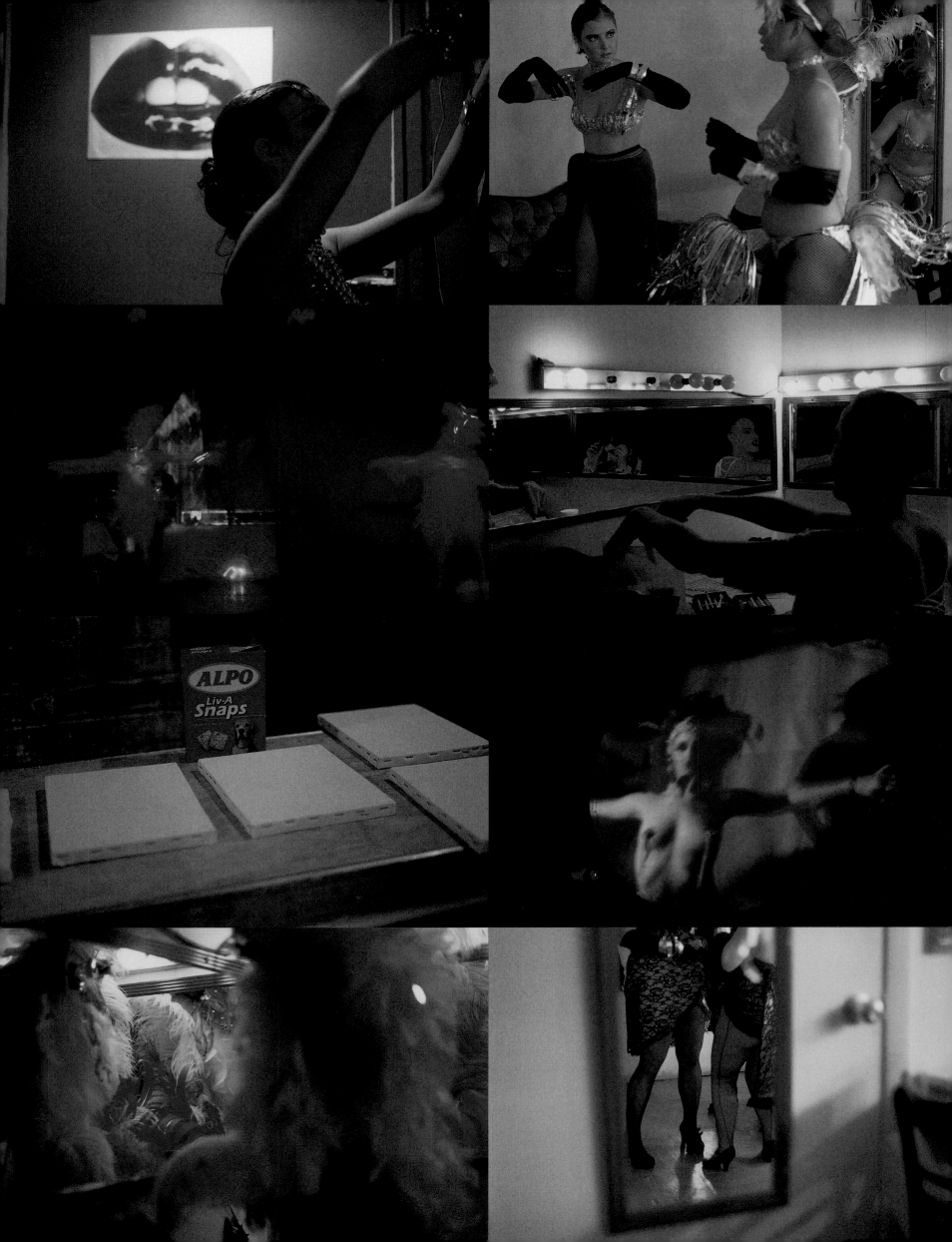

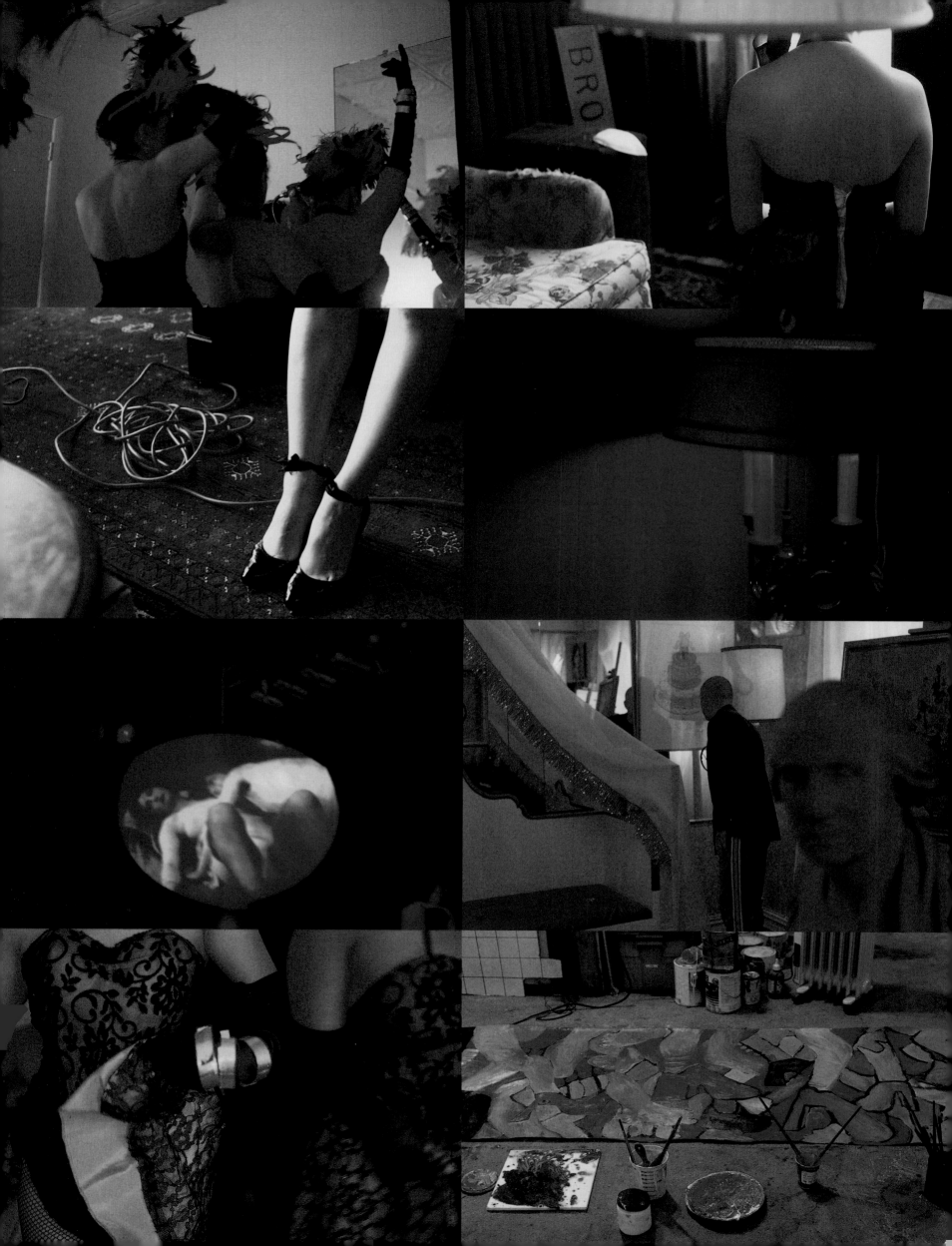

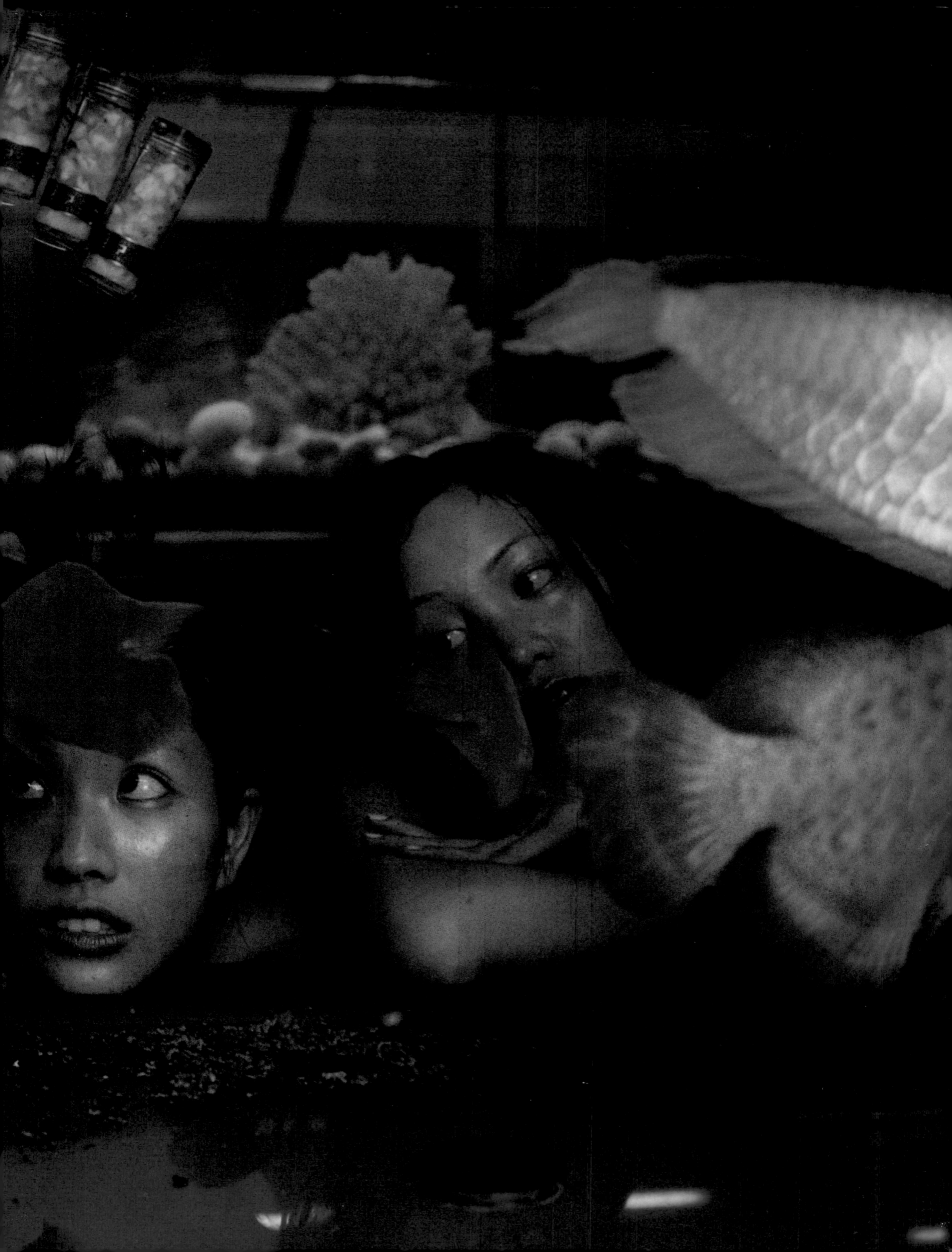

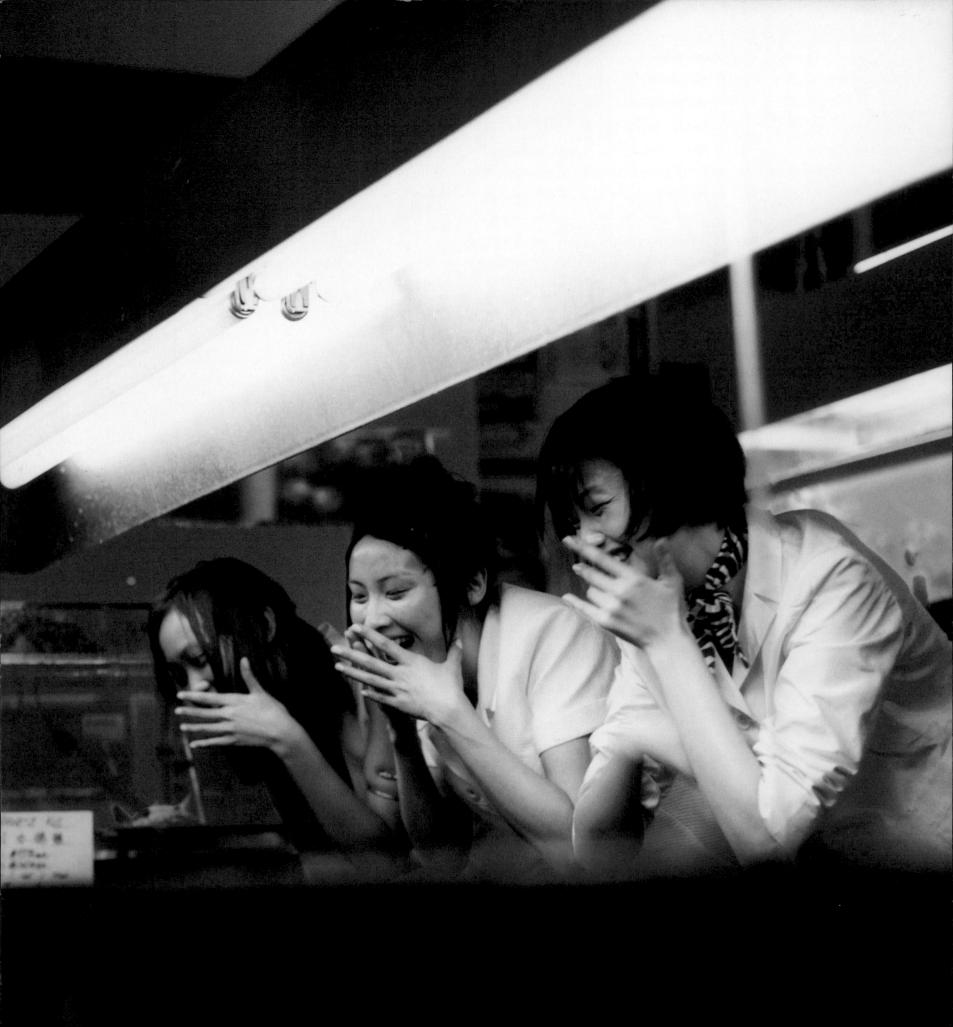

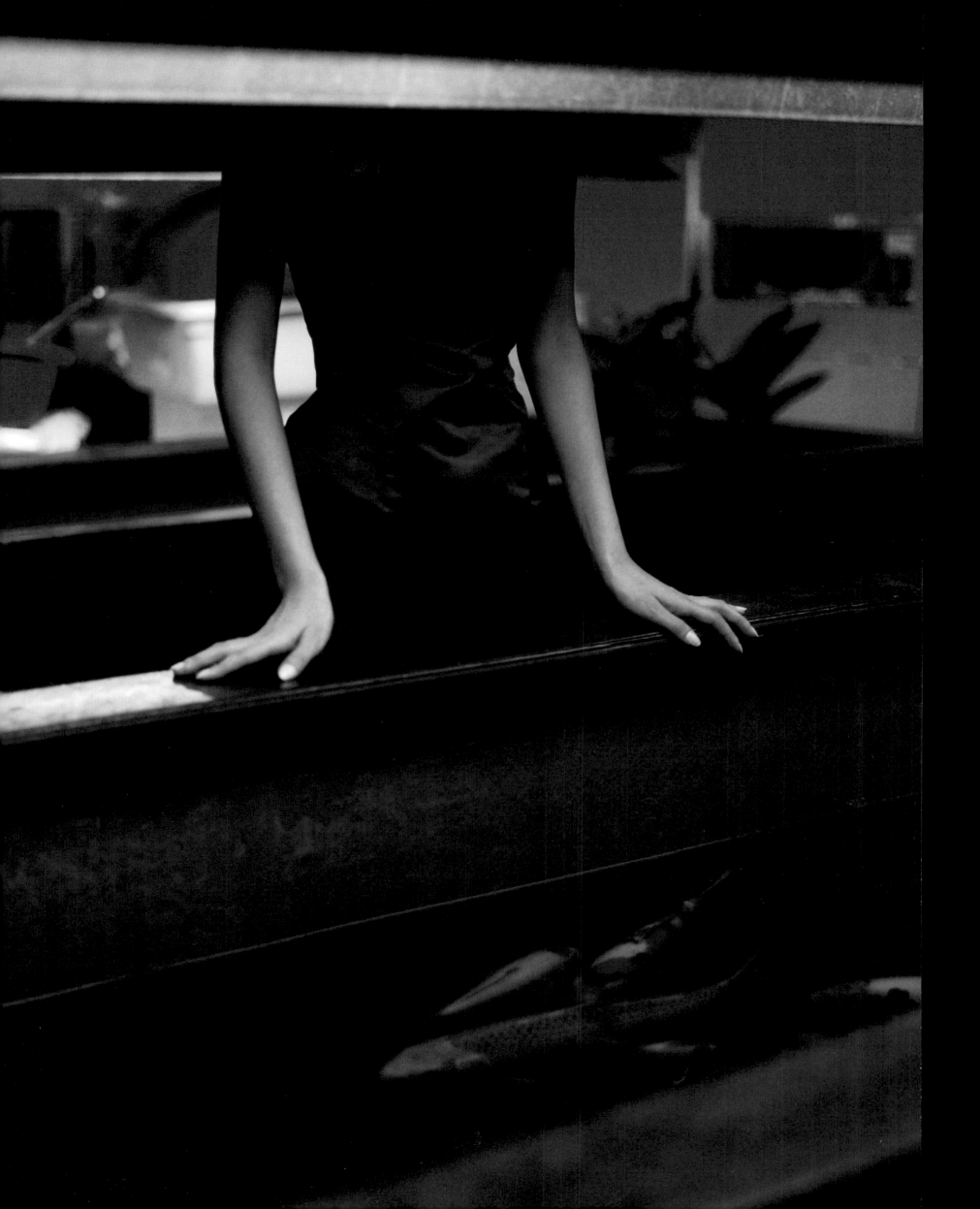

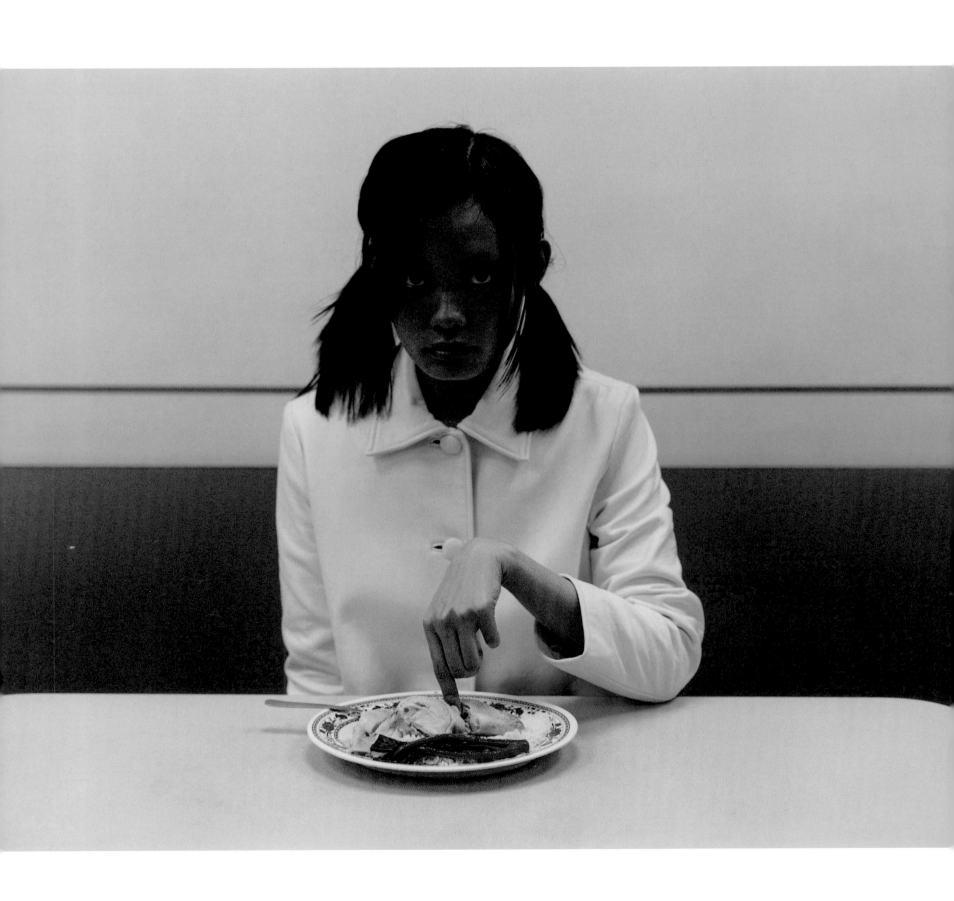

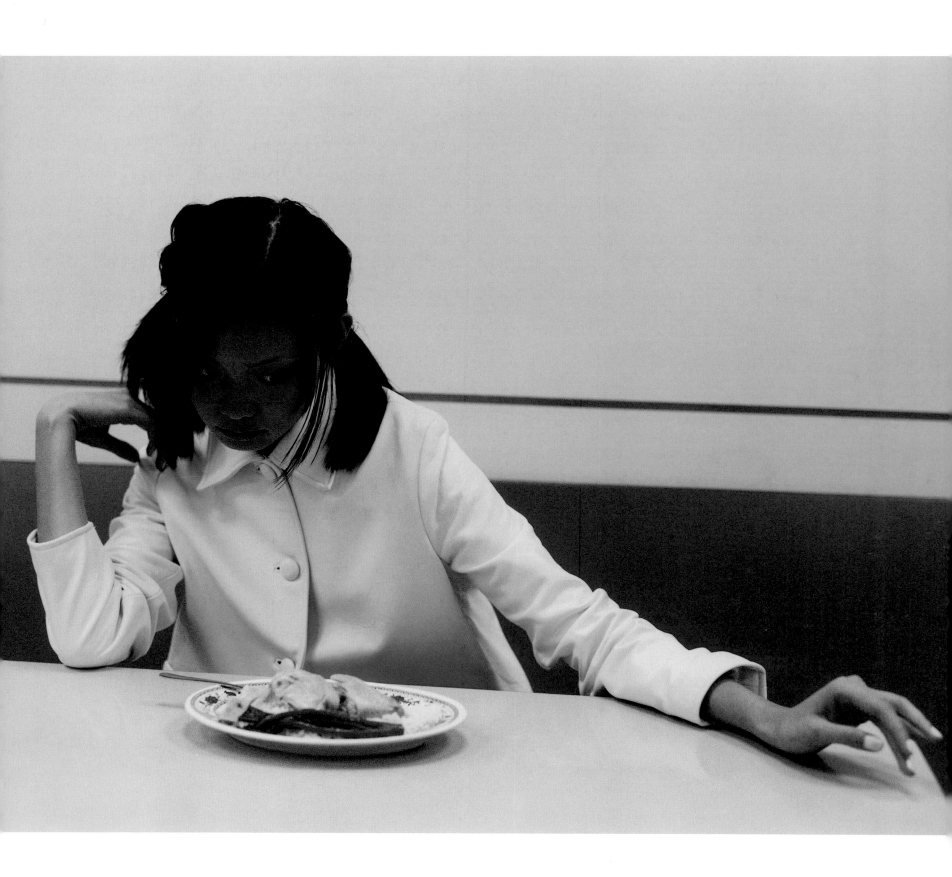

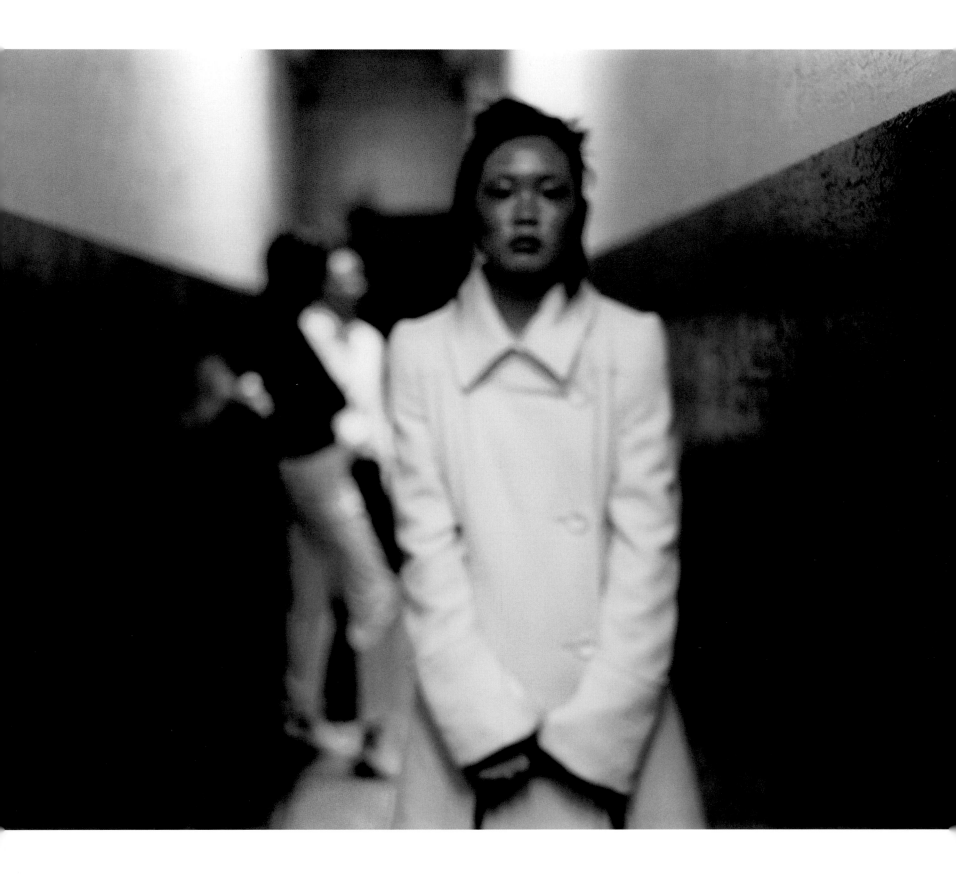

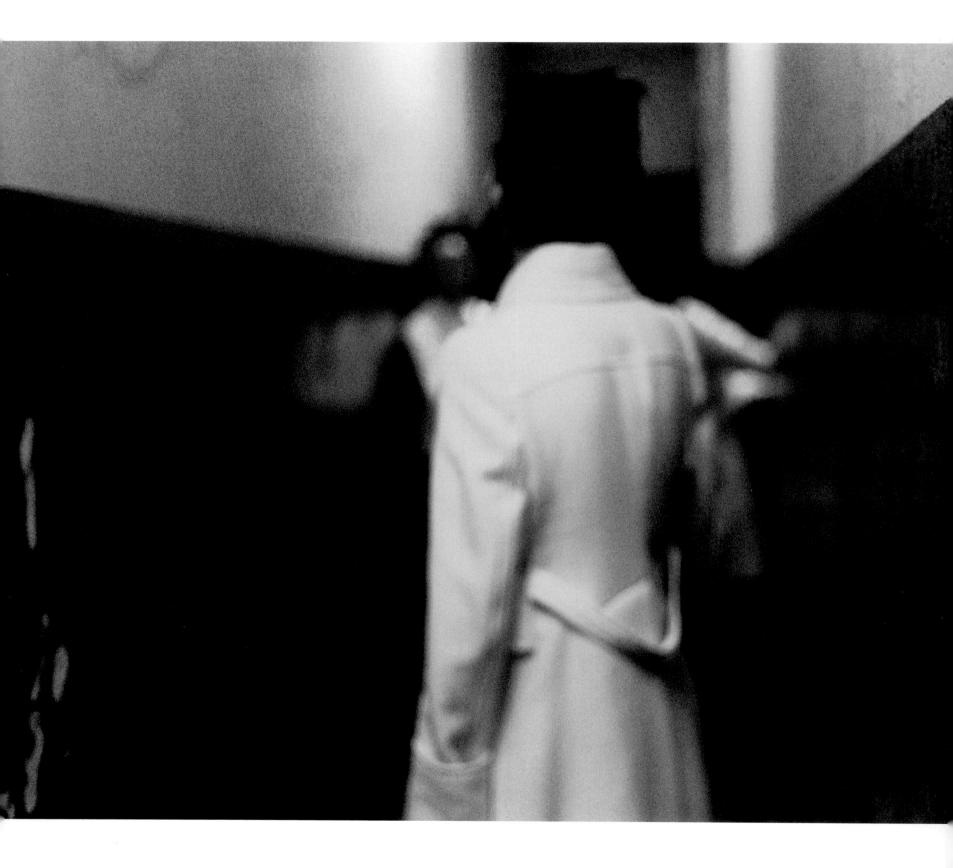

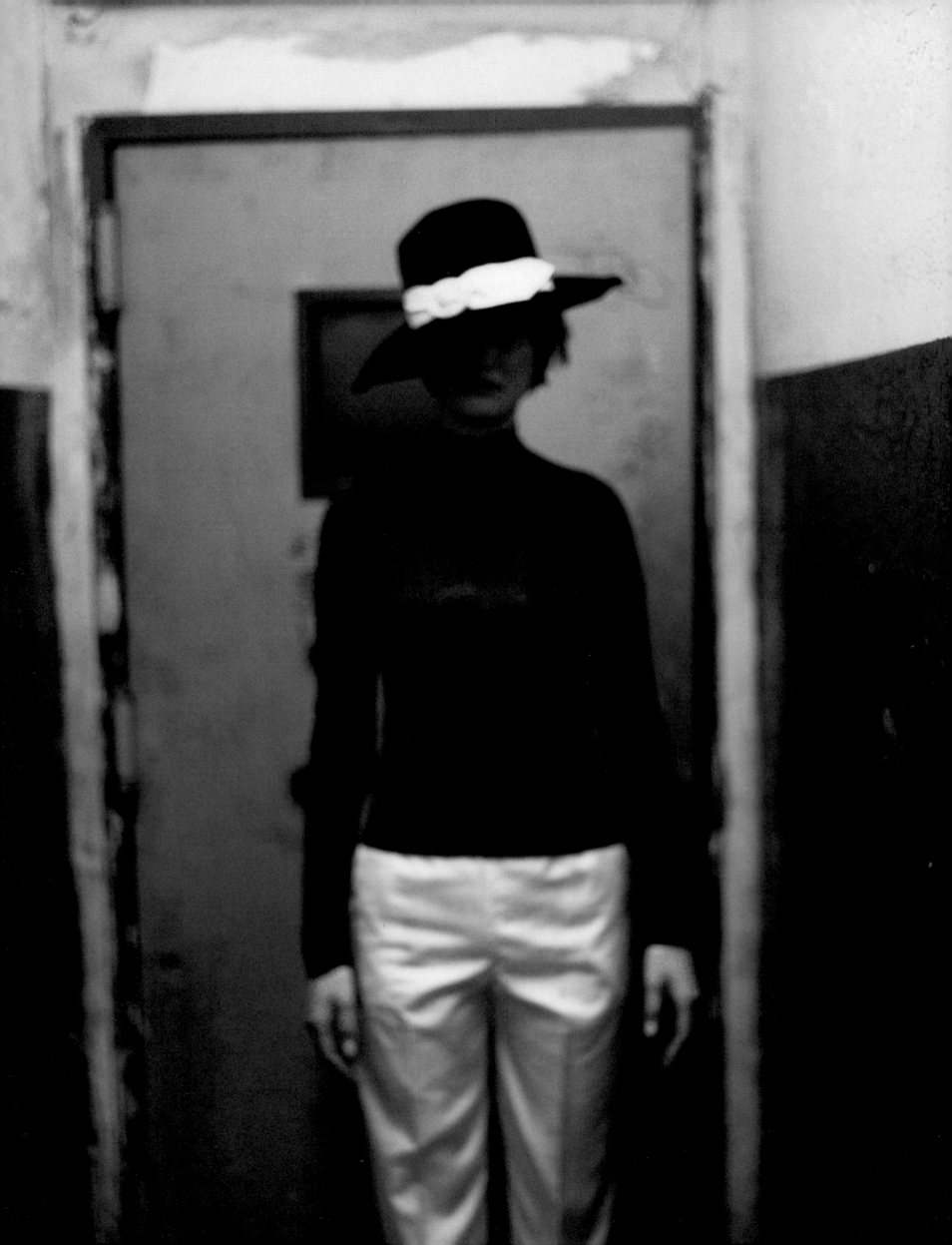

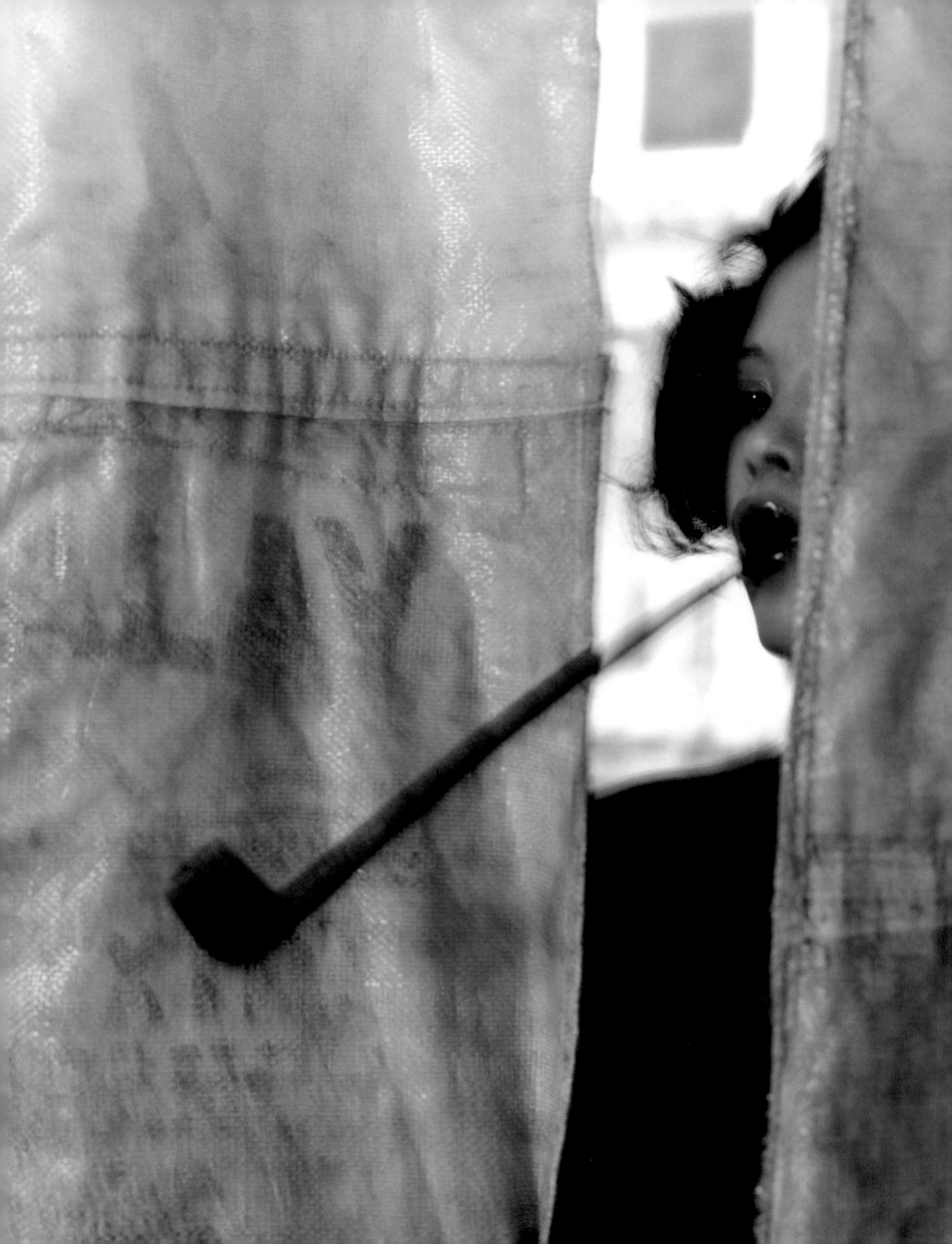

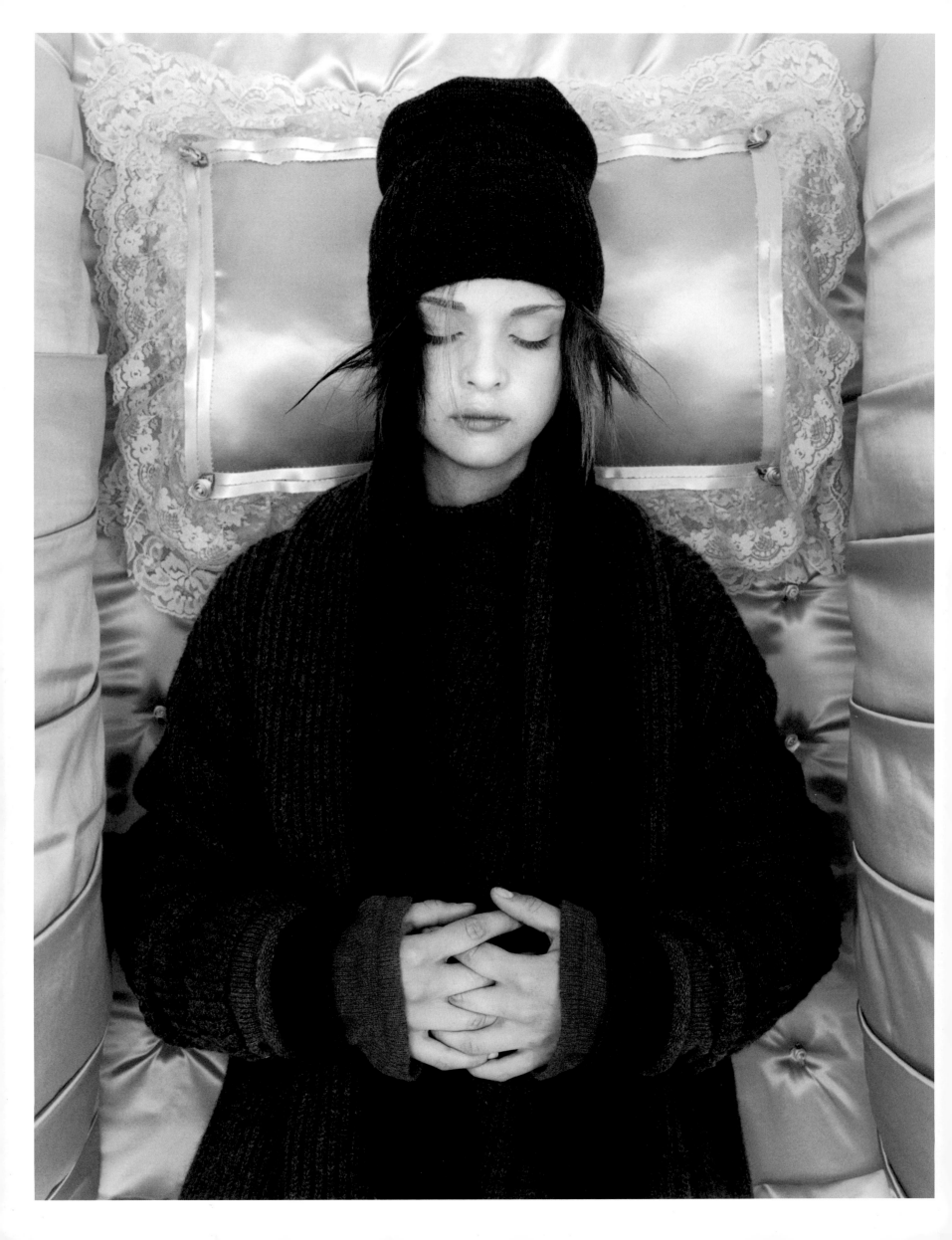

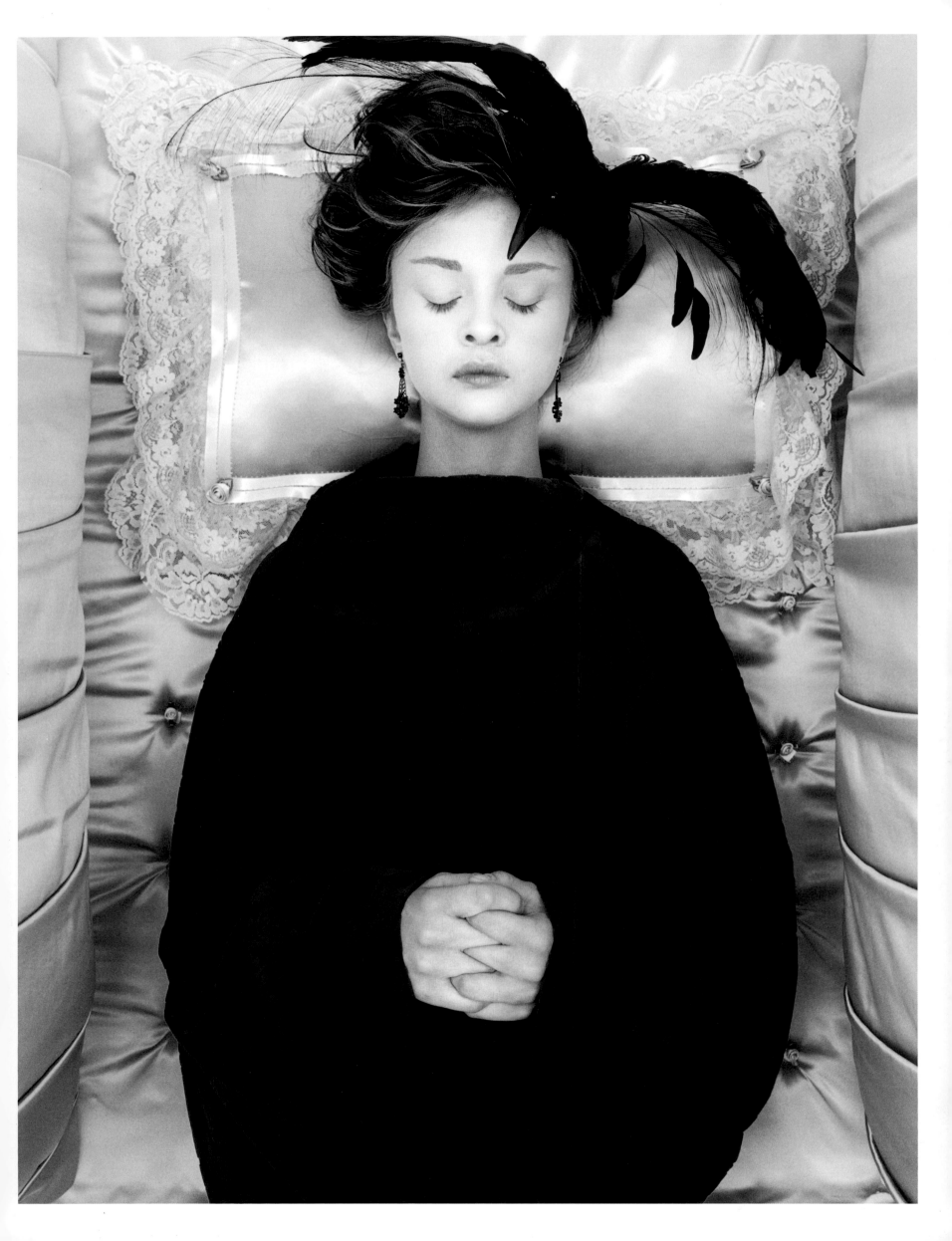

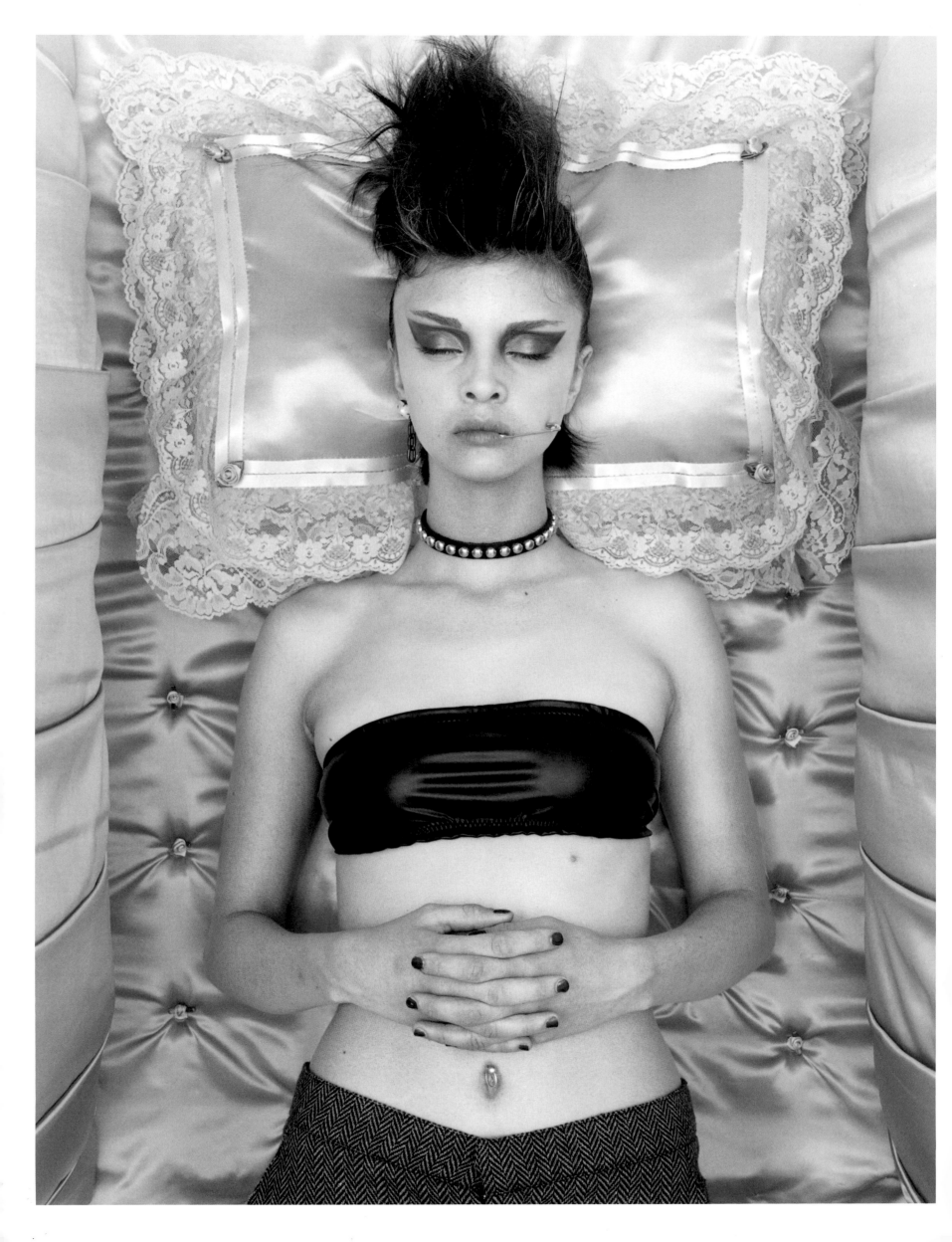

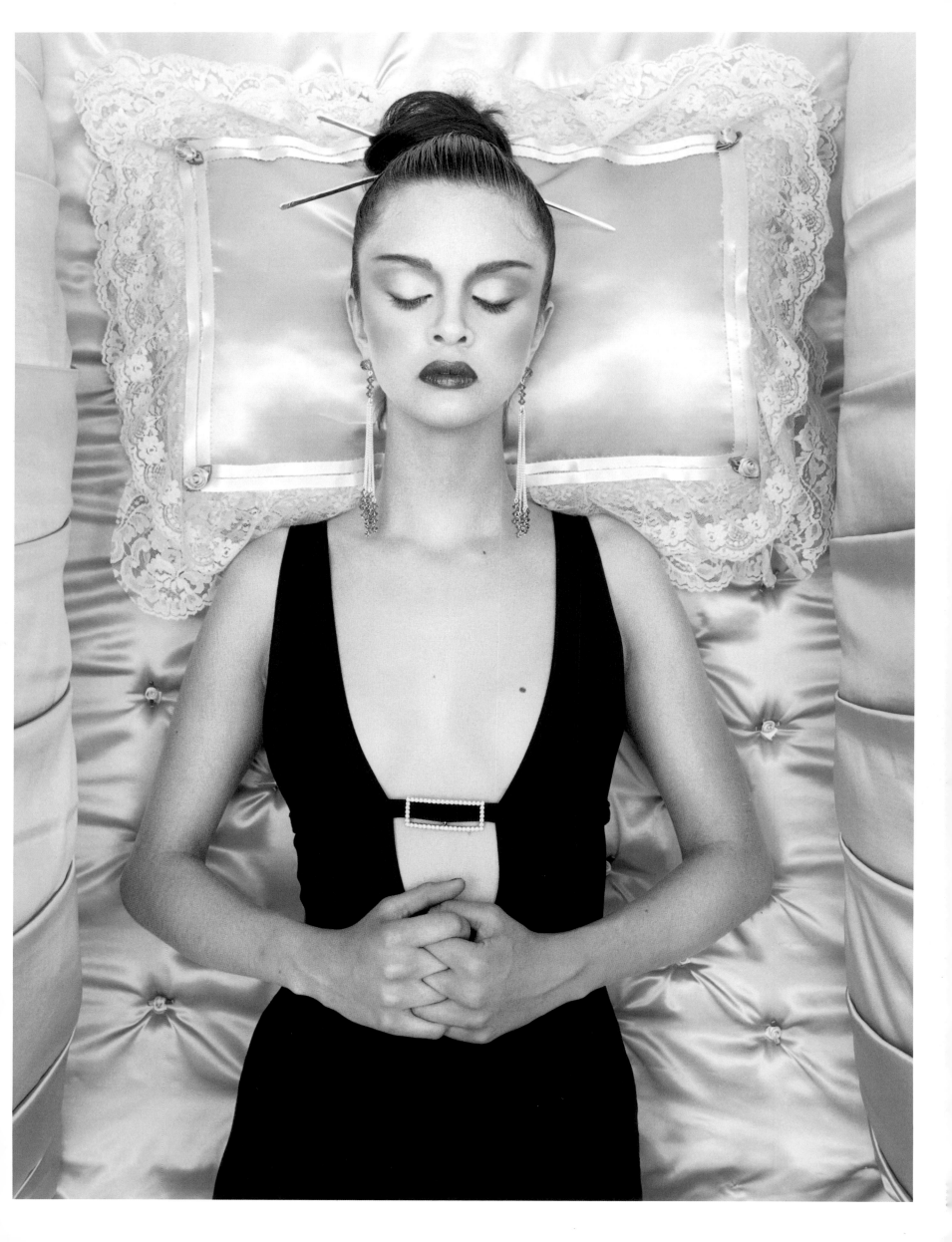

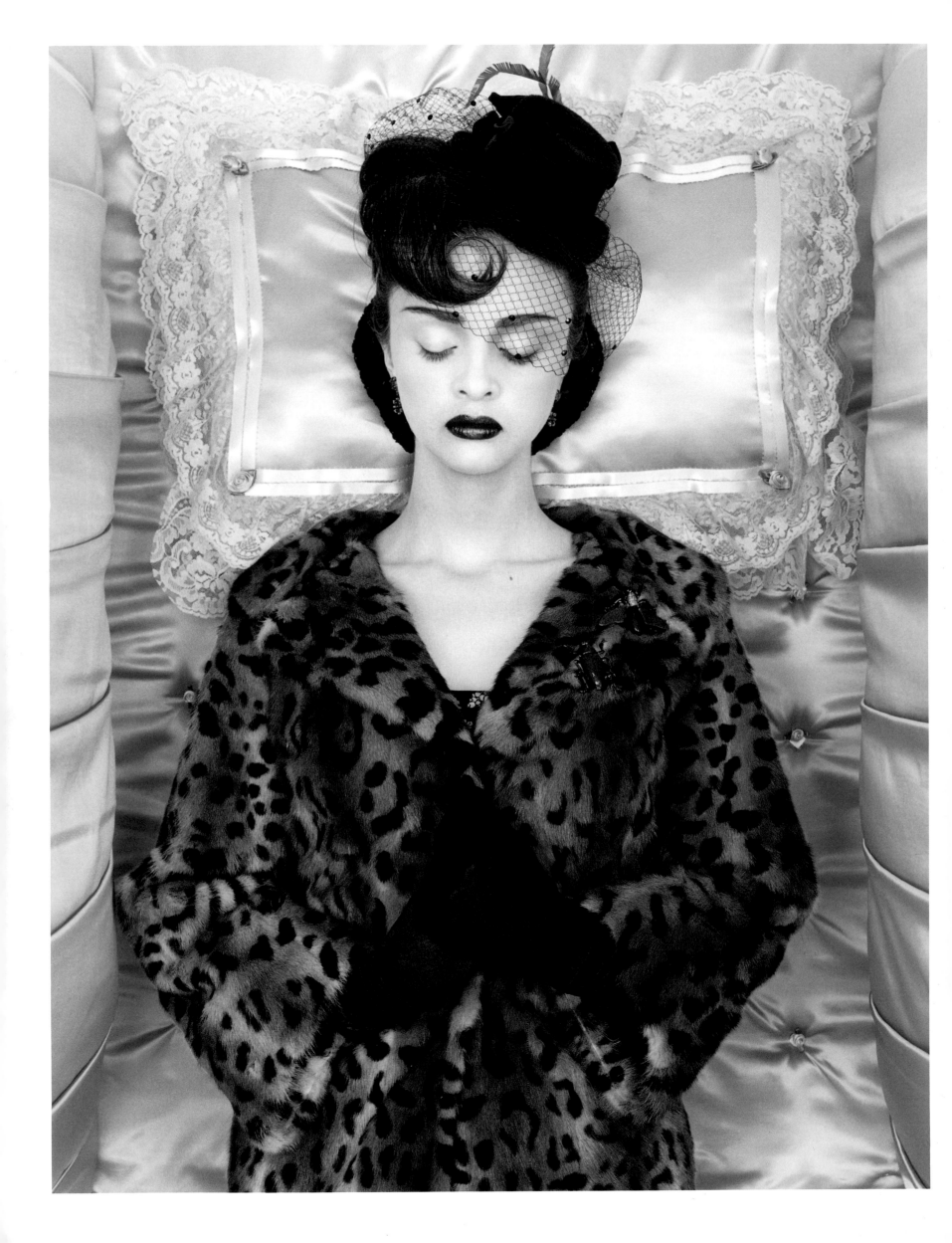

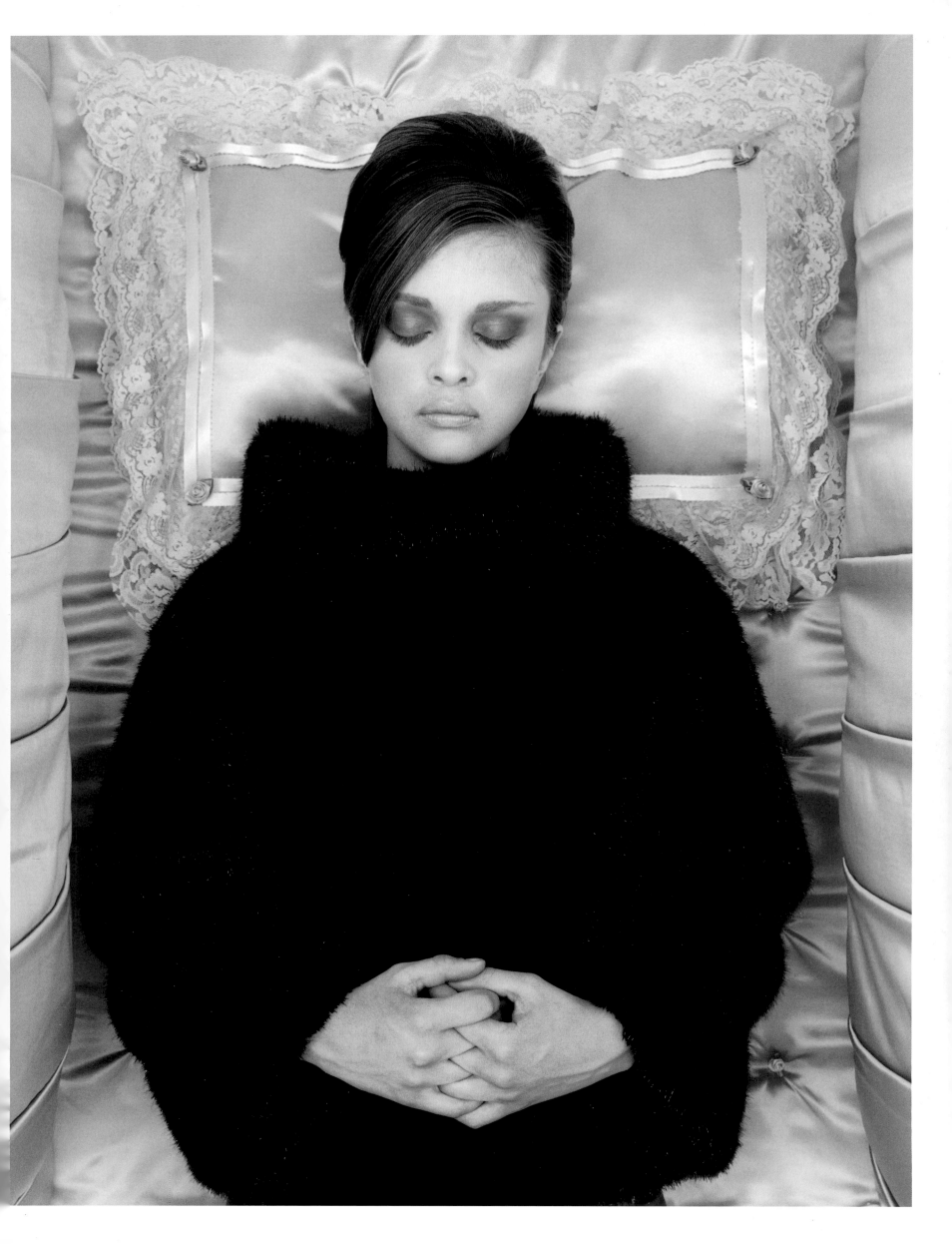

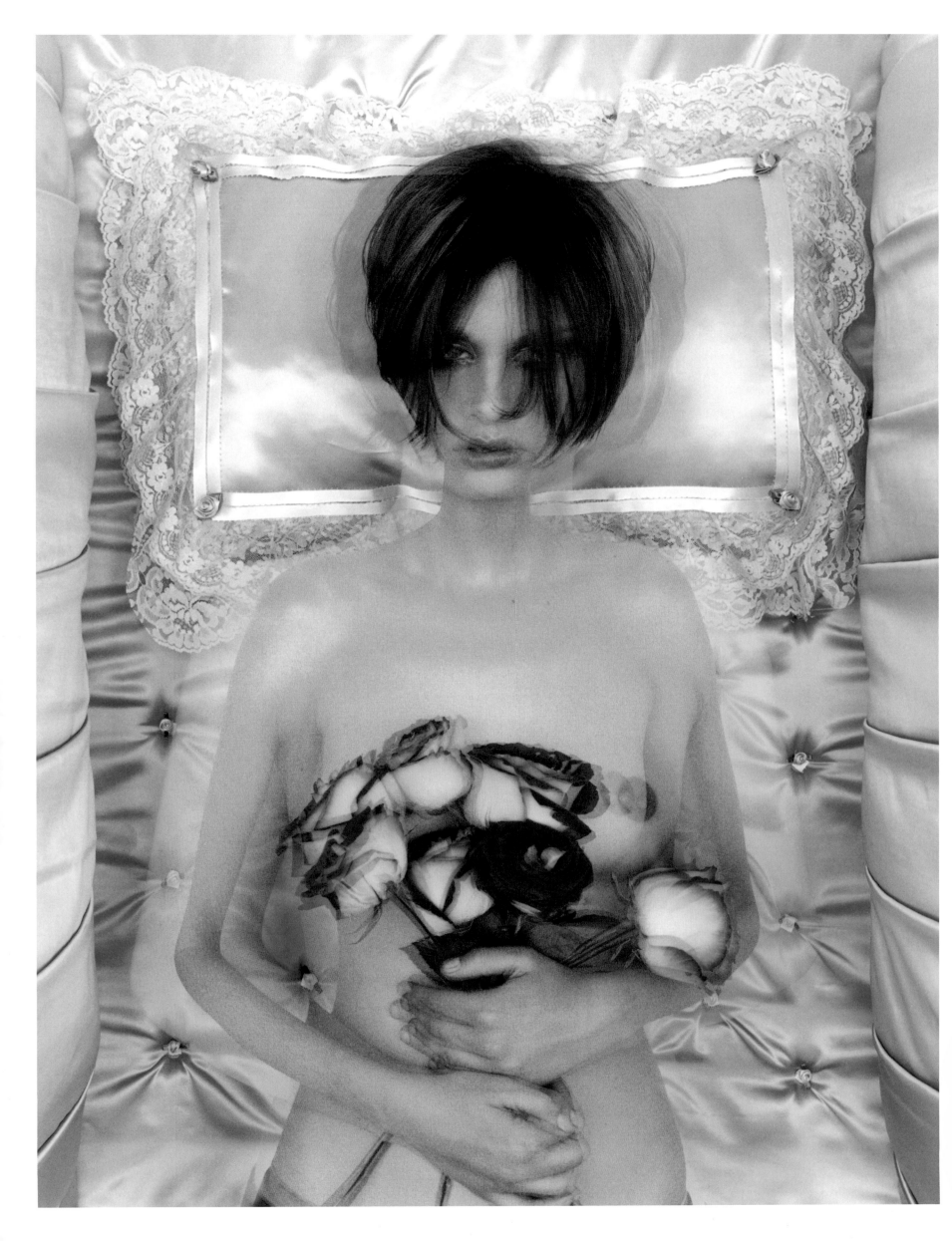

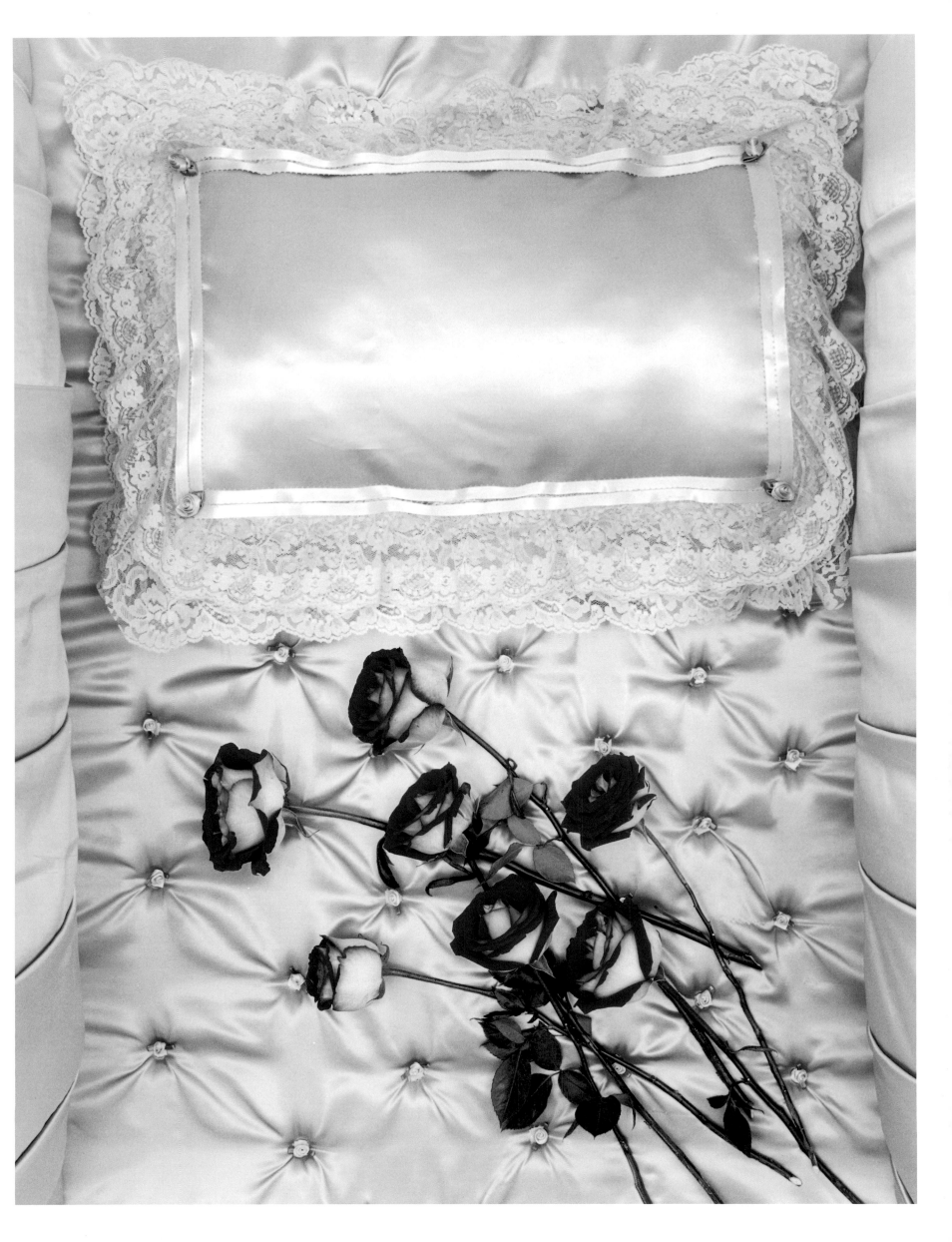

PAGE 1/2: "Shopping in Los Angeles," *Cosmopolitan*, Munich, Germany, Spring 1997. Stylist: Claudia Englmann. Make-up: Angie Parker. Hair: Ashley Javier. Models: Laura, Glenna. **4:** "Flourescent Night," *OneWorld* magazine, New York, Winter 1995/96. Stylist: Hector Castro. Make-up: Ashley Ward. Hair: John Caruso. Model: Sung Lee. **6:** "Shopping in Los Angeles," *Cosmopolitan*, Munich, Germany, Spring 1997. Stylist: Claudia Englmann. Make-up: Angie Parker. Hair: Ashley Javier. Models: Laura, Glenna. **11–23:** "Seduction of the Masses," *FAZ Magazin*, Frankfurt/Main, Germany, Spring 1996. Stylist: Jason Farrer. Make-up: Michael Delfino. Hair: Chuck Amos. Models: Cindy, Yalitza, Mayumi, Nikki, Kathleen, Julienne. **24/25:** Snapshots taken of dancers during production of the video clip *Emancipation* from "The Artist," Paisley Park Studios, Minneapolis, Fall 1996. Models: Kelly, Nick & James, Laurie, Stephanie, Tera, Tony, Carla, Michel, James, Salvatore, Cendise, Michel & Michelle, Tracy, Adriane, James, Nadine, Jill, Addie. **26–35:** "Silence of Times," *OneWorld* magazine, New York, Spring 1996. Stylist: John Hullum. Make-up: Ashley Ward. Hair: Rick Gradone. Manicure: Sae. Model: Mayumi. **36–41:** "Submit," homage to Wallis Franken, *Out* magazine, New York, Summer 1997. Stylist: Patti Wilson. Make-up: Shally Zuckers. Hair: Christopher Lockhart. Model: Autumn. **42/43:** "The Grip," excerpts from a triptych, Wittenbrink Gallery, Munich, Germany, Fall 1996. Model: Tony. **44–49:** "Untitled," *Cosmopolitan*, Munich, Germany, Spring 1998. Stylist: Bettina Runge. Make-up: Verena Jung. Hair: Verena Jung. Models: Indriaty, Lina. **50–55:** "Bauhouse Couture," *OneWorld* magazine, New York, Spring 1996. Stylist: John Hullum. Make-up: Shade. Hair: Pasquale Ferrante. Models: Tyrone, Zulema, Zoey, Allay, Darryll. **56–83:** "Shopping in Los Angeles," *Cosmopolitan*, Munich, Germany, Spring 1997. Stylist: Claudia Englmann. Make-up: Angie Parker. Hair: Ashley Javier. Models: Laura, Glenna, Alex. **84/85:** "Policemen," *aRUDE* magazine, New York, Summer 1998. **86–92:** "The Skinny," *Manhattan File*, New York, Winter 1996/97. Stylist: Jaqueline Allocca. Make-up: Jorge Serio. Hair: Cemal. Model: Eden. **93:** "Martina Topley-Bird," *Spin* magazine, New York, Summer 1997. Stylist: Eric Daman. Make-up: Michael Delfino. Hair: Chuck Amos. **94/95:** "Leo Castelli, Roy Lichtenstein," *Spiegel Spezial*, Hamburg, Germany, Winter 1996/97. **96:** "Susan Cianciolo," *Zeit Magazin*, Hamburg, Germany, Spring 1998. **97–99:** "Frances McDormand," Chelsea Hotel, *Entertainment Weekly*, New York, Spring 1996. **100/101:** "Fairydust," Thanks to Disneyland, *LA Times* magazine, Los Angeles, Summer 1998. Stylist: Phyllis Leibowitz. Make-up: Jeff Judd. Hair: Kevin Ryan. Model: Vanessa. **102/103:** "Snapshots," Irving Plaza "Grey Gardens"/Gramercy Park Hotel, New York, Spring 1995. Performance: Ami Goodheart. Filmlupes: Kaspar Stracke. Paintings: Leopoldo. **104–112:** "Flourescent Night," *OneWorld* magazine, New York, Winter 1995/96. Stylist: Hector Castro. Make-up: Ashley Ward. Hair: John Caruso. Models: Nanae, Phyllis, Judy, Yukiko, Sung Lee. **113:** "Silence of Times," *OneWorld* magazine, New York, Spring 1996. Stylist: John Hullum. Make-up: Ashley Ward. Hair: Rick Gradone. Manicure: Sae. Model: Mayumi. **114–121:** "Fashion Victims," *Surface* magazine, New York, 1996. Stylist: John Hullum. Make-up: Christopher Ardoff. Hair: Rick Gradone. Model: Katuta. **123:** "Shopping in Los Angeles," *Cosmopolitan*, Munich, Germany, Spring 1997. Stylist: Claudia Englmann. Make-up: Angie Parker. Hair: Ashley Javier. Model: Glenna. **127:** "Seduction of the Masses," Working Board, *FAZ Magazin*, Frankfurt/Main, Germany, Spring 1996. Stylist: Jason Farrer. Make-up: Michael Delfino. Hair: Chuck Amos. Models: Cindy, Yalitza, Mayumi, Nikki, Julienne, Kathleen.

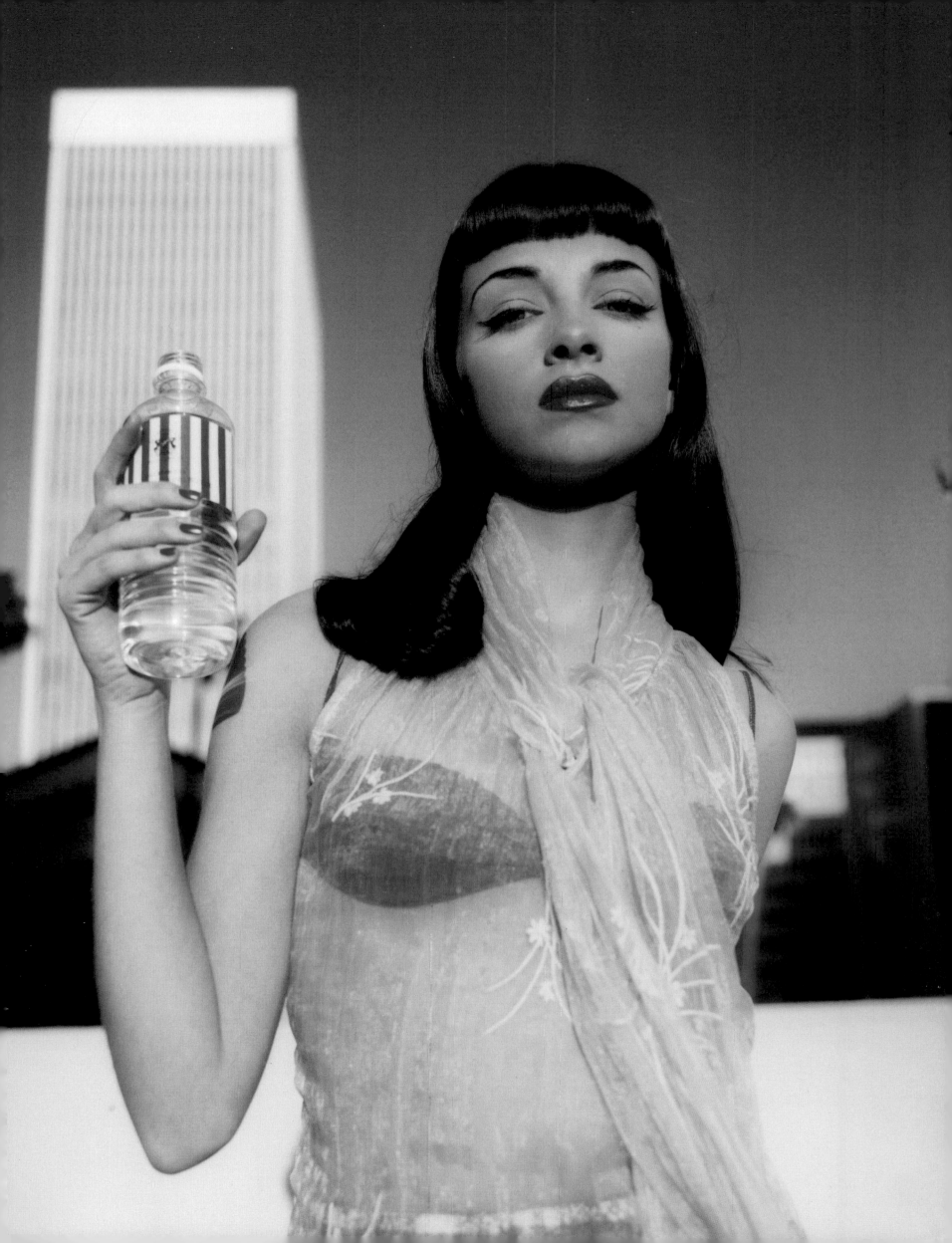

▶REDISGUISING THE ABSURD◀

Michelle Nicol

Fashion photography is an absurd field. Of that there can be no doubt. Melancholy eyes, awkwardly positioned legs and handbags tossed casually aside simulate an authentic something that turns around the very next moment and joins hands with glamour, glitter and sequins. In this way, emotions such as desire, exuberance or boredom are effortlessly introduced into the realm of beautiful illusion, filling it out completely. And the feat is accomplished so easily because fashion photography is a medium of meaning that has no meaning or, in other words, an empty vessel that can be filled with an endless variety of new sense relationships. And it is this very quality from which it derives its fascinating appeal, its alluring charm.

Katrin Thomas plays upon that appeal—in a photo for *Cosmopolitan* (p. 6), for instance. The composition is strictly symmetrical. Two models sit on two cream-colored leather easy chairs in the lower third of the picture. Turned away from one another, they are lost in autistic self-immersion. A high, narrow wooden pedestal with an ancient-looking spiral pillar rises from a behind them in the center of the photo. Placed upon it is a bouquet of assorted different flowers, small and large. The image is dominated by the deep, dark red background formed by a kind of plush-carpet tapestry. A length of heavy, black cord hangs suspended from above. It appears to belong to a particular type of Asian lamp that is striking by virtue of its kitschiness alone. The two models could be twins, for they look very much alike—extraterrestrial twins. They have matching hairstyles, egg-shaped bouffants of bluish-black hair with short bangs—a styled look that suggests devotion to a higher idea of beauty of the kind one finds only in fashion photographs. The girls remain firmly in place on the luxurious leather, like two hungry insects. The one on the left in the red dress rubs a purple eyelid with her ring finger. Her eyes are closed. Her companion on the right, with ochre-shaded lids, has fixed her expressionless gaze on some event apparently taking place beyond the boundaries of the photograph.

In a certain sense, Katrin Thomas is an entomologist. Her field of research is not the world of beetles, spiders and ants, however, but that of the sartorial code. Katrin Thomas illustrates fashion in her photographs. But at the same time she is constantly referring to its genesis: *How does glamour originate?*, she seems to be asking the viewer. Her pictures are both fashion photographs and documentaries, as is evident in the case of the bathing-suit photos done for the *Frankfurter Allgemeine Zeitung* (p. 19). Six female models sit in a row on a window bank. They appear to be waiting for the command to assume a pose. In the meantime, they examine their hands, gaze out of the window, yawn or grin—as if still waiting for the "right" photo to be taken. This is not one of those brilliantly staged presentations ostensibly required by the conventions of fashion photography. Yet the skyscrapers of steel and glass outside the glass façade do radiate a bluish, urban light. The glamour of the fashion world is in evidence. The young women wear athletic shoes, ankle boots, sandals or loafers with their bathing suits. The diversity of their footwear prompts us to wonder whether these are the shoes they wear in "real life." Or are they just the kind of shoes models put to go to a shooting? These girls would actually look quite natural if it weren't for the spiked hairdos that betray a certain artificiality. Katrin Thomas' glossy photos present no dream worlds as refuges of escape for glamour addicts. On the contrary, she regards fashion as performance and travesty and seeks aesthetic fulfillment in the exaggeration of the absurd.

Thomas' work *is* exaggeration. In her role as manipulator she stages fashion as a kind of solipsistic theater whose scurrilous mutations refer ultimately to itself. The models are her protagonists, whom she directs according to an imaginary script. They are chosen for their non-normality. They are not like other models. They are too young, too awkward, too tall or too short, too ethnic, too dark-haired or too blonde, too clumsy or too cool to be models at all. And so they file along in an orderly line over the bluish-gray carpet of some nameless hallway carrying shiny white shopping bags: iconic relics that allude to shopping as a socio-cultural act. Everything is but a pose. Even the colors are too loud and heavy-handed, as in a photo produced for *OneWorld* magazine

showing three Asian girls behind a huge aquarium (p. 104/105). Framed by the shapes of excited red-and-orange tropical fish, they become an integral part of the other world of this aquatic realm. It is exoticism on display. Thomas' locations are stereotypes, clichés. Barefoot girls in Chanel bangle their feet in a blue swimming pool (p. 1) for *Cosmopolitan*, while others lie down in a coffin with ice-blue upholstery (p. 114 ff.). In summary, one may conclude that, as a fashion photographer, Katrin Thomas stages the surface of things as hyper-gloss. "Photography is a kind of overstatement, a heroic copulation with the material world."[1] Through hedonistic overcoding and a radical purge of meaning, Thomas' photos create a world that reflects with irony on that of fashion photography yet participates in it nonetheless. The "repertoire of paroxysmic gestures,"[2] itself symptomatic of the artificial nature of fashion photography, is overstated by Thomas and reintroduced to the system of fashion like a delicious magic cake. The alluring aspects of clothing fashions are of only peripheral interest to Katrin Thomas. What really fascinates her is the process through which images become icons. The immanence of form is a product of deliberate staging. Every one of Katrin Thomas' fashion photographs is also a collage of color areas and lines. One need only close one's eyes to conjure up modernist landscapes in the mind's eye: a formalism that achieves its effects from a distance.

Katrin Thomas is a native of southern Germany. As a young girl growing up in Frankenthal in the Palatinate she loved leafing through the dream worlds of the fashion magazines—they had titles like *Carina* and *Brigitte*—imbibing the aura of the beautiful as she turned the pages. Her favorite color was bombastic, radiant red in a variety of shades. Her great obsession was drawing with colored felt-tip markers. The outcome was always the same: prototypes of women with thin arms and legs, round faces and triangular noses. The only variables were hairstyle—ponytails or the Farrah-Fawcett-flicks popular in those years—and fashions—bell-bottomed slacks with diamonds, pleated skirts, handbags with ethnic decorative patterns, shoulder-bags with tassels, Mary Janes and kitten heels. A drawing done in 1974 entitled *Im Kaufhaus* (Department Store Scene) features a formation of women of the type mentioned

above standing in front of clothing racks and rolling mirrors, helpless in the face of the need to make the great sartorial decision: *What shall I buy myself today?* Later on, during the eighties, Katrin Thomas was captivated and enchanted by a thin, narrow volume of black-and-white photographs by Bruce Weber. There were pictures of attractive people in attractive settings, people with lustrous, hairless bodies. Her image of ideal beauty in this case was smooth, straight hair, natural make-up, freshness. And so it is not unreasonable to assume that she really did believe that fashion held out a promise of salvation back then.

Katrin Thomas' photography is at home in many different contexts. Yet she deliberately chooses the restrictive medium of the fashion journal for the group of works that comprise her *Modefotografie*. Within the system of fashion, these publications are the popular agents of the moment. They illustrate and comment upon coming fashions and trends, constructing them with the aid of photography. They are economic instruments in the role of the seducer propagating the dancing circle of the eternally new. Or, expressed in different terms, what we recognize in these journals is the fetishized heart of desire in an endless variety of new disguises. The magazines in which Thomas publishes her self-referential photographs are the written manifestations of frivolous illusion. Within the framework they prescribe, Katrin Thomas displays fashion photography as something absurd. Achieved through exaggeration and formal abstraction, her stylized images are informed with an aesthetic distance one might describe as "disinterested pleasure." She treats fashion photography as an oddly beautiful entity to which she responds with a mixture of repulsion and attraction. Her photograph of an teenage Asian model (p. 108/109) seated at a white-clothed table in front of a green wall is a paradigm for this attitude. The food on the plate before her echoes the combination of white and green. The young girl examines it with a mixture of fascination and disgust—as if it were a strange reptile stretched out in front of her. Yet, as Baudelaire once remarked, the beautiful is always strange.

1 Susan Sontag, *On Photography*, 1973, p. 34.
2 op.cit, p. 105.

▸ACKNOWLEDGMENT◂

Biography

1963 Born in Bonn, Germany.

1983–1990 Studied Visual Communication at the Fachhochschule
 Darmstadt, Germany.

1989–1990 Assistant to the Spanish designer and illustrator Javier
 Mariscal, Barcelona. *Barcelona,* final photographic project
 for graduation.

1991–1992 Studied Fine Art, Photography & Film at the Art Center
 College of Design, Pasadena, California.

1992 Shot two short films, *Choice* and *Five Naturals.*

1992–1993 Worked on the *City of Los Angeles* book project and
 exhibition concept.

1995–1998 Studied fine art and photography at the Akademie der
 Bildenden Künste, Munich, Germany.

Since 1993 Katrin Thomas has been working as a free-lance
 photographer and artist in New York City.

Awards

1991 *Fulbright,* fine art, photography and film scholarship,
 Bonn, Germany

1992 Photography prize and scholarship awarded by the
 Senatsverwaltung für kulturelle Angelegenheiten, Berlin,
 Germany
 Received scholarship from the Art Center College of
 Design, Pasadena, California

1998 Otto-Steinert-Preis (Otto Steinert Prize) awarded by the
 Deutsche Gesellschaft für Photographie, Cologne, Germany

Selected Group Exhibitions

1995 450 Broadway Gallery, New York

1996 Wittenbrink Gallery, Munich, Germany

1997 Seidelvilla, Munich, Germany
 Spanisches Kulturinstitut, Munich, Germany
 Urban Camera, Dominican monastery, Braunschweig,
 Germany

1998 4. *Internationale Foto-Triennale,* Esslingen, Germany
 A *Streetwalk Named Desire,* Luzerner Ausstellungsraum,
 Lucerne, Switzerland
 Wittenbrink Gallery, Munich, Germany

I wish to thank
Edition Stemmle, Denis Brudna, F.C. Gundlach, Christoph Gassner,
Gerd Winner, Hanna and Bernhard Wittenbrink, Thomas Rempen,
Hans Hansen, Francine Parker, Iké Udé, Michelle Nicol, Betty Wilson,
Julian Richards, Susanne Schmitz, Christin Brümmer, Jeannette
Altherr, Wolfgang Hastert.

Thanks are due as well to
all of the models who have worked with me, my assistants and all
stylists, hair and make-up artists
the staffs of all of the magazines for whom I have worked, especially
John Pasmore and Franc Reyes of *OneWorld* magazine, who helped
me get started
everyone who has helped me along the way and everyone I have
forgotten to mention.

Very special thanks go to
my parents, Rainer and Elisabeth Thomas, Leni Kulze, Margarethe
Thomas, Annegret Oebel, Hans-Peter Thomas, Florian Wüst.

P1

P2

P3

P4

P5

P6

Photo reproduction copyrights by Katrin Thomas, New York
Text copyrights by the authors

Translation from the German by John S. Southard
Editorial direction by Sara Schindler
Layout and Typography by Guido Widmer, Zurich, Switzerland
Printed by Kündig Druck AG, Baar/Zug, Switzerland
Bound by Buchbinderei Burkhardt AG, Mönchaltorf/Zurich,
Switzerland

ISBN 3-908161-76-2